Revitalizing History

Recognizing the Struggles, Lives, and Achievements of African American and Women Art Educators

Edited by

Paul E. Bolin
The University of Texas at Austin

Ami Kantawala
Teachers College, Columbia University

Foreword by

Mary Ann Stankiewicz
Pennsylvania State University

Authors

Heidi C. Powell
The University of Texas at Austin

Christina Hanawalt
University of Georgia

Sue Uhlig
The Pennsylvania State University

Christina Bain
The University of Texas at Austin

Elise Chevalier
Independent scholar

Mary Hafeli
Teachers College, Columbia University

Kirstie Parkinson
Independent scholar

Jessica Baker Kee
The Pennsylvania State University

Debra Hardy
Independent scholar

Rebecca Dearlove
Independent scholar

Allison M. Clark
Independent Scholar

Kristin G. Congdon
University of Central Florida

Vernon Series in Education

VERNON PRESS

www.vernonpress.com

In the Americas:
Vernon Press
1000 N West Street,
Suite 1200, Wilmington,
Delaware 19801
United States

In the rest of the world:
Vernon Press
C/Sancti Espiritu 17,
Malaga, 29006
Spain

Vernon Series in Education

Library of Congress Control Number: 2017931117

ISBN: 978-1-62273-297-5

Cover Image: CAPE ANN MUSEUM, Gloucester, Massachusetts

Table of Contents

List of Figures

Foreword

Mary Ann Stankiewicz

What does it mean to revitalize histories of art education?

Historical researchers study the past using evidence from written documents, visual and material culture, oral histories, and other primary sources. Although students sometimes seem to believe just one authoritative version of past ideas and events exists—the boring paragraphs and questions for discussion found in assigned textbooks—historians argue that each new generation reinterprets multiple pasts from its own perspective. History is not dead leaders, dull facts, and boring arguments. Historical narratives develop from persistent detective work, careful documentation, and revisionist interpretations. Written histories help us identify questions that can be used to interrogate contemporary peoples, claims to the status of truth, and persuasive stories.

Revisionist interpretations bring the past to life by extending definitions of historical actors to include persons and groups underrepresented in traditional master narratives focused on political players, diplomatic agents, and economic elites. In histories of art education, researching and writing revisionist histories means moving away from the nineteenth-century Massachusetts policy makers and the White men and women with British and European ancestry who introduced drawing to the common school. Re-envisioning art education's history means questioning assumptions that institutions, such as public schools, offering formal instruction in the arts are and should be the norm. It means looking for examples of informal art education beyond the walls of art museums, in community art centers and communities created by marginalized artists.

Revisionist histories of art education require looking beyond land-grant universities or northeastern normal schools to identify how, at an institution founded to prepare African American and later Native American students for industrial labor, manual and domestic work intended to keep them in a low status, African American students exercised agency to begin collecting folklore and African art.

How did a community of African American artists who sold their paintings beside Florida's highways learn to paint? How did they resist the economic oppression of a segregated society? How did

this social network of artists become a shared resource supporting their emancipation, aesthetic values, and voices?

How did African American artists and art educators on the South Side of Chicago work with women of the Black middle class to establish a community art center? What political challenges forced left-leaning leaders to surrender power to conservative members of the community so that the center might continue?

How did a film program at New York's Museum of Modern Art support African American filmmakers and offer urban audiences perspectives on diversity, Black lives, and the Civil Rights movement during a tumultuous period in U.S. history?

From the day Massachusetts Normal Art School opened its doors in November 1873, women have outnumbered men as art education students and teachers. Given the pervasive sexism of North American society, feminist researchers have had to unearth stories of women art educators buried by men who thought their version of history was the one, true story. As a result of their work, some female art educators now constitute a revisionist canon of movers and shakers. Multiple researchers are filling in gaps and reinterpreting the lives and work of women art educators like Dorothy Dunn, the White woman whose beliefs about Native American art shaped expectations for artists educated at the Santa Fe Indian School; Helen Gardner, the art historian whose teaching at the School of the Art Institute of Chicago informed the first edition of an art history text for the ages; and Anna Curtis Chandler, noted storyteller at New York's Metropolitan Museum of Art.

On the other hand, digging more deeply into male-dominated interpretations of the field can introduce us to Margaret McAdory whose work at the intersection of design theory, aesthetic values, and psychometric testing sought to develop valid, reliable instruments to measure aesthetic judgment and indicate aptitude in visual art. In another example, a high school art teacher grounded in her sense of place in a fishing and tourist center on the rocky North Shore of Massachusetts connects the Normal Art School where Walter Smith was founding principal with the Pennsylvania State College where Viktor Lowenfeld taught summer mural making courses informed by his work at Hampton Institute.

The stories of these women art educators are told through frames of material and visual culture. Studies of postcard albums and articles on good design in women's magazines led these artist-

researchers to appropriate and recreate Mabel Spofford's documentation of her summer experience and Margaret McAdory's forced choices in good taste. Research into family history, reflections on memory, and curating one grandmother's Native American heritage led one author to create an original work of art. Another author bonded with her research subject over shared experiences of place and interests in puppetry. In the story of Nancy Renfro, readers will examine how a woman with disabilities contributed to informal arts education, worked as an entrepreneur, and expressed herself through powerful paintings.

The chapters in this book do not focus solely on individual art educators, however. Another cut through the eleven essays reveals that one-third examine institutions as well: the Santa Fe Indian School in New Mexico, Hampton Institute in Virginia, the South Side Community Art Center in Chicago, and the Department of Film at the Museum of Modern Art in New York City. Interest in institutional histories is growing among art educators, an index of increasingly sophisticated approaches to historical research. Historical researchers in the field are demonstrating their understanding that art education is more than the work of isolated, often charismatic individuals, an approach reflecting Romantic myths of artistic genius. Lively, vital histories of art education acknowledge complex intersections among social networks, cognitive frameworks, and the institutions where art education practice is normalized.

When Ami Kantawala and Paul Bolin first began planning a conference on histories of art education, they claimed leadership in building research capacities among art educators. Focusing on methods of historical research, benefits of doing and reading historical research for graduate students and early career faculty, and approaches to teaching history of art education, they planned "Brushes with History: Imagination and Innovation in Art Education History." This conference held November 19-22, 2015, at Teachers College, Columbia University, in New York City, built on their extensive experience teaching history of art education.[1] In undergraduate and graduate courses on art education history at the Pennsylvania State University and the University of Texas Austin, Paul has encouraged students to seek out primary sources in archival collections, to interpret histories framed by material culture and community-based art education, and to re-examine stories told by other art educators. In her history of art education courses at Teachers College, Ami has mined the rich resources for historical

investigations in New York City and the surrounding region, curated exhibitions of visual histories created by her graduate students, and convened conferences to examine intersections of historical research and digital technologies.

The short title of this book, *Revitalizing History*, resonates with the goals described in the conference program for "Brushes with History." The conference organizers wanted to convene a gathering where information, ideas, issues, and research methods used in historical investigations—ranging in scope from local to global—could be presented and discussed. They wanted those attending the conference to learn about and engage with resources for art education histories gathered at Teachers College, and dispersed across the Borough of Manhattan in venues such as the Tenement House Museum and the Abrons Art Center of the Henry Street Settlement House, both on the Lower East Side; the Whitney Museum of Art on the Lower West Side; and the New York Historical Society near Central Park West. They sought to encourage art educators to undertake more sophisticated approaches to historical research in order to produce more meaningful studies. The conference planners hoped that presenters would identify gaps in written histories of art education; explore, challenge, and critique ideas in the field; and approach histories from multiple, divergent points of view. As the introductory essay in the conference program declared: "Our hope is that the conversations generated in this conference will continue to strengthen and encourage more interest in histories of art education, but also more sophisticated and innovative approaches to research."

The conference subtitle, "Imagination and Innovation," identifies threads running through this collection of edited conference papers. From the imaginative reflections on curating memories that opens this collection, to the innovative analysis of how twentieth-century African American painters created a community and an art movement in Florida, these essays contribute to reviving interest in histories of art education. The editors and authors invite readers to become researchers and writers bringing their own versions of art education's histories to light and to life.

Mary Ann Stankiewicz

Pennsylvania State University

Endnote

[1] In the interests of full disclosure, I was one of the conference organizers, with Drs. Bolin and Kantawala, and Dr. Judith Burton of Teachers College, as well as a discussant during the conference. In order to avoid conflicts of interest during my term as Senior Editor of *Studies in Art Education* (2015-2017), I chose not to participate in reviewing, selecting, and editing conference papers for the current book, nor for the special issue of *Visual Inquiry: Learning & Teaching Art*, 5(2), guested edited by Bolin and Kantawala. Several papers originally given at Brushes with History were revised, submitted to *Studies in Art Education* in response to a call for a theme issue on histories and historical research, and published in the first two issues of volume 58. As a result, participants in the November 2015 conference had access to three distinct opportunities for publication.

Acknowledgements

Our heartfelt 'thank you' to Dr. Judith Burton (Teachers College, Columbia University) who gave a supportive "nod" when we pitched to her the idea of a *Brushes with History* Conference a couple years ago. That conference and this book could not have been possible without her support, as well as the funding and assistance received from Provost Thomas James and our sponsors, the Art and Art Education Program staff, the Macy Gallery staff at Teachers College, Columbia University, New York , and our colleagues— especially Mary Ann Stankiewicz. Paul Bolin would like to thank the Walter and Gina Ducloux Fine Arts Faculty Fellowship Endowment from The University of Texas at Austin for its assistance in supporting work on this volume. We thank all discussants at the *Brushes with History* Conference who volunteered their time, read the papers, and offered substantive feedback to move ideas forward for an ongoing conversation. This book would not be possible without Judith Burton, Doug Blandy, Doug Boughton, Ansley Erickson, Kerry Freedman, Judith Kafka, Grace Hampton, Mary Hafeli, Amy Kraehe, Dònal O'Donoghue, John Howell White, and Graeme Sullivan. We could not have accomplished this work without you. A debt of gratitude is also given to Gabriella Oldham for her careful editing and formatting; Alex Kruger and Argiris Legatos from Vernon Press who have given us this opportunity; and lastly, to Geneva Robinson for managing this publication with much-needed precision and finesse. Our gratitude to all of you!

A Past Forward

All stories begin with "once upon a time," figuratively, if not literally. The stories presented in *Revitalizing History: Recognizing the Struggles, Lives, and Achievements of African American and Women Art Educators* reveal, and inform in special ways, what happened once upon a time in art education history (Eisner, 1997; Gombrich, 2008). History opens up the possibility for researchers to bring forward stories from the past, carving out new spaces to include in the historical record the experiences and perspectives of individuals who might otherwise linger in the shadows of more prominent figures or become veiled from history. Educational theorists J. Dean Clandindin and Jerry Roseik (2007) have encouraged researchers to discover the extraordinary in ordinary lives by listening more deeply to personal narratives that can serve as models for the future. This can be an easily universal endeavor as stories resonate with humans on both individual and social levels (Connelly & Clandinin, 1990) because of an innate, subconscious need we possess to hear them. Moreover, as Alessandro Portelli (2006) has noted, a story's structure and organization help the storyteller relate more deeply to the topic and its contextual history.

The historian typically engages with the arrangement of chronological data to craft a historical narrative, which is thought to possess an apparent beginning, middle, and end. Hayden White (1973) has offered that the aim of the historian is to explain the past by finding or uncovering stories that lie buried in the chronicles, and the difference between history and fiction is that the historian finds stories while the fiction writer invents them. This conception of the historian's task, however, obscures the extent to which imagination, innovation, and interpretation also play a part in the historian's operation. In other words, the same event can serve as a diverse element within a wide range of historical stories, depending on its assigned role in the specifically characterized narrative set to which it belongs. For example, the death of a king may be a beginning, an ending, or simply a transitional event in three different stories (p. 7). Here, we invite readers to view the stories presented in this volume as a beginning or a stepping stone to exploring the shadowed and hidden histories of past art educators.

Despite many publications on the histories of art education produced over the last century, the struggles, lives, and accomplish-

ments—in short, the stories—of many female and minority art educators continue to be hidden. A few publications beginning in the 1980s have attempted to fill this void. For example, the National Art Education Association (NAEA) published edited volumes titled *Women Art Educators* in 1982 and 1985 featuring personal histories of several women for the first time. A third volume, co-edited by Kristin Congdon and Enid Zimmerman (1993), offered the autobiographies and pedagogical practices of contemporary women artists and art educators, as well as critiques of books related to feminism and multiculturalism. The Canadian Society for Education Through Art produced the next volume, examining little-known artists through the themes of racism, politics, and social change in the classroom, and even grieving and loss. Finally, the fifth volume, published in 2003, focused on formal and informal education, interculturalism, spirituality, and retirement pertinent to women. Nevertheless, even with these important glimpses into forgotten lives, many histories of women and especially African Americans remain in the shadows, depriving the field of a richer understanding of larger social, cultural, political, and historical contexts on a global scale.

One contributor to this narrow view of the importance of certain lives is the dominant perspective of describing art education history through a Eurocentric narrative (e.g., Efland's 1990 chronological account of the impact of German and English art education on American pedagogy). One might argue that for the last century, and even earlier, great *men*—not women and minorities—have defined the history of art education. Only in the past three decades have researchers and historians attempted to create a broader overview of the field. For example, the Penn State Seminars on the History of Art Education in 1985, 1989, and 1995 highlighted a handful of women and African American art educators in their histories, although the coverage was not extensive. At the dawn of the 21st century, Paul Bolin, Doug Blandy, and Kristin Congdon (2000) made clear in the subtitle of their book (*Making Invisible Histories of Art Education Visible*) that women have been denied the attention that their dedication and accomplishments merit. More rigorous efforts have been made since then to reexamine forgotten artists and educators as a springboard to question what their stories mean for a modern world, but women's voices even in these works remain minimal or excluded (Eisner & Day, 2004; Stankiewicz, 2001). Such journals as *Studies in Art Education, Women's Art Journal,* and *International Journal of Education Through Art* have also

made inroads by publishing articles that acknowledge women's contributions to art education. But one might suggest that the over-arching idiosyncrasy of art education historical literature is its hesitation to bring to light a number of hidden histories of women and minority art educators. This volume, then, might be seen as the first step in addressing this need exclusively.

The chapters in this volume are the result of *Brushes with History: Imagination and Innovation in Art Education History*—a conference held at Teachers College, Columbia University in New York City in November 2015 (http:// www.tc.columbia.edu/ conferences/ brushes-with-history). The goal of this conference was to provide a forum for presenting and discussing ideas, issues, information, and research approaches utilized in the historical investigation of art education within local and global contexts. The conference offered opportunities to engage with rich resources in art education history, explore more sophisticated approaches and methods of historical research, encourage interest in historical inquiry, and extend the conversation on how meaning is produced in historical research trends and representations.

In the first chapter, "Becoming a Curator of Memories: Memorializing Memory as Place in Art Making for Art Education," Heidi C. Powell argues that the memories we give voice to form the very echoes of our field and our hope to leave legacies as historical research. For those in art education—student, teacher, artist, or scholar—recognizing and (re)collecting memories are forms of historical research. Such inquiry helps us shape personal identity and culture in ways that shift and augment our understanding of where we have come from, who we are in the current age, and who we will become in our future histories as we move forward to make art, educate about art, and foster growth.

Christina Hanawalt and Sue Uhlig in the next chapter, "Making Place Through Mabel Spofford (1883-1981): Archival Materials, Assemblages, and Events," tell the story of Mabel Spofford, an early 20th-century art educator from Massachusetts. Through the material artifacts created and collected by this historical art educator, the authors focus on the ways that Mabel's material outputs—her copious written notes, her journals and handmade scrapbooks, her postcard correspondences, her artwork—have actively served to *make place*, not only for Mabel, but also for the authors themselves as well as for us as readers.

In the chapter, "Nancy Renfro and the Fabric of Our Lives: Discovering Art Education History Through Puppets, Place, and Pedagogy," Christina Bain expresses the powerful story of Nancy Renfro's life (1937-1993) and her work as a teaching artist. Bain explains the connections she herself made to Renfro, which were based on living in places where Renfro also resided. The author reminds us that history should be thought of as a collective story in which we layer or weave our personal experiences into our examination of the past.

Elise Chevalier, in her chapter "Lessons From Dorothy Dunn (1903-1992): The Studio at Santa Fe Indian School, 1932-1937," tells the story of an art educator who founded the first painting program in Santa Fe Indian School, New Mexico, in 1932. The Santa Fe Indian School painting program, which became known as the Studio, launched the careers of several prominent artists and influenced the course of Native American painting in the Southwest throughout the mid-20th century. Chevalier's work sheds new light on the pedagogical ideas and activities of Dorothy Dunn, exploring the impact of her educational practice within the context and conditions of Dunn's time in New Mexico.

In her chapter "Matters of Taste, Measures of Judgment: The McAdory Art Test," Mary Hafeli examines Margaret McAdory Siceloff's (1890-1978) pioneering work in the testing of aesthetic judgment. While art education scholars have examined and critiqued Norman Meier's early work and his later tests of art judgment, there has been no such close examination of McAdory Siceloff's noteworthy work in the same area. Drawing on primary documentation, including all of the plates from the original McAdory Art Test, McAdory's dissertation, and the subsequent technical reports she and her colleagues issued, Hafeli's intent here is to examine the test in light of the aesthetic trends and tastes of the period in which it was created, and to describe the historical and cultural conditions that persist in the quest to quantify artistic thinking and practice.

The chapter titled "Life and Work of Helen Gardner" by Kirstie Parkinson examines the life of this author and art educator and the first two editions of her renown volume on the history of art (1926, 1936). Gardner's book is arguably still one of the most popular English art history texts used today, yet most of its readers know little about its author, given the paucity of biographical material available on Gardner. This chapter provides information about this influential art historical educator, particularly shedding new light on her life and thinking behind her work.

The chapter that follows, "Uncovering Hidden Histories: African American Art Education at the Hampton Institute (1868-1946)" by Jessica Baker Kee, examines the intersections of art education, African diaspora art, and African American folkloric history at the Hampton Institute in Virginia from the late-19th century leading up to Viktor Lowenfeld's tenure as professor and curator. Kee's goal here is to provide a deeper understanding of an underrepresented aspect of American art education. The author takes up Bolin et al.'s (2000) call to uncover hidden and marginalized narratives in order to challenge ethnocentric master narratives of art education history.

In "The Detrimental Effects of McCarthyism on African American Art Institutions," author Debra Hardy explores the South Side Community Art Center (SSCAC) in Chicago, Illinois, which is regarded as being among the first African American cultural centers in the United States and one of the last remaining Works Progress Administration-founded community art centers still in its original form and location. Founded in 1939, the SSCAC celebrated its 75th anniversary in 2015, remaining a vital community organization in its Bronzeville neighborhood. Its history, however, has been overlooked by writers outside the Chicago area. Of the more than 100 art centers founded by the WPA, the SSCAC stands as a lone survivor, and is now finally given its long overdue recognition in art education.

Rebecca Dearlove, in her chapter "The Museum of Modern Art's Department of Film: How Educational Film Programs Responded to Social and Cultural Changes in the United States," narrates the story of the efforts this famous film department in the world-renown museum made to promote and expand its public programming and educational resources since its induction into the museum in 1935. Its initial purpose was to collect and preserve film for educational purposes. From its vivacious energies in supplying government agencies with film during World War II, to inviting young filmmakers to screen and discuss their social problem documentaries in the late 1960s and 1970s, the Department of Film continued to reevaluate its didactic mission. This chapter offers insight into these various departmental changes as observed in its public programming from the early 1940s through the 1970s, and also examines the film library's developmental years in strengthening its educational foundation.

In "Constructing Social Imaginaries: Exploring Anna Curtis Chandler's (1890-1969) Storytelling Practices at the Metropolitan Museum of Art, 1917-1918," Allison M. Clark establishes a biograph-

ical portrait of a determined, politically engaged educator whose actions were situated within the nation's contemporaneous Americanization efforts. Chandler is often remembered as one of the preeminent storytellers working in art museum education during the early-20th century, conjuring imaginative tales for audiences of all ages at the Metropolitan Museum in New York City. During her nearly 18-year career as an educator at the museum, Chandler has been credited with attracting tens of thousands of visitors; establishing cooperative partnerships with local public schools; offering teachers resources via lectures and publications; advancing storytelling as a dramatic pedagogy unique to art museums; performing for two nationally broadcast radio programs; and authoring eight widely popular storybooks.

In the book's final chapter, "The Highwaymen's Story: Landscape Painting in the Shadow of Jim Crow," Kristin Congdon presents the story of 26 African American landscape painters (25 men and one woman) who began painting as young adults in the 1950s until the early 1970s during Jim Crow times, in and around Fort Pierce, Florida. Congdon describes the now highly honored group and places their art education within the context of their segregated community as they worked in the open studio of White artist A. E. 'Bean' Backus, who fostered a time and place of optimism for both Blacks and Whites. Their boundaried community is considered not a devalued space but rather a place that can be used as a resource. The Highwaymen's landscape paintings are now acknowledged as catalysts for the aesthetic process that overturned western approaches to valuing art. Congdon suggests how the story of the Highwaymen fits into the Civil Rights movement, changing the lives of both Blacks and Whites and creating important implications for the history of art education.

In recent years, the field of history has undergone significant changes, including transformations in historical methodology that have responded to influences within and outside the discipline. Historical writing, as viewed by traditional historians, has evolved from gathering and presenting facts about past events to incorporating a wide range of topics ranging from art to psychology. Previously, a historian's primary task was to investigate information and document the actions of people in the past. Traditional history has offered a view from above; that is, it has focused heavily on the deeds of individuals, statesmen, generals, and sometimes church leaders, relegating the rest of humanity to only a passing mention in

its narratives. By contrast, new historians are concerned with history *from below*, that is, they are now looking through the eyes of everyday individuals as they experience social change (Burke, 2001). Today, historians view their work as interpretive and fluid as they take up the challenge to recognize and investigate relationships between past and present. Hence, today's histories reflect multiple perspectives (Bolin et al., 2000; Hamblen, 1985). Peter Burke (2001) identified some of these recent developments in his text *New Perspectives in Historical Writing*. These developments offer a contemporary view of history whereby Burke sees the need to understand what is important and worthy of historical study and to move beyond the study of historical documents to a position that can generate numerous responses to broader questions about the nature of human history.

There is much to know and interpret about past events that are not part of published or unpublished documents. Hence, Burke (2001) underscores the need to move beyond the study of historical documents alone. Stories and objects that are passed between generations create circumstances for understanding "then" and "now" in ways that are missed if history is only examined through a discursive written form (Bolin et al., 2000). According to Burke (2001), historians who are more concerned with a greater variety of human activities than their predecessors must now examine a wider range of visual and verbal evidence. Consequently, these diverse data can establish prolific connections between past and present while also offering insight into the future. Moreover, history itself does not furnish single answers to meaningful questions; instead, questions about history can generate a multitude of valid responses (Burke, 2001). As the breadth of topics for historical analysis increases, so does the scope of questions that motivate historians. Consequently, contemporary history should be seen as complex and multifaceted, with investigations that can satisfy both historian and general reader.

The chapters in this volume invite deeper dialogue and engagement with the often overlooked life stories of women and African Americans. The text models how historians can begin to select intriguing narratives that identify and interpret written documents, images, and stories which help to complement and balance the larger history of art education. By elevating the "underside" of art education (Perks & Thomson, 1998), so to speak, this book challenges previous assumptions and judgments by spotlighting women and African Americans who have influenced and transformed

lives by their courage to face and address the needs of their com-
munities. So, too, this book hopes to transform. Our desire is that
this volume generates conversations to question, explore, probe,
and celebrate forgotten stories and develop innovative approaches
to research in art education and education history.

Paul E. Bolin and Ami Kantawala, Editors

References

Bolin, P., Blandy, D., & Congdon, K. (Eds.). (2000). *Remembering others: Making invisible histories of art education visible.* Reston, VA: National Art Education Association.

Burke, P. (Ed.). (2001). *New perspectives on historical writing.* University Park, PA: The Pennsylvania State University Press.

Clandinin, D.J., & Roseik, J. (2007). Mapping a landscape of narrative inquiry: Borderland spaces and tensions. In D.J. Clandinin, (Ed.) *Handbook of narrative inquiry: Mapping a methodology* (pp. 35-76). London, UK: Sage.

Congdon, K., & Zimmerman, E. (Eds.). (1993). *Women art educators: III.* Reston: VA: National Art Education Association.

Connelly, M. F., & Clandinin, D.J.. (1990). Stories of experience and narrative inquiry. *Educational Researcher, 19*(5), 2-14.

Efland, A. (1990). *A history of art education: Intellectual and social currents in teaching of the visual arts.* New York, NY: Teachers College Press.

Eisner, E. (1997). The promise and perils of alternative forms of data representation. *Educational Researcher, 26*(6), 4-10.

Eisner, E., & Day, M. (Eds.). (2004). *Handbook on research and policy in art education.* Mahwah, NJ: Lawrence Erlbaum.

Gombrich, E. H. (2008). *A little history of the world.* New Haven, CT: Yale University Press.

Hamblen, K. (1985). Historical research in art education: A process of selection and interpretation. In B. Wilson & H. Hoffa (Eds.), *The history of art education: Proceedings from the Penn State conference.* Reston, VA: National Art Education Association.

Perks, R., & Thomson, A. (1998). *The oral history reader* (2nd ed.). New York, NY: Routledge.

Portelli, A. (2006). What makes oral history different? In R. Perks & A. Thomson (Eds), *The oral history reader* (pp. 45-58). New York, NY: Routledge.

Stankiewicz, M.A. (2001). *Roots of art education practice.* Worcester, MA: Davis.

White, H. (1973). *Metahistory: The historical imagination in nineteenth-century Europe.* Baltimore, MD: The Johns Hopkins University Press.

Chapter 1

BECOMING A CURATOR OF MEMORIES: MEMORIALIZING MEMORY AS PLACE IN ART MAKING FOR ART EDUCATION

Heidi C. Powell

It was 1971 as I looked at my Lenni Lenape grandmother's ceramic piece that was in an exhibition in a museum in Boston, a contemporaneous exemplar form of an innovative Native American wedding vase, the one I loved the most. She said it was her version, which was not so traditional. It had two openings, one larger than the other, like two jars loosely formed of different heights and widths stuck together. I always wondered why she made it that way, obtuse and unconventional in contrast to the perfectly symmetrical wedding vases crafted from Indian traditions. It was textured with rows of indentations, which she made with wooden sticks and clay tools, and it had a white wash that only stayed on the edges of the natural brown clay used to form it. Grandmother was intense when she worked, and only allowed us as kids to watch from the doorway of her small studio that was not much bigger than a closet. So much energy was always present when she worked, whether by hand or on the wheel, as she made the clay take form. Often, if it turned out not to her liking, she would throw the object down in dissatisfaction, crushing it flat to the floor. It was a simple cycle, watching the same experience on repeat: building, crushing, and beginning again. However, when she felt she had succeeded in being creative, nothing mattered more, only to look at it critically the next day to decide whether it should hit the studio floor and be swept up later as dry matter. She destroyed more forms than she kept. But this piece, this unconventional wedding jar, survived and made it for all to see, a survivor of her craft, her effort—a cultural augmentation of her own history and traditions (see Figure 1.1).

Figure 1.1 *Untitled*

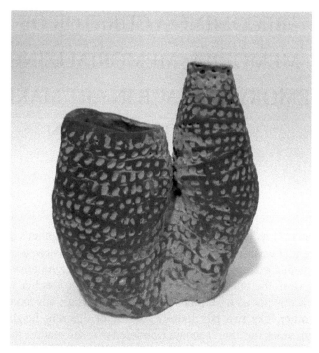

Lucille Francis Powell (Lenni Lenape), c. 1969, clay.

Introduction

Memories—they connect the past to the present, individuals to family, friends, and community. They create a place to reflect on who we are, what we do, and how we think as we create histories, both lived and perceived, in the formal and informal places in art education. What does it mean to memorialize memory and place in art making and art education? How do we effectively (re)collect our experiences in art and art making? How do we understand the idea of memory as a place of *knowing* and *learning*? Memorializing memory as a place in art making and art education causes us to look through the lens of our own histories, demonstrating how artifacts function as personal and community identity narratives.

Memory Palaces of Personal and Community Identity

The very foundation of memorializing memory is in the very act of (re)telling and (re)collecting through story and object making. Memories are often unspoken histories, yet they are the most powerful legacies we leave of our everyday experiences. Memory helps us *become,* influences how we see the world, and has the potential to leave cadres of knowledge and hope for those who come after us. St. Augustine in his *Confessions* (387A.D./1907) referred to memories as the *"palaces"* where innumerable images are perceived by the senses (p. 210). These *memory palaces* are the intangible form of what exists in our work as artists and art educators and often find voice in the tangible object, becoming both truthful and imaginative reconstructions and constructions, built out of actions, reactions, and/or experiences in the human journey. As we look toward memory in arts contexts as a pedagogy of practice—or what I call *arts-based memory pedagogy,* which I have defined as stringing together thoughts and ideas of experiences or remembrances where connections are made for learning and knowing—we realize memory has a significant impact on how we think and learn in the arts, whether making, talking about, looking at, or valuing art. It is a place where we acknowledge that memories embody knowledge as a frame for empowerment. Frigga Haug (2008) explained it this way:

> *In working with our memories, we are trying to do two things: to find out how we actively conform with existing power relationships; and also, where in the past there are "sparks of" in which we recognize ourselves "as ones who are meant."*
> *(p. 538)*

The emotional and memorial landscapes in which we create and others paint for us are powerful. Often this lens we see through is important because it creates action and change in us. This way of knowing through memory and place in the arts is constantly relived in the telling, making, and teaching about art. People, stories, and objects create the very curricula of life, and memory is the functional architect of our psyche, influencing the choices we make as artists, art educators, and humans in a world of constant change. This impacts what we come to know. Remembered truth is where the past is witnessed and appreciated in today's practices and

where those who surround us—whether family, friends, or others—can be viewed as historians (Congdon, Blandy, & Bolin, 2001). As you read on, this chapter is a reflective investigation of how memory lives in personal history, story, and historical research, and how each flows together with the other to articulate new ways of knowing as we move toward a future that will be remembered in art education.

The Personal Narrative

I live on the periphery of being Native. I have not lived on a reservation. Like any other American, I have had struggles in a country that my ancestors built. I live in the memory of being Native. I live the Native life in how I interact with Native communities today, but even more so I live in the memories of my father, in the memories of my grandparents, and in the memories passed on from their parents. Although I am deeply rooted in my own histories, I am anchored more so in today's contemporary contexts of situational knowledge, cultured memory, and spinning my own web of existence in a world with fewer and fewer borders and boundaries. I can and do visit domestic and foreign lands to expand on my Native heritage, in virtual space, in static and real time, as well as actually being present. I watch powwows in real time and their recordings that happen throughout North America. I have attended many powwows and danced in street clothes, made art about my heritage. Am I any less *Indian*[1]? I don't know. My memories are mine, a recollection, a knowing, and a way of being I experience daily. I not only relive my own memories, but also the retelling of those in my family; the oral histories, the passing down of stories and memories, both retold and relived, become this history I make.

These memorialized places in my personal narrative become the art, creating a visual historical narrative present in the object or work itself, but also shared by exhibiting, sharing, and retelling through these works. Hutton (1993) reminded us that as we inquire into history, *"memory is an integral part"* (p. 16) that emphasizes how we see the relationship between historical understanding and ourselves. When we consider memory, we often think in terms of the past, yet we relive experiences through the life of memory, and pass on traditions, rituals, and even the nonverbal of how we have experienced life, and how we re-experience it again through its retelling in the present. Gibbons (2007) described memory as key to the emotional understanding of our worlds, and as we move from memory to history and/or history to memory, *"art has become one*

of the most important agencies for the sort of 'memory work' that is required by contemporary life and culture" (p. 5). Our memories matter not only for the nostalgic value of being emotionally reflective, but also for the value they hold as the storied history of our experiences; they are (in)credible artifacts of histories. They are the annotated versions of day-in and day-out living; they fill the unconscious and conscious corners of our mind and resurface once again to retell the stories of our lives. They have helped shape who we are and who we will become (even long after we are gone).

This chapter is not based on the premise of challenging memory, but rather identifying memory as an integral part of how we come to exist as artists and art educators, recognizing that memory is fundamentally interpretive in nature and travels in *the-before*, in *the-midst-of*, and in *the-post-lived* experiences of our personal histories. It is like a baton being passed from moment to moment, human to human, and generation to generation. The intermingling array of connections shift what we know and come to know again and remember. Yates (in Hutton, 1993) said, *"the art of memory is not just a technique . . . but a resource for recovering lost worlds"* (p. xvii). These lost worlds are the constellations of how memory connects and reconnects with past, present, and future and with the people who enter those memory spaces with us.

Memory begins when we are young. We curate as we relive moments over and over through the act of remembering or retelling. We often recall not only the feelings and emotions, but also the nuances of things like smell, texture, vocal tone, and imagery. Memories and their retelling are important to how we reflect on the past and push toward the future in art education.

Memorializing Memory in Art Education

Memories are living, the intangibles of what creates the foundation as we move toward researching ourselves and others as history makers. We are all history makers in art education, and memories offer us a vast reservoir into which we can delve to explore the impact we have on those who also impact us. The memories I wish to focus on are not solely the observed public ones, but the personal and up-close memories of those who have shaped and formed the fabric of art education. Not only does this include those we consider public leaders in the field, but also *you*, the leaders in your domains who are strands of the woven fabric of what we do in public schools,

communities, museums, academia, and art. Your memories, our memories, are important.

The Importance of (Re)collecting Memory

According to Rubin (2005), the strength of recollecting an event can be predicted by the "vividness of its visual imagery," and "much that people 'remember' as part of their life story is really shared cultural knowledge about the life course" (p. 79). As our recollections filter through our memory and emerge through story, it is important to acknowledge that (re)collecting is grounded in cultural nuances and ripe with personal values and emotions. How do we effectively employ these (re)collections of our experiences through art and art making? This question includes consideration not only of experiences that were found in school, but also of histories that occurred anywhere else but school.

Why are these memories important? Richard Restak (2001), a neuroscientist, commented that on a fundamental level we are what we remember, and that our "very identity depends on all of the events, people and places [we] can recall" (p. 53). In our memories, we leave a legacy for the future of art education not only in our art making, but in our art teaching. As we take on historical research in art education, we can look to memory as the archive, full and ripe with people, events, and places. Thus, the relationship between history, memory, story, and historical research becomes a place to curate memories and memorialize what we come to know about ourselves and others. This becomes a place for interpretation beyond educative modes of thinking, and more important, a place from which to grow in forming 'k/new' knowledge. Roberts (1997) described the interpretive task as being one that includes "other modes of knowledge" (p. 73). By bringing those 'k/new' knowledges together, as memory interacts with others and becomes an interpretive endeavor, more memories are spawned. The very act of creating is no longer driven by what we already know, but more by how we choose to express what we know through our memories. We then become curators of our own memories.

Memory Embodied in Art Making

I introduced you to my grandmother through a memory I had of her, her work and her art-making process in her studio. Stepping beyond this, I now explore how memory as a mental gesture brings a cultural order to our artistic landscapes and ways of thinking. As

we choose to make art, whether for art's sake, expression, or empo-
werment, the artwork becomes an artifact of material culture that
often embody memories, whether our own or those of the other.
The gesture of memory articulates *"the successions of events and
transactions in human life"* and, when remembered and related,
make history (Bain, 1868, p. 123). For us in historical research in art
education, witnessed and narrated events assign history to memory.

I created an artwork based on a memory of one of the stories my
grandmother told about an ancestor named Diodema. This oral
history was passed down to her from her parents as they shared the
memories of their parents. *Voices of Our Ancestors* (see Figure 1.2)
was created in 2010 for the SOMA sculpture garden in Little Rock,
Arkansas—a state that contributed to the history of the Trail of
Tears, part of Diodema's story. The sculpture came about because
of a story my grandmother told and retold us as we grew up. This
story was of a Lenni Lenape (Delaware) baby who was born on the
Trail of Tears. Her name was Diodema and she was my ancestor
(said to be my grandmother's great-great-grandmother). The story
became an oral tradition in its telling and retelling. Diodema, born
on the Trail of Tears near the Tennessee border, was left in a hollow
log near a cabin. The owners of the cabin, the Bartletts, found the
newborn Diodema in the log, took her in, and named her Jane. They
raised Jane as their own for the next seven years until Diodema's
parents were released from the removal camps and returned to the
Bartletts' cabin to reclaim Diodema, who was brought back into the
Indian nation. This story is not only an oral tradition of personal
heritage, but it speaks to the goodness of humanity, and the atmos-
phere of a place and time and one family's goodness during the
implementation of inhumane policy in U.S. history. It is a storied
history brought out in a work of art that speaks to memory, reflec-
tion, and a broader history—and how we can come to know about
and share through the artwork so others may also know.

Figure 1.2 *Voices of Our Ancestors*

H. Powell-Mullins, 2009 [wood, metal, stone]. Depot Museum Permanent
Collection, Morrilton, AR.

The artwork itself was not only designed for physical interaction of stone stepping, reading, and push-plate chimes, but for historical questioning and interaction as well. This work is an expression that embodies the very notions of memory with syncretic histories and cultures that are situated in place, time, and identity. The interaction and circularity of memory, and its sharing through art making, bring about a new consciousness and notion of how we process and understand who we are as individuals, artists, and art educators. Eisner (1996) explained this by articulating that the personal is made communicable through "*the choice of a form of representation [and] is . . . the way the world will be conceived*" (p. 42) and, from a memory standpoint, will be (re)memoried and memorialized. This is important because memorializing memory reframes the relationship between memory and place, and compels us to speculate and see it as a form of BOTH physical and mental material culture. Bolin (2009) referred to this speculation and historical impulse as "*any attempt to understand a time and place beyond our own [which] requires the ability to wonder about and empathize with questions and speculations*" (p. 111). This recognition is important to the idea of historical memory—that being any past observance or perception which remains in our psyche—and its circularity and potential for repetition in any form, whether verbal, visual, mental, or as mental or physical material culture (as artwork).

Memory as tacit understandings can help us make new sense of things around us. These tacit understandings empower us to have a dialogue with our past in our present, thus melding new meanings. These new meanings contribute to the 'memory palaces' of identity that we can draw on daily as we approach art making, art looking, art teaching, and engaging in all things art. By looking to memories as places of knowing, we can understand ourselves and each other as we come to discover that "*people in their plurality, in their distinctiveness, speaking in terms of who, not what, they are, embarking . . . on new beginnings as they come together to create something in common among themselves*" (Greene, 2001, p. 139). As we memorialize our history through memory, we find we can create common and new places that resonate with others and discover meaningful connections to past and present within ourselves and our world. As Arnheim (1960) discussed, memory links past with present through the act of looking at artwork. Similarly, our memory experiences are linked and survive in differing potencies, depending on the emotional connection and impact of the 'memory palaces' that fund us.

The Historical and Circularity in Memory

Why are these internal and external 'memory palaces' so important to who we are in our multiples identities? There is circularity in memory, whether personal or historical, whether through narrative or object. This circularity engages reflection. Schön (1983) noted that reflection brings about the willingness to experiment, and often with new phenomena that elicit more reflection, where tacit understandings help us make new sense of all around us. As we explore our own histories as artists and art educators, we are re-minded of art as process, and all the associated memories that we create, if shared, become their own unique artifacts of history and material culture which others can employ as historical research. Memory is situational, yet local memory is rarely reflected in art education research—although it can be through material culture tied to memory. Blandy and Bolin (2003) described material culture as *"broad-based in its meaning and application [that] describes all human-made and modified forms, objects, and expressions mani-fested in the past and in our contemporary world"* (p. 249). As we connect the intangibles of memory to objects, the cycle of memory and circularity continues, embodying the hidden and overt history and memory of the maker's/audience's stories. This connection also creates, fosters, and perpetuates new memories for those who choose to enter the memory space embodied by interacting with art works—which may or may not be directly related to the artist or artwork. By engaging with art, these memory spaces help us as humans get in touch with empathetic modes of thinking that build more memories and become embedded as a strategy for ways of knowing.

The memories we give voice to form the very echoes of our field and our hope to leave legacies as historical research. For those in art education—student, teacher, artist, or scholar—recognizing and (re)collecting memories are forms of historical research. Such in-quiry helps us shape personal identity and culture in ways that shift and augment our understanding of where we have come from, who we are in the current age, and who we become in our future histo-ries as we move forward to make art, educate about art, and foster growth. Campbell (1991) suggested that our lives are *"much deeper and broader"* than we conceive them to be and only a *"fractional inkling"* of what is really within giving us *"life, breadth, and depth"* (p. 70). When we include our memories, we create constellations of reality that make our world more vastly alive. Jannson, Wendt, and

Ase (2008) discussed memory work as a foundation that becomes a method of exploring and theorizing about how we as individuals construct ourselves in the lived practices of everyday life and in a place where closeness and experience have value in research (p. 231). It is a hidden mechanism and way of knowing that is undervalued and can inform our practice in our shifting roles as art educators. In this way, we have opportunity to focus not only on the quality of what we do, but also on the nature of why we do what we do. We can as well focus on who we become in forming our personal and collective cultural identities that evolve to find the points of social resonance as historians, art makers, and art educators. Material culture and social actions then become visual symbols in documenting our world.

Aldeman (1998) discussed this idea when he received feedback from his mentor Ron Silvers, who was quoted as saying that the *"phenomena that emerge out of the tacit concerns and sensitivities"* we bring are the *"unconscious and conscious [that] come together to inform us of what animates our action"* (p. 150). As we look ahead to the importance of learning, we need to understand how memory that folds back on itself can reveal new places of learning. I compare this to Burgin's (1996) notion of the *"mirror stage"* (p. 125) in critical theory, that emphasized a more psycho-corporeal way of knowing. Those who (re)collect acknowledge their own reflection in memory where they are caught looking. The notion of reflection, if captured through memory, represents tomorrow's inherence, creating a landscape of valuable insights for art education that no longer consists of simply public places (museums, historic sites, or arenas in art education). Rather, in looking at memories, we can create a local and collective scholarship that builds art education history.

The Theory and Power of (Re)telling and (Re)making Memories

There is power in the (re)telling and (re)making of memories through art. hooks (1989) stated that confession and memory can be used to *"illuminate past experiences"* constructively and provide *"a way of naming realities."* It is a way to emerge from one's inwardness and mirror our souls, *"theorizing experience as we express personal narrative"* (p. 109). There is power in recognizing how memories as stories are shared through the art experience in the in-between spaces of our daily lives. These stories change who we are in both large and small ways. These stories for me have created the 'memory palaces' of our field, and are the warp and weft of all we

do, the fabric of how we make sense of our world. All the formal elements of the art world add to our core knowledge in the field— but there is much more. Hearing about the lives of people who are living with art in everyday contexts, who have created and contributed their stories, and who are the recipients adding to the stories, will help us understand who we all are in some measure. These memories as stories, give us all a personal look at what it means to be human behind the curtain of teaching and learning when we step out of the public light of art education settings.

Conclusion

My goal in writing this chapter is to urge each of us to create our own 'memory palaces' through art experiences, to look at how we can memorialize memory in art education histories. In so doing, each of us should acknowledge people who have influenced us from both near and far, those who have brought us to *Aha!* moments and memorial moments of learning and share in the hidden curricula and experiences of our world. How can we leave these memories, these stories as a legacy in art education? Our memories are the historical places of art education, and they are memorialized in sharing through all their multiplicities. How we choose to curate these memories—whether in making art, writing or talking about the memories, or teaching through them—determines how we can share these memories to create a vast exhibition of mental material culture that informs us and others. Memories may help us locate the cracks and ambivalences in what we think we already know. They may take us beyond traditional discourses in art education contexts to initiate and fuel our creative endeavors.

Much like my own retelling of how and who I saw my grandmother to be, and much like my *Voices of Our Ancestors* sculpture that visually expresses the story of my ancestor Diodema, I realize that the essence of our culture—personally, professionally, and humanly—does not only revolve around the *"artifacts, tools, and other tangible cultural elements"* (Banks, 1993, p. 8). More so, the essence revolves around how people perceive them. We grasp our reality through what we (re)collect as influencing how we see the world. It is up to us to perpetuate the potential to leave legacies of knowledge and hope for those who come after us in art education. In this way, we can transform the intangible existing in our work as artists and art educators into the tangible. We can find voices that are truthful and imaginative reconstructions and constructions, built

from the actions, reactions, and experiences of the human journey. There is a powerful synergy in the act of (re)collecting memories as experience and history. Our memories provide multilayered meanings to help us connect with and communicate about our histories in art education.

References

Aldeman, C. (1998). Photocontext. In J. Prosser (Ed.), *Image-based research: A sourcebook for qualitative researchers.* New York, NY: Routledge Falmer.

Arnheim, R. (1960). *Art and visual perception: A psychology of the creative eye.* Berkeley, CA: University of California Press.

Augustine, Saint (1907). *The confessions of St. Augustine* (E. B. Pusey, Trans.). New York, NY: E.P. Dutton & Co. (Original work published 397 A.D.).

Bain, A. (1868). *Mental and moral science: A compendium of psychology and ethics.* London, UK: Longmans, Green.

Banks, J. (1993). Multicultural education: Characteristics and goals. In J. Banks & C. Banks (Eds.), *Multicultural education: Issues and perspectives* (2nd ed.). Boston, MA: Allen and Bacon.

Blandy, D., & Bolin, P. (2003). Beyond visual culture: Seven statements of support for material culture studies in art education. *Studies in Art Education, 44*(3), 246-263.

Bolin, P. (2009). Imagination and speculation as historical impulse: Engaging uncertainties within art education history and historiography. *Studies in Art Education, 50*(2), 110-123.

Burgin, V. (1996). *In different spaces: Place and memory in visual culture.* Berkeley, CA: University of California Press.

Campbell, J. (1991). *The power of myth with Bill Moyers.* New York, NY: Anchor.

Congdon, K., Blandy, D., & Bolin, P. (2001). *Histories of community-based art education.* Reston, VA: National Art Education Association.

Eisner, E. (1996). *Cognition and curriculum reconsidered.* New York, NY: Teachers College Press.

Gibbons, J. (2007). *Contemporary art and memory: Images of recollection and remembrance.* New York, NY: St. Martin's Press.

Goldstein, A. (2015). Colonialism undone: Pedagogies of entanglement: Response 2. In S. Grande (Ed.), *Red pedagogy: Native American social and political thought* (10th Anniversary Edition). Lanham, MD: Rowen and Littlefield.

Greene, M. (2001). *Variations on a blue guitar: The Lincoln Center Institute lectures on aesthetic education.* New York, NY: Teachers College Press.

Haug, F. (2008). Memory work. *Australian Feminist Studies, 23*(58), 537-541.

hooks, b. (1989). *Talking back: Thinking feminist, thinking Black.* Cambridge, MA: South End Press.

Hutton, P. (1993). *History as an art of memory.* Hanover, NH: University Press of New England.

Jannson, M., Wendt, M., & Ase, C. (2008). Memory work reconsidered. *NORA: Nordic Journal of Women's Studies, 16*(4), 228-240.

Restak, R. (2001). *Mozart's brain and the fighter pilot: Unleashing your brain's potential.* New York, NY: Three Rivers Press.

Roberts, L. (1997). *From knowledge to narrative. Educators and the changing museum.* Washington, DC: Smithsonian Institution Press.

Rubin, D. C. (2005). A basic-systems approach to autobiographical memory. *Current Directions in Psychological Science, 14*(2), 79-83.

Schön, D. A. (1983). *The reflective practitioner: How professionals think in action.* New York, NY: Basic Books.

Endnotes

[1]*Indian* (Native American) as an identifier addresses issues of domination, colonialism, and authenticity. From the 1970s, U.S. Indian policy affirmed the recognition of Indian self-determination. According to Goldstein (2015), decolonization is *"neither achievable or definable"* (p. 47) and creates the myth of what it means to be an Indian in contemporary society in its multiplicities.

Chapter 2

MAKING PLACE THROUGH MABEL SPOFFORD (1883-1981): ARCHIVAL MATERIALS, ASSEMBLAGES, AND EVENTS

Christina Hanawalt and Sue Uhlig

In his book *Material Culture*, Henry Glassie (1999) argued that history is known through the objects of the past that happen to live in the present, and is *"designed to be useful in constructing the future"* (p. 6). In researching Mabel Spofford (1883-1981), an early 20th century art educator from Massachusetts (see Figure 2.1), we have come to know the past and present through the material artifacts created and collected by this historical art educator.

Figure 2.1 Passport photograph of Mabel Spofford, 1924

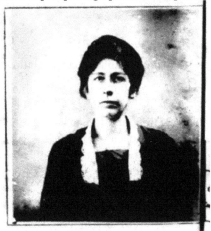

National Archives and Records Administration (NARA), Washington, DC; NARA Series: Passport Applications, January 2, 1906-March 31, 1925; Roll #2433; Volume #: Roll 2433; Certificates: 373850-374349, 26 Feb 1924-28 Feb 1924. Accessed via Ancestry.com. U.S. Passport Applications, 1795-1925 [database online]. Provo, UT: Ancestry.com Operations, Inc., 2007.

Although our previous writings and presentations of research sur-
rounding Mabel Spofford have generated an imagined and a spe-
culative interpretation of her life and learning as inextricably in-
tertwined with a sense of place (Hanawalt, 2016), in this chapter we
have chosen to focus on the ways Mabel's material outputs—her
copious written notes, her journals and handmade scrapbooks, her
postcard correspondences, her artwork—have actively served to
make place, not only for Mabel but for us.[1] The materials of this
research have enveloped us in an assemblage, which brings Mabel's
experiences from the past into relation with our experiences in the
present. Here, we draw upon Jane Bennett's (2010) vital materiality
and Elizabeth Ellsworth's (2005) places of learning to conceptualize
assemblages in which disparate entities come into relation, smudg-
ing time/space/place and creating generative spaces where new
understandings can come to be. We view these generative spaces as
events made possible by the assemblage, which includes not just
human but also non-human actants, such as the archival matter of
Mabel Spofford.[2] This chapter traces the ways archival matter has
made and continues to *make place* for us through the events of our
research. We explore the events of our initial experiences of Mabel's
archives, and then investigate the events of our visit to the physical
places associated with Mabel in Massachusetts. Through our explo-
ration of these events, we recognize the ways archival materials
"live in the present" (Glassie, 1999), activating research assemblages
and generating places of learning always *"in the making"* (Ellsworth,
2005, p. 5).

Matter, Assemblages, and Relations

In her book *Vibrant Matter,* Jane Bennett (2010) challenged an un-
derstanding of the world that assumes humans possess an agency
that nonhumans cannot. Bennett rejected a life/matter binary and
instead emphasized the capacity of matter as an actant with inhe-
rent liveliness. Referencing sociologist Bruno Latour, Bennett pro-
vided a definition of an actant as *"a source of action that can be
either human or nonhuman; it is that which has efficacy, can do*
[emphasis in original] *things, has sufficient coherence to make a
difference, produce effects, alter the course of events"* (p. viii). Using
this definition, nonhuman matter has the potential to *do* things and
impact experience, suggesting that the artifacts and materials of
archival research can be understood as playing an active role in
research processes. Bennett (2010) also contended, however, that

"an actant never really acts alone. Its efficacy or agency always de-pends on the collaboration, cooperation, or interactive interference of many bodies and forces" (p. 21). The coming together of all sorts of vibrant materials (human and nonhuman) is theorized using De-leuze and Guattari's (1987) concept of assemblage. Assemblage (from the French *agencement*) can be used as both a noun, to de-scribe the heterogeneous group of actants, and a verb, to describe the assembling of those actants (Nordstrom, 2015; Richardson, 2011). Moreover, although the diverse components of assemblages exhibit agency, the assemblage, as a *"living, throbbing confederation,"* also has agency in its ability to generate effects (Bennett, 2010).

The effective energy, produced in, through, and by assemblages, was also explored by Ellsworth (2005) in her book *Places of Learn-ing: Media, Architecture, Pedagogy*, in which she analyzed anomal-ous places of learning in order to understand the qualities and de-sign elements that *"constitute [their] pedagogical force"* (p. 5). Using examples such as the United States Holocaust Memorial Museum and the multimedia installations of Krzysztof Wodiczko, Ellsworth perceived of places of learning as pedagogic assemblages that ad-dress learners as moving, sensing bodies. Citing cultural critic Bar-bara Kennedy (2003), Ellsworth conceived of encounters with such places of learning as *"sensation constructions,"* in which the *"bodies"* of the environment or event assemble with participant bodies through a *"web of inter-relational flows"* (p. 27). Through these pedagogic assemblages or *"sensation constructions"* and the inter-relational flows they generate, places of learning have the ability to move us, invite unintentional experiences, and complicate things in ways that provoke the emergence of something new.

Following the arguments of Bennett and Ellsworth, the generativi-ty and effectivity of dynamic assemblages are not to be undervalued or underestimated. In the case of archival research, then, it is im-perative to consider the effects of dynamic assemblages of research which include both researcher and researched, sensational and material, human and nonhuman. In her article, archival researcher Maria Tamboukou (2014) drew on feminist theorist Karen Barad (2007) to explore the *"material and discursive entanglements"* with-in archives and the ways her research processes and interpretations emerge as *"intra-actions between space/time/matter relations and forces within the archive"* (p. 618). The emphasis on Barad's term *"intra-actions"* was used purposefully to describe the ways entities, both human and nonhuman, emerge as an effect of relations be-

tween entities. In other words, researchers and archival materials do not exist separately as discrete entities coming together only through the interpretation and writing involved in the final stages of research. Rather, researchers and archives are in a constant state of becoming through the entangled intra-actions of the research assemblage during the entire research process. Both researcher and researched emerge as an effect of relations between the entities (material, physiological, spatial, social, historical, etc.) of archival research through intra-actions.

Taking into consideration the work of Bennett, Ellsworth, and Tamboukou, one can rethink archival research in ways that: (a) acknowledge nonhuman matter as actants; (b) understand researchers, archival materials, and archival spaces as existing within pedagogic research assemblages that produce flows of inter-relations, have their own agency, and are generative; and (c) emphasize relations between research assemblage entities as forces capable of remaking both researcher and researched through dynamic intra-actions. In this chapter, we attempt to rethink our own archival research, considering the ways our bodies as researchers assembled with the "bodies" of archival materials and environments associated with Mabel Spofford, thus prompting flows of relationality, remaking researchers and researched, and provoking events in which something new came to be.

Making Place Through Relational Events

Through and with Spofford's archives, we were moving and sensing bodies in the time/space/matter assemblage. Art educator Jack Richardson (2011) suggested that place has thingness and *"agency with the capacity to move, affect, and combine with other material forms including other spaces and places"* (p. 5). As actant, place folds into the assemblage, and we respond as learners-in-the-making in a *"mutually transforming relation"* (Ellsworth, 2005, p. 7), from which the events of our place-making emerge. Sally Gradle (2007) suggested that sensory experiences shape our perception of place, and qualities of place are entangled with interactions from both human and nonhuman actants. Gradle quoted place philosopher Edward Casey (1996) that *"we are not only in places but of them* [emphasis in original]*"* (p. 19), participating in a dynamic and fluid inter-relation with place in our sensing bodies.

The place of Mabel Spofford was Essex County, Massachusetts. Mabel taught art in Essex County for the first half of the 20th cen-

tury, serving as Supervisor of Drawing first in Rockport beginning in 1908, then in her hometown of Danvers, and last in Gloucester (Massachusetts School of Art Alumni Association, 1938). Throughout her long teaching career, she maintained a strong connection to the place of her childhood home in Danvers, where she lived after her retirement from the Gloucester schools in 1950. We know through archival material, such as her notes and postcard correspondence, that Mabel traveled widely and attended numerous professional development opportunities, including Penn State Summer Art Institutes in 1947 and 1948 with Viktor Lowenfeld.

We first encountered the archival materials of Mabel Spofford in the Special Collections Library at Pennsylvania State University as doctoral students in early 2013. While the library contained hundreds of boxes and folders of art education materials from which to choose, we both honed in on the minimal Spofford collection, consisting of two small folders of artifacts from Mabel's visit to Penn State in 1947 and 1948. Sue selected Mabel's handmade book containing postcards of Penn State's campus, while Christina selected Mabel's plans for a mural to investigate and analyze further (Hanawalt, 2016). In the following sections, we each narrate the events of our research assemblage intra-actions.

Sue's Event of Place-making

My sense of place is rooted in the U.S. Midwest where I spent my entire life, first in suburban Chicago, then in central Indiana. Because I enjoy traveling frequently, I did not expect or anticipate that a move to new surroundings in central Pennsylvania could affect my sense of place, described by Gradle (2007) as *"belonging or attachment"* (p. 392). At the time of my first interaction with the Mabel Spofford archives, I was still attached to memories of the Midwest and felt disconnected and uprooted in my new place (Gradle, 2007).

When I found the handmade book in Mabel's collection, I felt an immediate connection, and the book, as actant, prompted a difference in my perspective of my new surroundings (Bennett, 2010). As a postcard-collecting enthusiast, I was delighted when I opened the book and saw 21 postcards depicting black-and-white photographs of Penn State's campus from the 1940s mounted on black paper. I paged through the book and read Mabel's sparse handwritten descriptions of campus as I imagined Mabel, an art educator from Massachusetts who came to Penn State for just two weeks over two years' time, as a place-maker connecting with her temporary sur-

roundings. I decided that if Mabel could establish a sense of place during her short time at Penn State through the event of this postcard book, I could do the same through the construction of my own book of postcards.

Through an intra-active collaboration with Mabel's book, I found a way to reclaim my sense of place. In dialogue with the images, I practiced an embodied and sensorial performance of what I imagined Mabel sensed during her stay at Penn State (Gradle, 2007). The book, specifically the postcards depicting the campus in the 1940s, became what Ellsworth (2005) called a *"pedagogical hinge"*; the book emerged as a relational collaborator to connect my learning self to the experience of place-making.

I deepened my sense of place through the experience of first photographing Mabel's postcards of the campus from the 1940s, then re-photographing the same scenes from a similar perspective in 2013. Using these photographs as reference, I was mindful of and present in my sensing movements as I researched and physically retraced the places found in her book. I carefully lined up each camera shot as I re-photographed 10 scenes of the campus, noting how the landscape and buildings changed during the last 70 years. Art critic and curator Lucy Lippard (1997) identified former geologist Mark Klett as one of the first to use re-photography in order to tell his story *"as a participant, and not just an observer of the land"* (p. 182). My aim in re-photographing the postcards in Mabel's book was not only to be a participant in place, but also to be *of place* as active place-maker in the event assemblage, where the 1940s postcard scenes, Mabel's experience at Penn State, and my own being as learner-in-the-making intra-act.

Mabel left 10 blank pages in her postcard book, and I saw those pages as an invitation to collaborate in the research assemblage by including my narrative of place as a means of *"becoming* rather than *being* [emphasis in original]"* (Lippard, 1999, p. 11). Using an imaginary interactive dialogue with Mabel, I added 10 additional pairs of photographs. I photographed buildings, public art, and natural spaces constructed sometime after Mabel's stay in the 1940s, which I believed would have been of interest to her. Using a postcard app on my smartphone, I uploaded the 20 pairs of photographs to create 20 separate postcards. I added text to each card to reference historical events, architectural descriptions, captions that Mabel used in her book of postcards, and my own interactions with/in those places. The postcard app generated physical postcards which

can be sent through the postal system, and I mailed all 20 to my home address. In addition, Mabel's book prompted me to create my own handmade book. I created a double-pocket concertina book using a large printed satellite map of Penn State's campus to house the 20 postcard diptychs. The 10 postcards re-photographed from Mabel's collection slip into pockets on one side of the book, and the other 10 postcards of new relational images slip into pockets on the other side (see Figure 2.2).

Figure 2.2 Postcard Book of Penn State

Sue Uhlig, *Making Place with Mabel,* double-pocket concertina book with 20 diptych postcards, 2013.

Tamboukou (2014) wrote of being entangled in archival research, in the matter/space/time intra-actions that emerge in the research assemblage with the researcher, the materiality of the archives, and

the sensory conditions surrounding the process and place of re-
search. Similarly, I became entangled in the research assemblage
with my embodied practice of studying, identifying, and then visit-
ing the places depicted in Mabel's book. I collaborated with Mabel's
book as actant, and what emerged was the creation of my own
postcard book as a place-making event.

Christina's Event of Place-making

I was initially drawn to the Mabel Spofford archives at Penn State
because Mabel was a high school art teacher, which I had been as
well. Although this simple similarity was cause for my initial contact
with Mabel's archives, I was soon drawn into a deeper interaction
with the story of Mabel Spofford through her detailed plans for a
mural titled *Gloucester and the Friendly Sea*. Early research into
Mabel's life turned up almost no leads, but eventually I discovered
the Cape Ann Archives in Gloucester, Massachusetts, which owned
a wealth of her personal materials and collections. I requested and
received photocopies of various teaching materials, Mabel's 1939
thesis from the Massachusetts School of Art, and to my surprise, a
photograph of Mabel's completed *Gloucester and the Friendly Sea*
mural (1947-1950) (see Figure 2.3). Through these and other
sources, I was able to piece together details of Mabel's life and expe-
riences and develop a sense of her connection to the places she
called home.

Figure 2.3
***Gloucester and the Friendly Sea* (ca. 1947-1950), by Mabel Spofford**

Photograph of Gloucester Mural (ca. 1947-1950). Mabel Spofford Collection
(Box #14, Series 1 & 2, Folder 1), Cape Ann Museum Archives, Gloucester, MA.

Mabel's mural plan begins:

Gloucester has been very dear to me during the twenty-five years which I have spent there. Often when I am leaving school, I decide to walk or drive home along the boulevard rather than to take the shorter route, and I tell myself [to do this] because I know that I shall not have the lovely view of the sea and sky after I am through teaching there. So I felt that I should like to make Gloucester the subject of my mural, my love of Gloucester, and as much as I can, put into it some of its characteristic features and try to do it all in such a way as to express my love of the city.
(Spofford, ca. 1947)

Mabel wrote these words while attending a mural course with Viktor Lowenfeld at a Penn State Summer Art Institute in 1947. The written plan is a beautiful, sensory description of each part of her mural. When reading through the seven pages of handwritten notes, it became apparent that Mabel *felt* her connection to Gloucester. Her detailed account of the land, sea, and buildings of Gloucester were combined with her own narrative and the narratives of the people who inhabited the seaside location. As I looked back at my experiences of interacting with the mural plan, I realized that Mabel's written words, both in meaning and material presence, were powerful actants in my initial analysis and interpretation of the mural. It was as if the cursive marks of Mabel's pen and her evocative words hovered around me, hinting at the wistful, romantic notion of the city she loved and entangling me in a story of profound connection to place. Perhaps because of the power of Mabel's words and my entanglement in an assemblage of place-making, I felt compelled to visit Gloucester in person. Of course, I asked Sue if she would accompany me on this journey to Massachusetts.

The following summer, Sue and I embarked on an exploration of the places where Mabel Spofford lived and worked, including both Gloucester and Danvers. Still very much entangled in the archival matter of Mabel Spofford, my experiences of each city prompted intra-actions between the materiality of the environments, my sens-

ing body, and my prior experiences with Mabel via the research as-
semblage. The flows of relationality within the complex assemblage
of my experiences provoked an event—a place of learning—in which
my understandings of Gloucester, in particular, were remade.

 Due to Mabel's romantic description of Gloucester, the industrial
feel of the city came as a surprise, placing me in an experience
fraught with the kind of productive tension often necessary to pro-
voke a learning experience (Ellsworth, 2005). A previously idealistic
understanding of Gloucester was replaced by one carrying the
weight of social inequality. Upon re-engaging with the *Gloucester
and the Friendly Sea* mural, I now saw that Mabel's art was not just a
beautiful tribute to the city she loved; it also revealed the very real,
contradictory narratives of the history of Gloucester. In the bottom
half of the mural, Mabel paid homage to the beaches of Stage Fort
Park as well as the artist colony in Gloucester. These scenes may
seem idyllic, but in reality only the summer tourists of Gloucester
were able to take part in the leisure of the beach or the expense of
local art (Spofford, 1939). What functioned as a resort town or
summer home for city dwellers and artists was a home to hard-
working, mostly low-income families throughout the rest of the
year. The top half of the mural told the less idyllic story of the fami-
lies who lived and worked in Gloucester year round—stories of
young boys beginning their life work on the fishing docks, memorial
services for fishermen lost at sea, and local architecture giving way
to a modern style (Spofford, 1939). Mabel's mural brought forth her
understandings as a long-time inhabitant of Gloucester who lived
and experienced the contradictions inherent in its dynamic activi-
ties. This interpretation seems clear to me now, and yet it was not
available to me prior to my experience of Gloucester. As a place
pulsating with the histories of inhabitants and the vibrant materiali-
ty of a fishing industry town, Gloucester was both an actant within
the assemblage of my research and a sensational force within my
embodied experience of the landscape itself. My research into the
life and work of Mabel Spofford cannot be separated from my inte-
ractions with her handwritten documents and my experiences of
the places she called home. Rather, these entities exist in relation,
within a research assemblage that is always becoming.

Archival Research as Events in the Making

In this chapter, we attempted to think about archival research differently. Rather than focusing on what we as researchers do to make sense of the people, places, and events embodied in archival materials, we focused on what archival materials *do* to us. For both of the authors, the archival matter created by Mabel Spofford became truly vibrant, acting as a pedagogical force within a research assemblage that led to powerful events of place-making. For Sue, Mabel's handmade book of postcards served as a stimulus to perform the place-making act of re-photographing Penn State and enabled her to establish a sense of belonging in a new home. For Christina, Mabel's handwritten mural plans and an image of the mural itself became critical actants within her experience of Gloucester, prompting intra-actions with materials and place that resulted in new understandings of Gloucester, Mabel, and the mural. As Tamboukou (2014) theorized, *"The archive is a dynamic spatial and discursive milieu forcefully acting upon the research process, the analytics of research, the 'research findings' and the researcher herself"* (p. 623). The authors' experiences exemplified Tamboukou's description of archives as forceful actants, but also added to this description that archives are entangled in dynamic research assemblages capable of acting upon even more than research processes; in our case, the archives were an active force in our place-making. If we had not taken this opportunity to consider Mabel Spofford's archival materials as nonhuman actants in our research, we might have closed ourselves to understanding the relational possibilities of archival research. Instead, we have realized that each entity within the research assemblage has agency, and our relations within the assemblage are in a constant state of becoming, *"never finished; never closed"* (Massey, 2005, p. 9). Each interaction with archival research, therefore, should be embraced as an experience charged with the generative potential of an event in the making.

References

Barad, K. M. (2007). *Meeting the universe halfway: Quantum physics and the entanglement of matter and meaning.* Durham, NC: Duke University Press.

Bennett, J. (2010). *Vibrant matter: A political ecology of things.* Durham, NC: Duke University Press.

Casey, E. (1996). How to get from space to place in a fairly short stretch of time: Phenomenological prolegomena. In S. Feld & K. Basso (Eds.), *Senses of place* (pp. 13-52). Santa Fe, NM: School of American Research Press.

Deleuze, G., & Guattari, F. (1987). *A thousand plateaus: Capitalism and schizophrenia.* Minneapolis, MN: University of Minnesota Press.

Ellsworth, E. A. (2005). *Places of learning: Media, architecture, pedagogy.* New York, NY: Routledge Falmer.

Glassie, H. (1999). *Material culture.* Bloomington, IN: Indiana University Press.

Gradle, S. (2007). Ecology of place: Art education in a relational world. *Studies in Art Education, 28*(4), 392-411.

Hanawalt, C. (2016). Gloucester and the friendly sea: An early twentieth-century art teacher's mural as a pedagogical hinge. *Studies in Art Education, 57*(3), 221-237.

Kennedy, B. M. (2003). *Deleuze and cinema: The aesthetics of sensation.* Edinburgh, UK: Edinburgh University Press.

Lippard, L. (1997). *The lure of the local: Senses of place in a multi-centered society.* New York, NY: New Press.

Lippard, L. (1999). *On the beaten track: Tourism, art, and place.* New York, NY: New Press.

Massachusetts School of Art Alumni Association. (1938). Fiftieth anniversary record, 1888-1938. Boston, MA: Massachusetts College of Art and Design Archives.

Massey, D. (2005). *For space.* London, UK: Sage.

Nordstrom, S. N. (2015). A data assemblage. *International Review of Qualitative Research, 8*(2), 166-193.

Parr, A. (2010). *The Deleuze dictionary* (rev. ed.). Edinburgh, UK: Edinburgh University Press.

Richardson, J. (2011). The materiality of space. In P. E. Bolin & D. Blandy (Eds.), *Matter matters: Art education and material culture studies* (pp. 3-11). Reston, VA: National Art Education Association.

Spofford, M. (1939). *Thesis: Meeting the art needs of Gloucester's young people, Massachusetts School of Art, 1939.* Mabel Spofford Collection (Box #3, Series 1, Folder 1), Cape Ann Museum Archives, Gloucester, MA.

Spofford, M. (ca. 1947). *Notes for Gloucester and the Friendly Sea mural.* Mabel Spofford Collection of Art Education Materials, 1947-1982 (bulk 1947-1948, Folders 1 and 2), PSUA 1008, Special

Collections Library, University Libraries, The Pennsylvania State University, State College, PA.

Tamboukou, M. (2014). Archival research: Unravelling space/time/matter entanglements and fragments. *Qualitative Research*, 14(5), 617-633.

Endnotes

[1]For further discussion on the historical context of the life and work of Mabel Spofford, refer to Hanawalt (2016).

[2]We use "event" in the Deleuzian sense as *"the potential immanent within a particular confluence of forces"* (Parr, 2010, p. 90). The event is *"not a particular state or happening itself, but something made actual in the State or happening"* (p. 90).

Chapter 3

NANCY RENFRO AND THE FABRIC OF OUR LIVES: DISCOVERING ART EDUCATION HISTORY THROUGH PUPPETS, PLACE, AND PEDAGOGY

Christina Bain

My research journey to explore the life and work of Nancy Renfro (1937-1993) serendipitously began when my colleagues at The University of Texas at Austin and I commenced brainstorming for a Texas Art Education Association (TAEA) conference. For the past decade, we have collaboratively presented on themes such as space, identity, travel, and memory. Tipping our hat to the popular television show *History Detectives*, we titled a recent TAEA presentation "Art Education History Detectives" and our presentation description read:

> *History is much more than a set of boring facts. This session explores how museum objects can serve as a metaphor for personal histories and identity. Four art educators mine the museum and discover art objects can be a part of our personal histories. (Texas Art Education Association, 2014)*

This opportunity prompted me to explore museum archives in my hometown of Austin, Texas.

The Harry Ransom Center (HRC) is an internationally known humanities research library and museum. While the first-floor museum has an intimate scale, its extensive collections provide a rare

look at the creative process of writers and artists in order to expand our understanding and appreciation of literature, photography, film, television, visual art, design, and the performing arts. For example, the newest HRC archive contains costumes, scripts, screen tests, planning notes, props, and other materials from the television show *Mad Men*. While a vast range of objects is available for study in the HRC collections, I struggled to find a personal connection at the beginning of this project. Finally, after typing "art educator" into the HRC database, I found the spark that had been eluding me. After scanning the first few entries, a biography about a woman named Nancy Renfro caught my attention because of these keywords: Syracuse, New York; Austin, Texas; and Pratt Institute. Since I had grown up in Syracuse, completed my student teaching through Pratt Institute, and was currently living in Austin, I felt an immediate connection to this mystery woman. Ellsworth (2005) argued that place plays a significant factor in learning because knowledge is activated through *"our understanding of the world and our own bodies' experience of and participation in that world"* (p. 1). Although Nancy Renfro and I did not live in these locations at the same time, I wondered: "Who was Nancy Renfro?"

The Creative Life of Nancy Renfro

Biographical Background

Renfro, Roberts, Keever, and Morehead (2016) wrote:

> *Although relatively unknown, Nancy Renfro was Art, just as surely as Sylvia Plath was Poetry, Virginia Woolf was Literature, Dora Carrington was Painting, and Marilyn Monroe was Movies. They all had three things in common— extraordinary gifts, profound sadness, and early death. Nancy Renfro's life is a remarkable story of perseverance in the face of great adversity. More important, it is the story of a transcendent creative visionary. (p. xiii)*

The middle child of Ragnar (Bill) and Helen Winberg, Nancy was born into a highly creative middle-class family of Swedish and German immigrants in Long Island, New York, on December 13,

1937. Childhood photos of Nancy depict an angelic, petite, blond youngster with a warm, sunny smile (see Figure 3.1). However, the photos do not depict Nancy's multiple disabilities. With a 50% hearing loss, a bilateral lisp, and tunnel vision, Nancy had difficulty communicating.

Figure 3.1

Nancy Winberg [Renfro] as a girl

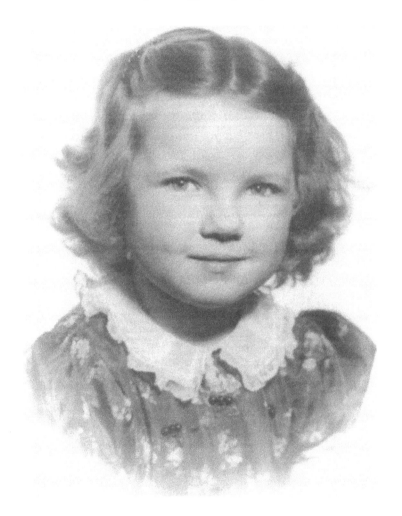

Circa 1942. Photo courtesy of Bob Renfro.

To overcome these challenges, Nancy attended special classes for lip reading and speech in her public school in Floral Park, New York. In a Special Child Lecture that occurred at the Texas School for the Deaf in the 1980s, Nancy reminisced:

> *I have spent most of my elementary classroom years window staring, clock-watching and daydreaming. And, to this day, I find I'm only happy in environments that have windows and unobstructed views. I also have a mad passion for clocks. As far as daydreaming goes, I prefer to spend most of my time now pursuing real dreams. Windows, clocks and daydreaming it appears are not what schools were meant for. For a child such as myself with a hearing impairment it was a remedy and my only salvation from certain destruction. It offered a visual relief in what was predominantly then an audio form of education. (Renfro et al., 2016, p. 146)*

It was not until she began formal schooling that Nancy realized she was different from other children. While Nancy felt excluded socially, an early propensity for endurance was evident when she stated:

> *Not until I went to kindergarten did the bomb suddenly drop! And for the first time I realized that I was deaf . . . of course, this prevented me from fitting into the normal kindergarten social circle and a terrible sense of insecurity and unacceptance took place which is probably what at some time or another all handicapped people must face—that feeling of rejection or being different. However, I really do feel lucky. For me this odd negative experience provoked an extremely positive response—a strong will for self-survival. (Renfro et al., 2016, p. 146)*

Nancy's mother Helen, a talented cook, painter, and musician in her own right, nourished her daughter's artistic interests from an early age. Later, Nancy excelled in non-academic classes at Sewanhaka High School (see Figure 3.2) and formed relationships with peers and teachers who admired her talent. She reminisced, *"at last I belonged in some sort of social circle which was very, very important to me"* (Renfro et al., 2016, p. 147).

Figure 3.2

Nancy Winberg [Renfro] high school photo

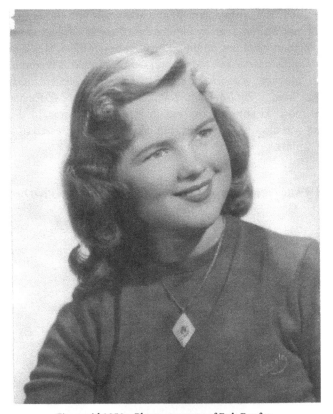

Circa mid 1950s. Photo courtesy of Bob Renfro.

After graduating from high school in 1955, Nancy continued her formal art training at Pratt Institute in Brooklyn, New York. At this time, college-educated women were expected to forego careers in order to marry and care for family (Meyerowitz, 1994). Perhaps that is why Nancy's father, a successful inventor with limited formal

education, believed that a college education was unnecessary for women. Opposing her husband's viewpoint, Helen insisted that Nancy be permitted to attend college. However, Nancy's overprotective parents did not allow her to live on campus and they insisted she choose a major with which she could support herself. In hindsight, Nancy claimed she would have preferred majoring in fine arts, but selected industrial design because it offered financially stable job opportunities.

Although Nancy endured a long daily commute from her parents' home to campus, Pratt opened up a whole new world of opportunities for her. She pushed herself both artistically and socially, moving out of her comfort zone by joining the 1956-1957 college cheerleading squad, despite her profound hearing impairment. Her husband, fellow industrial design student Bob Renfro, smiled as he reminisced about *"the pretty cheerleader who was always a half beat behind in her cheers"* (Renfro, Renfro, Scott, & Roberts, 2015). Bob recollected that while most art students dressed in jeans and paint-stained shirts, Nancy was always impeccably, but conservatively, dressed in a tight skirt, white blouse, and high-heeled shoes (see Figure 3.3).

Figure 3.3

Nancy Winberg [Renfro] (center) with studio classmates at Pratt Institute

Circa 1957. Photo courtesy of Bob Renfro.

Several factors that endeared her to her professors, but likely caused some of her peers to be jealous of her, were her exceptional talent and unflagging work ethic. Bob recalled how *"she would arrive [for class] with a huge cardboard box of all the homework that she'd done that night. All the rest of us were struggling to get some tiny, little piece of something done"* (Renfro et al., 2015). He elaborated:

> *Bill Kotavolos, one of the brightest industrial designers in the country and a professor, knowing she [Nancy] was capable of more, once told her to come back the next day with fifty sketches of the assignment. Kotavolos, partially deaf himself, was a popular and outstanding teacher, and he knew how to motivate his students. He probably identified with Nancy because of their common disability, and he probably thought she would return the next day with a reasonable increase of effort. She did the fifty sketches. Kotovolos was speechless. (Renfro et al., 2015)*

Texan-born Bob Renfro was captivated by Nancy's beauty and childlike charm. In many ways, their relationship demonstrated that opposites attract. For example, Nancy had grown up in the north; Bob had grown up in the south. Nancy's family was boisterous and artistic; Bob's family was more reserved and intellectual. Despite different upbringings and perspectives, Bob and Nancy bonded over their mutual passion for art. The couple wed shortly after Nancy's graduation in 1959 (see Figure 3.4) and Bob's job led them to Syracuse, New York.

Figure 3.4

Wedding portrait of Nancy and Bob Renfro

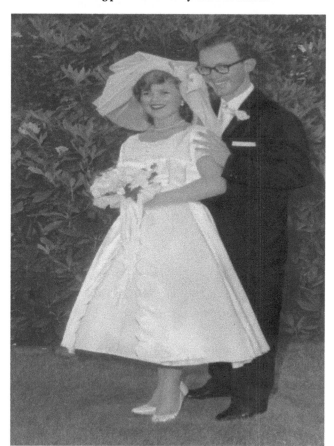

Photo courtesy of Bob Renfro.

Transitioning to adulthood and married life was difficult for Nancy. Not only had she had been socially sheltered throughout her life, but Nancy's undiagnosed bipolar disorder contributed to the beginning of a rocky marriage. Despite the challenges the couple faced, Bob's pride was evident when he described Nancy's accomplishments as an industrial designer at General Electric during this time:

It was her job to design the house of the future,
which would include all GE products, of course.
Well, she came up with this really wonderful, very
creative, idea and with all kinds of funny little
things that helped all these people with electron-
ic things that people would have in the future.
Like little phones that you carry with you, long
before now. And television sets about that big
[indicating the size of a large-screen television].
She invented those—in her mind. And she'd make
little clay figures and they'd have a little tiny tele-
phone in their hand or whatever the device was.
It was presented to the Board of Directors at Gen-
eral Electric. You know, here's this little gal
who'd never really had a profession at all, and it
made it into the GE magazine! Showing all these
things that GE is going to do. All these wondrous
things they're going to do for you all in the fu-
ture. (Renfro et al., 2015)

Nancy's innovative ideas preceded technology; former colleagues described her as a visionary genius (Renfro et al., 2015). Her professional work life can be divided into three stages: first, as an industrial designer from 1959 through the late 1960s, as described above; second, as a puppeteer, puppetry business owner, author, and community art educator from the late 1960s through the late 1980s; and third, as a painter during the last decade of her life.

Puppetry and Education

During the second stage of her professional life (late 1960s-late 1980s), Nancy cultivated a career centered on utilizing puppets for storytelling and educational purposes. She wrote/co-wrote 20 books that explored educational applications of puppetry, performed as a puppeteer, wrote/co-wrote several plays, taught puppetry workshops to children, operated an after-school puppetry studio, led hundreds of puppetry professional development workshops to early childhood educators and librarians, and directed Nancy Renfro Studios which sold a line of more than 300 puppets and educational media for educators.

What prompted this drastic change in Nancy's career direction? Bob Dylan's 1964 song, "The Times They Are A-Changing" is symbolic of a decade filled with turbulent political, social, and civil rights upheavals in the United States (Farber, 1994). The women's movement also gained momentum in the early 1960s, demanding equality between men and women (Baxandall & Gordon, 2005; Collins, 2004; Friedan, 1963). In 1964, Bob left his industrial design job in Syracuse to enroll in the Yale School of Architecture. Worn out from the demands of her job at General Electric and struggling to control her mental health issues, Nancy decided this move signaled an opportunity for her to try something new as well. She began to find her own voice in expressing what *she* wanted to do, not simply trying to please other people. Bob laughed when he recalled Nancy's plan for the two of them to sell all of their belongings, buy a Volkswagen bus, and tour the country as folk singers. That dream never came true, partly because Bob was enrolled in school and partly because he claimed he could not carry a tune to save his life. Instead, Nancy explored several short-lived entrepreneurial endeavors, such as selling homemade candy and artwork to local stores. A turning point in her life occurred when she noticed signs asking for volunteers to teach crafts or puppetry at the local library. Although she had a great deal of knowledge about crafts but knew nothing about puppetry, she volunteered as the puppetry instructor. While puppetry may have seemed like an unlikely professional avenue after her industrial design training at Pratt, in many ways it was a logical step. Her creativity, willingness to immerse herself in a new venture, unflagging work ethic, sewing skills, affinity for working three-dimensionally, knowledge of how she learned best given her disabilities, and unwavering confidence were traits defining Nancy that moved her in this direction. Debbie Sullivan, a puppeteer and

former employee of Renfro Studios, marveled at Nancy's ability to excel in new endeavors when *"she had no background in ANY of this! And yet she'd just do it! And everything she did, she did well"* (Renfro et al., 2015).

Despite Nancy's lack of formal training in child development and education, she seemed to understand intuitively how to connect with and motivate children. After gaining experience teaching puppetry at the New Haven Public Library, Nancy opened her own afterschool puppetry studio called the Puppet-Tree in the mid-1960s. Because of her deafness, Nancy worked diligently to make learning experiences visually stimulating and engaging. When I think of Nancy's description of clock watching to pass the time in her elementary classroom, I can understand why she would use puppetry in innovative ways to instruct young children and spark their imaginations. Rick Strot, a former workshop participant and currently a professor of education at Baylor University, described Nancy's style while leading professional development workshops:

> *She was very spritely. Elfin-like in the way that she approached things. She always had a twinkle in her eye and a smile that invited you into her world. And for anybody who works with children, everything that she said was just presented in a way that was fun. . . . But [she had] just lots of energy, lots of enthusiasm for the topic. Let's put it that way. It was infectious. (Strot, 2015)*

Although I have found no evidence that Nancy had any formal training in educational theory or art education pedagogy, her teaching approach could best be described as aligned with child-centered curricular ideologies (Dewey, 1997; Lowenfeld, 1951). Advocates of this method favor experiential learning through hands-on exploration. Two sisters who experienced Nancy's teaching firsthand were Deb and Jenni Springstead. These sisters have fond memories of puppetry classes in Nancy and Bob's home between 1974 and 1975. Deb, who was a middle school student at the time, recalled a particular incident that greatly impressed her. Nancy was showing the group how to do a reverse stitch on the sewing machine and Deb mentioned she had recently learned a different technique in a home economics class at school. Nancy was very

interested in the alternate technique and asked Deb to demonstrate it for her. Deb described this memory as unique because *"I don't recall adults, in general, coming to me to learn anything before and she was very interested in that"* (Springstead & Springstead, 2016).

It can be further argued that as a teaching artist, Nancy's work between 1969 and 1990 focused heavily on educational, as opposed to entertainment, aspects of puppetry. While professional artists have a long history of teaching in schools and community organizations (Efland, 1990), the term *teaching artist* first appeared in the 21st century (Dawson & Kelin, 2014). Booth (2009) stated, *"A teaching artist is a practicing professional artist with the complementary skills, curiosities and sensibilities of an educator, who can effectively engage a wide range of people in learning experiences in, through, and about the arts"* (p. 5). He listed 25 guidelines for teaching artists that apply to all artistic disciplines, of which two are particularly pertinent to this discussion: placing a high priority on personal relevance, and using engagement before information; both of these guidelines were significant in Nancy's educational work.

Personal relevance. As an author and a puppeteer, Nancy explored issues that were socially and personally significant. One example, *Make Room for the Animals,* was a play she co-wrote and performed in that protested the extension of an interstate highway separating the African American community from the White community in Connecticut. As Bob explained, *"It was as much about teaching the children about responsibility, how to save the animals [as well displaced people]"* (Renfro et al., 2015). In addition, the amount of consumer waste in America greatly bothered Nancy; her workshops and books frequently promoted using recycled materials to create puppets (Hunt & Renfro, 1982; Renfro, 1979).

Nancy's work with children in the 1960s prepared her to lead hundreds of workshops for educators and librarians across the United States as well as two summer workshops in Japan during the 1970s. In 1978, she received a Citation Award from the Puppeteers of America for her outstanding contributions as a teacher. Although Nancy enjoyed working with children, she claimed, *"It's better to teach the teachers because they can teach so many more"* (Renfro et al., 2015). During her teacher workshops, Nancy consistently offered individualized help encouraging teachers and librarians to make connections to their own curriculum or classroom. A typical question Nancy asked educators was, *"How can you use or adapt this for your classroom?"* (Renfro et al., 2015).

Engagement before information. Debbie Sullivan, who assisted Nancy in many teacher workshops, explained how she would capture her audience's interest at the start of each workshop. Debbie explained, *"She would put on a show—something theatrical at the beginning. Then she'd bring those trunks, of the handmade puppets that we would make in the studio, inspired by her, and her books"* (Renfro et al., 2015). Although her books illustrated step-by-step (close-ended) directions to create puppets, Nancy's workshops could be described as inspirational and open-ended (see Figure 3.5, 3.6, and 3.7). While she demonstrated techniques and processes, she also suggested a variety of approaches to spark participants' creativity.

Figure 3.5

Nancy Renfro in tree costume that she created

Circa mid-1970s. Photo courtesy of Bob Renfro.

Figure 3.6

Nancy Renfro in her Austin studio circa 1987

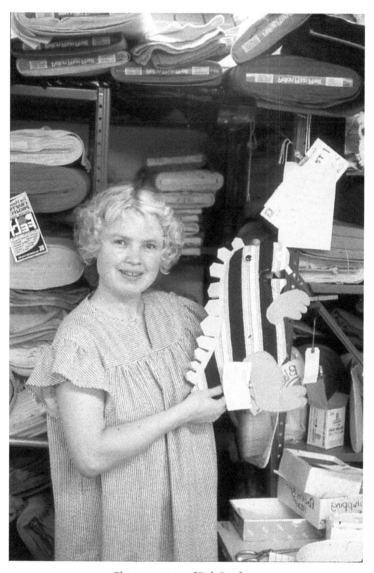

Photo courtesy of Bob Renfro.

Figure 3.7

Nancy Renfro's studio on West 9th Street in Austin, Texas

Photo courtesy of Bob Renfro.

In addition to her work as a teaching artist, Nancy was an astute businesswoman and prolific author. Puppetry transformed how Nancy viewed her academic abilities, as she explained: *"When I pursued a puppetry career in later years I was rather amazed in how interested I did finally become in academics. Well, through writing books on puppetry, all of a sudden I learned that I could write and I had never been a good writer in school"* (Renfro et al., 2016, p. 148). This change also impacted her desire to improve her speech in order to become a more effective public speaker. Nancy said:

> *It really wasn't until I became an adult, when I became fully involved in puppets that all of a sudden I found new motivation for improving my speech and took speech lessons so I could have clearer diction for performing and conducting workshops. I am an actual case of the puppet's effectiveness in teaching and refining speech with the special child. (Renfro et al., 2016, p. 148)*

Between 1969 and 1990, Nancy wrote or co-authored 20 books (see Appendix). Titles indicate Nancy's interests in storytelling, children with special needs, and recycled materials. In 1977, she founded Nancy Renfro Studios, a cottage industry that produced educational media, books, and a selection of more than 300 whimsical puppets ranging in size from small finger puppets to full body-sized puppets (see Figures 3.8, 3.9, 3.10, and 3.11).

Figure 3.8

A few examples of Nancy Renfro's puppets in the Harry Ransom Center Archives

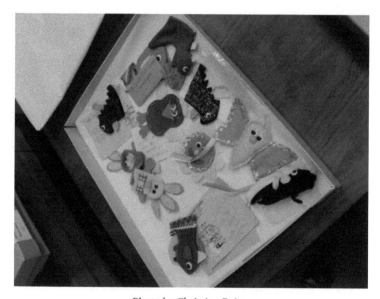

Photo by Christina Bain.

Figure 3.9

Examples of large puppets based on "The Old Woman Who Swallowed a Fly"

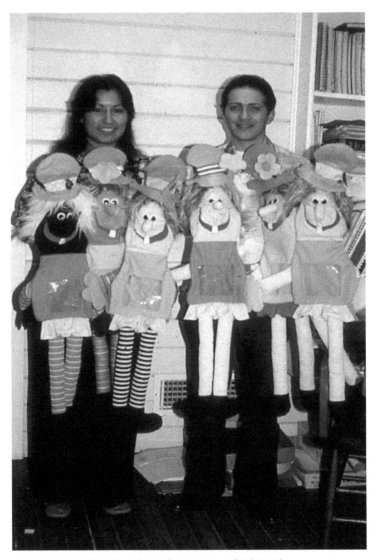

Photo by Bob Renfro; courtesy of Bob Renfro.

Figure 3.10

Cow mitt/hand puppet

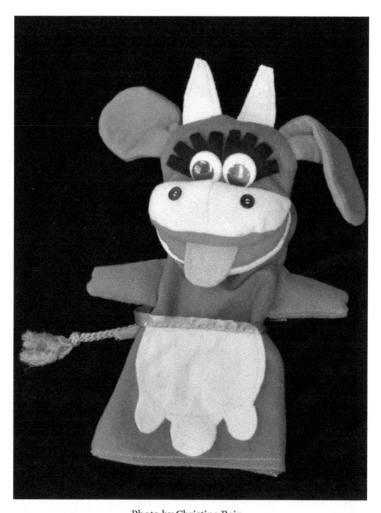

Photo by Christina Bain.

Figure 3.11

Owl mitt/hand puppet

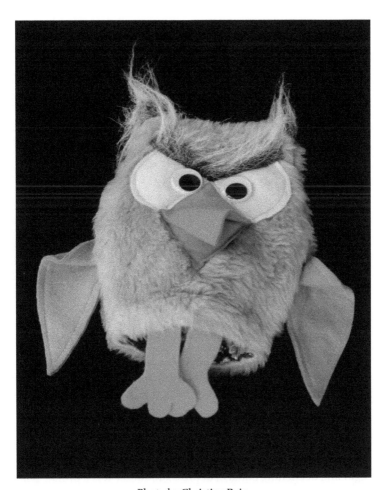

Photo by Christina Bain

At its highpoint, the studio employed nine seamstresses, a shop manager, and her mother who supervised the bookkeeping. Nancy's notes to her seamstresses (see Figure 3.12) demonstrate her keen attention to detail and high standards.

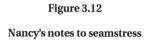

Figure 3.12

Nancy's notes to seamstress

Photo by Christina Bain.

Picking up the Paintbrush: Nancy's Third Career Direction

By 1983, Nancy's passion for puppetry began to ebb and Bob surmised that she "gave up on puppetry, finally, [because] she felt like she said everything she needed to say. And she wanted to really express herself through different means and there's nothing quite like painting" (Renfro et al., 2015). Although Nancy's work as a painter is not discussed in detail here, it is important to mention this period in order to understand her career holistically. Despite failing eyesight and deepening bouts of depression, Nancy was a prolific painter, producing more than 300 paintings during the last decade of her life. Colleague Ellen Scott described this body of work as "phenomenal" in both quantity and quality. Nancy's work is difficult to categorize because it is often fraught with tension between circus-like figures and anthropomorphic animals (see Figures 3.10 and 3.11). Her large-scale compositions and masterful use of color are simultaneously seductive and frightening, challenging viewers to make their own interpretations about the relationships and stories portrayed on the canvases (see Figures 3.13 and 3.14). Sadly, Nancy Renfro committed suicide in 1993 at the age of 54.

Figure 3.13

Alligator Dance

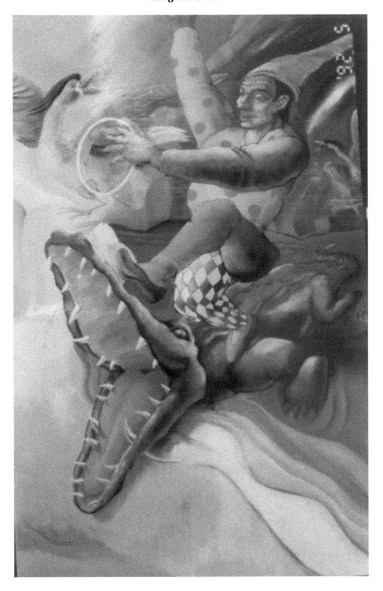

Oil painting by Nancy Renfro. Photo courtesy of Bob Renfro.

Figure 3.14

Polar Embrace

Oil Painting by Nancy Renfro. Photo courtesy of Bob Renfro.

Collective Fibers of Our Lives: Place, Puppets, and Pedagogy

My initial interest in Nancy Renfro began when I discovered that we both have lived in three of the same locations: Long Island, Syracuse, and Austin. These were Nancy's homes, and at one time or another in my life, they were mine. Because of my intimate knowledge of these places, I found myself weaving personal connections into Nancy's story. I could envision someone I will never meet carrying on her life in these environments. The smells, sounds, and sights of our shared environments are layered in my imagination. I can envision the sounds and sights of college students on Sixth Street in Austin 'keeping it weird,' the vibrant colors of fall foliage in upstate New York, and the screech of brakes as a Long Island Railroad train barrels into a station. Although Nancy and I lived at different times and I can never fully understand her perspective, these undocumented sights, smells, and sounds are unwritten, yet important, common threads connecting our lives. Her own words, as well as those of family members and colleagues, help paint a more complete picture of this complex and largely unrecognized teaching artist.

Nancy's story has become further intertwined with my own on a layer I did not anticipate at the outset of my exploration. Because of this research, I have become more acutely aware of the potential of puppets in education. Born in 1964, I was *Sesame Street*'s original target audience, learning important life lessons as well as my ABCs from Big Bird. More recently, a colleague and I took a continuing education puppetry class and discussed ways we can integrate puppets into art education coursework. This work continues to evolve as I recently co-presented at a state art education conference with my undergraduate students on the topic of how to connect storytelling and puppetry. I see much potential for further work in this direction.

In learning about Nancy's role as an educator, I reflected on my own teaching philosophy and pedagogy. As I found similarities and differences, I identified most with her desire to make education relevant and engaging. Finally, some of Nancy's words on the power of art particularly resonated with me:

> *Art helped me survive emotionally and intellec-*
> *tually. I also used art to build up my self-esteem*
> *and I was always fortunate to have someone who*
> *helped keep that sense of self-esteem at a high*

level. My parents were very supportive that way, a
few special friends, and my husband. . . . Teachers
and librarians do not always have the time to
give this special kind of attention, but whenever
it is possible it is important to apply it. And it
takes on a cumulative affect—every little bit
counts. (Renfro et al., 2016, p. 148)

By all accounts, Nancy was an exceptionally talented woman who made a difference in the lives of many people through her puppets, performances, and teaching. It is my hope that this chapter has served two purposes, that: (a) it has shed light on Nancy Renfro's life and accomplishments, and (b) readers will consider how their lived experiences, bounded by personal memories of sights, smells, experiences, and places, connect them to a historical tapestry in which we are all connected.

References

Baxandall, R., & Gordon, L. (2005). Second-wave feminism. In N. A. Hewitt (Ed.), *A companion to American women's history* (pp. 414-423). Malden, MA: Blackwell.

Booth, E. (2009). *The music teaching artist's bible.* New York, NY: Oxford University Press.

Collins, G. (2004). *America's women: 400 years of dolls, drudges, helpmates, and heroines.* New York, NY: Harper Collins.

Dawson, K., & Kelin, D. A. (2014). *The reflexive teaching artist.* Chicago, IL: Intellect.

Dewey, J. (1997). *Experience and education.* New York, NY: Touchstone.

Efland, A. (1990). *History of art education: Intellectual and social currents in teaching the visual arts.* New York, NY: Teachers College Press.

Ellsworth, E. A. (2005). *Places of learning: Media, architecture, pedagogy.* New York, NY: Taylor & Francis.

Farber, D. (1994). *The age of great dreams: America in the 1960s.* New York, NY: Hill and Wang.

Friedan, B. (1963). *The feminine mystique.* New York, NY: W. W. Norton.

Hunt, T., & Renfro, N. (1982). *Puppetry in early childhood education.* Austin, TX: Nancy Renfro Studios.

Lowenfeld, V. (1947). *Creative and mental growth: A textbook on art education.* New York, NY: Macmillan Company.

Lowenfeld, V. (1951). *Creative and mental growth: A textbook on art education.* New York, NY: Macmillan.

Meyerowitz, J. (1994). *Not June Cleaver: Women and gender in postwar America, 1945-1960.* Philadelphia, PA: Temple University Press.

Renfro, N. (1979). *Puppetry and the art of story creation.* Austin, TX: Nancy Renfro Studios.

Renfro, R., Renfro, K., Scott, E., & Roberts, D. (2015, February 12). Interview by C. Bain [Digital recording]. Personal collection of Christina Bain. Pflugerville, TX.

Renfro, R., Roberts, D., Keever, E., & Morehead, S. (2016). *Artistic triumph amid darkness: Nancy Renfro's remarkable creative odyssey 1937-1993.* [Limited circulation book]. Available at bob.renfro1931@gmail.com.

Springstead, D., & Springstead, J. (2016, May 21). Interview by C. Bain [Digital recording]. Personal collection of Christina Bain. Pflugerville, TX.

Strot, R. (2015, October 9). Interview by C. Bain [Digital recording]. Personal collection of Christina Bain. Pflugerville, TX.

Texas Art Education Association. (2014). *2014 Conference schedule.* Dallas, TX.

APPENDIX

Nancy Renfro wrote/co-wrote the following 20 books on puppetry from 1978 to 1990:

Bissinger, K., & Renfro, N. (1990). *Leap into learning: Teaching curriculum through creative dramatics and dance.* Austin, TX: Nancy Renfro Studios.

Champlin, C., & Renfro, N. (1980). *Puppetry and creative dramatics in storytelling.* Puppetry in Education Series. Austin, TX: Nancy Renfro Studios.

Champlin, C. & Renfro, N. (1985). *Storytelling with puppets.* Washington, DC: American Library Association.

Frazier, N., Renfro, N., & Sears, L. D. (1987). *Imagination: At play with puppets and creative drama.* Austin, TX: Nancy Renfro Studios.

Hunt, T. & Renfro, N. (1982a). *Puppetry in early childhood education.* Puppetry in Education Series. Austin, TX: Nancy Renfro Studios.

Hunt, T. & Renfro, N. (1982b). *Pocketful of puppets: Mother goose rhymes.* Puppetry in Education Series. Austin, TX: Nancy Renfro Studios.

Hunt, T. & Renfro, N. (1987). *Celebrate! Holidays, puppets, and creative drama.* Austin, TX: Nancy Renfro Studios.

Renfro, N. (1969). *Puppets for play production.* New York, NY: Funk and Wagnalls.

Renfro, N. (1978). *A puppet corner in every library.* Austin, TX: Nancy Renfro Studios.

Renfro, N. (1979a). *Puppetry and the art of story creation.* Puppetry in Education Series. Austin, TX: Nancy Renfro Studios.

Renfro, N. (1979b). *Make amazing puppets.* Learning Works.

Renfro, N. (1982a). *Pocketful of puppets: Poems for church school.* Austin, TX: Nancy Renfro Studios.

Renfro, N. (1982b). *Puppet shows made easy.* Austin, TX: Nancy Renfro Studios.

Renfro, N. (1984a). *Puppet shows made easy.* Austin, TX: Nancy Renfro Studios.

Renfro, N. (1984b). *Puppetry, language, and the special child: Discovering alternate languages.* Austin, TX: Nancy Renfro Studios.

Renfro, N. (1984b). *Puppet shows made easy.* Austin, TX: Nancy Renfro Studios.

Renfro, N. (1987). *Bags are big! A paper bag craft book.* Austin, TX: Nancy Renfro Studios.

Renfro, N., & Sullivan, D. (1985). *Puppets USA Texas: Exploring folklore and music and crafts with puppets.* Austin, TX: Nancy Renfro Studios.

Sullivan, D., & Renfro, N. (1982). *Pocketful of puppets: Activities for the special child.* Puppetry in Education Series. Austin, TX: Nancy Renfro Studios.

Winer, Y., & Renfro, N. (1983). *Pocketful of puppets: Three plump fish and other stories.* Austin, TX: Nancy Renfro Studios.

Chapter 4

LESSONS FROM DOROTHY DUNN (1903-1992): THE STUDIO AT SANTA FE INDIAN SCHOOL, 1932-1937

Elise Chevalier

Introduction: The Studio at Santa Fe Indian School

Dorothy Dunn (1903-1992) founded the first painting program at the Santa Fe Indian School in Santa Fe, New Mexico, in 1932. The Santa Fe Indian School painting program, which became known as the Studio, launched the careers of several prominent artists and influenced the course of Native American painting in the Southwest throughout the mid-20th century (Brody, 1971).[1] Dunn headed the Studio from 1932 to 1937, and under her leadership, the Studio program became increasingly popular with students, with enrollment growing from 40 students in 1932 to 170 students in 1937 (Dunn, 1960a). The popularity of the Studio also expanded into national and international art markets, as Dunn promoted dozens of exhibitions of Studio paintings during her tenure at the Santa Fe Indian School (Eldridge, 2001). These exhibitions promoted the careers of several students who became prominent artists, including Allan Houser (Chiricahua Apache), Joe H. Herrera (Cochiti Pueblo), Pop-Chalee (Taos Pueblo), and Pablita Velarde (Santa Clara Pueblo). Although Dunn taught at the Santa Fe Indian School for only five years, from 1932 to 1937, the Studio program promoted a painting style that remained popular throughout the Southwest in the following decades (Brody, 1971).

By the mid-20th century, educators and critics in the Southwest began to question Dunn's legacy. During the late 1950s, educators such as Lloyd Kiva New (Cherokee) argued that the style popularized by the Studio had become outmoded (Gritton, 2000). In 1971, art historian J. J. Brody characterized Studio-style paintings as bereft of meaningful content in his text *Indian Painters and White Patrons.* In more recent years, art education historian Peter Smith

(1999) defended Dunn's intentions, suggesting that *"given the historical moment during which Dunn taught, her approach can be judged as laudable and valid"* (p. 122). Laurie Eldridge (2001) echoed earlier critiques of Dunn's methods, which argued that she had required adherence to a particular style. While considering a range of critical responses to Dunn's Studio program, this chapter describes and contextualizes Dunn's pedagogy within wide-reaching political, social, and educational movements during the late 19th and early 20th centuries. Moreover, it develops descriptive examples of Dunn's pedagogy from documents housed in the Dorothy Dunn Kramer Archives in Santa Fe, New Mexico, and from Dunn's published writings, including her ambitious art history text, *American Indian Painting of the Southwest and Plains Areas*, published in 1968.

Dunn, a Kansas-born Anglo educator trained at the School of the Art Institute of Chicago, attempted to develop a pedagogy that would connect her students with artistic traditions of diverse Native communities (Dunn, 1960a). Dunn's goals for the Studio asked students to paint according to particular formal conventions, express both their individual and community identities, and create marketable artworks. These goals became paradoxical at times, resulting in an internal tension pervasive in Studio practice. Dunn predicated her pedagogy on two assumptions. First, Dunn (1968) viewed Native American art as distinctively separate from European and Anglo American art, emphasizing cultural authenticity in her students' work. Second, Dunn believed she could and should teach what she considered to be authentic Native American artistic conventions at the Santa Fe Indian School. However, Dunn's emphasis on authenticity in Native American art contradicted the reality of her role as a representative of a colonial U.S. government. Dunn's complex and sometimes contradictory goals for the Studio program were closely related to reform movements of the late 19th and early 20th centuries.

The Studio in Context: Assimilation Policies and the Indian New Deal

Because Dunn was a U.S. government employee, historical relationships between the communities of her students and the U.S. political system underpinned the colonial dynamic within the Studio. Throughout the 19th century, the U.S. government maintained antagonistic positions towards Indigenous communities in North

America, warring against Native nations to expand the country's territorial boundaries. In the post-Civil War years, violent conflicts between a rapidly growing number of Anglo settlers and existing Native communities prompted the U.S. government to take action (Takaki, 2000). Attempting to satisfy intensifying industrial interests in the West while avoiding outright genocidal war against Indigenous communities, the United States adopted "assimilation" policies during the late 19th and early 20th centuries (Szasz, 1999, p. 8). The U.S. Bureau of Indian Affairs, based in Washington, D.C., enforced assimilation policies, attempting to coerce Native peoples into relinquishing land rights, legal sovereignty, and cultural traditions. During the assimilation period, federal boarding schools banned Indigenous languages, forced the adoption of Christianity, and barred students from depicting their home lives in art (Szasz, 1999). The Carlisle Indian Industrial School, established in 1879 by Captain Richard Henry Pratt, served as a model for later Bureau of Indian Affairs schools. Pratt's philosophy towards Native American students was summed up by his infamous quote: *"Kill the Indian and save the man"* (Dunbar-Ortiz, 2014, p. 151). The motto was all too accurate in describing the intentions of 19th century federal schools, including the Santa Fe Indian School. The Bureau of Indian Affairs opened the Santa Fe Indian School in 1890, among 25 off-reservation boarding schools the U.S. government established between 1880 and 1900 (Szasz, 1999). The Santa Fe Indian School implemented assimilation through military-like discipline (Hyer, 1990).

In the 1920s, an expanding group of U.S. reformers and activists funded a number of studies to document the many human rights violations committed under assimilation directives (Szasz, 1999). One of the most influential of these studies was the Brookings Institution's 1928 *The Problem of the Indian Administration,* better known as the Meriam Report (Szasz, 1999). The Meriam Report documented the pervasive malnutrition, overcrowding, poor medical care, and excessive student labor typical of boarding schools administered by the Bureau of Indian Affairs. The Meriam Report also recommended that most non-reservation boarding schools become day schools, with an exception for those that emphasized the *"particular contribution each school might make to Indian progress through education"* (Brookings Institution, 1928, pp. 404-405). The Santa Fe Indian School met the Meriam Report's recommendation by specializing as an arts and crafts school for the entire Indian Service in 1932 (Eldridge, 2001).

Dunn's founding of the Studio in 1932 was only possible due to U.S. reformers of the 1920s and 1930s, whose collective efforts pushed forward significant changes in government policies related to Native American communities. A series of legal reforms termed the *Indian New Deal* supported certain political and economic rights for Native nations (Szasz, 1999). Newly appointed officials in the Bureau of Indian Affairs, such as Commissioner of Indian Affairs John Collier, attempted to align federal schools more closely with the diverse cultural traditions of their students (Gritton, 2000). The Studio was founded during a period of rapid political reform, including changes in Bureau of Indian Affairs leadership, the appointment of reform-minded Superintendent Chester Faris over the Santa Fe Indian School, and the passage of the 1934 Indian Reorganization Act (Szasz, 1999). Mirroring the Indian New Deal reforms, Dunn attempted to restore what she believed to be traditional Native American aesthetic conventions.

Dunn believed her students could produce paintings that reflected both their individual and community identities, thereby securing critical recognition in a global fine arts context. Through the Studio program, Dunn (1960a) sought to expose the fallacies of assimilation, the *"supposed complete superiority of the superimposed culture,"* by encouraging students to produce paintings with *"tribal and individual distinction"* within an international fine arts context (p. 19). Perhaps because she intended to reverse many of the effects of assimilation policies through her teaching practice, Dunn (1960a) claimed that the *"one fixed principle"* of the Studio was that *"the painting would have to be Indian"* (p. 18). As the Studio developed, Dunn's desire to foster a uniquely Native American style may have restricted her understanding of the authentic in her students' work.

According to Dunn (1968), the style she had promoted in the Studio *"was determined by customary usage, past and present, insofar as known, among the Indian people themselves"* (p. 261). However, given that her students came from communities whose recent histories included war, colonization, and forced assimilation, one might wonder how Dunn connected customs of artistic expressions between the ancient and the modern. She was well aware that assimilation policies impacted the production of Native arts, but claimed that the differences between ancient and 20th century Pueblo painting were negligible. Dunn (1936) equated the ancient and the contemporary, claiming that Pueblo painting was among the *"oldest in the sense that the Indians have painted for centuries for*

themselves, and one of the youngest because only within the past few
years have they been putting down their ancient truths, in modern
media, for other people" (p. 30). Pueblo painting was, in Dunn's
view, symbolic of a *"oneness with nature"* (p. 36), which may explain
her distaste for any non-Native artistic influences in the Studio.

Authenticity in the Studio: A "Vibrant Elusive Spirit"

The notion of authenticity often arises in histories of the Southwest
Native American art world. Bernstein (1999) characterized authen-
ticity as *"a discursive element which now permeates all parties asso-*
ciated with the Indian art world" (p. 57). Art historian David W.
Penney (2004) noted that the concept of authenticity gained partic-
ular currency in the early 20th century, when wealthy Anglo
Americans became increasingly disenchanted with a modern life
seemingly infected *"by the rancid and decaying culture of Europe"*
(p. 197). In 1934, Commissioner of Indian Affairs John Collier wrote
that the *"white world"* of the 20th century had become *"psychically,*
religiously, socially and esthetically shattered, dismembered, direc-
tionless" (p. 9). Collier next suggested that perhaps Anglo culture
could be healed through contact with Native communities (p. 10).
Although Dunn's writings never revealed an existential despair
equal to Collier's, she also seemed to find spiritual hope in Native
American cultures. For Dunn, notions of spiritual and cultural au-
thenticity were intertwined. In 1936, Dunn wrote that a *"Pueblo*
painter catches the vibrant elusive spirit of life forces and forms—the
ancient cloud and sun, his brother animals, himself, impersonally, in
all his activities—and shows them to be more real than they ordina-
rily seem" (p. 31).[2] Dunn (1968) later claimed that Native American
painting was *"mainly of nature,"* capturing the *"spirit of a creature"*
(pp. 28-29). Such writings indicate that Dunn (1936) found authen-
tic experiences in an idealized connection with the past and with
nature, as exemplified in Native American paintings (p. 31).

Source materials for Dunn's Studio support a notion of authen-
ticity grounded in historical continuity. Dunn (1968) claimed that
for *"Indians who have had any fair chance to remain Indians at all,*
their fundamental expressions of art remain essentially the same as
they were before the white man came" (pp. 29-30). The Studio pro-
gram encouraged connections between ancient and contemporary
Native painting through the study of archeological source materials.
As the Studio director, Dunn (1968) drew source materials from
archaeological and anthropological research, often in collaboration

with the Laboratory of Anthropology. Students enrolled in the Studio program completed design studies similar to those she herself drew from ancient Southwest pottery under the tutelage of anthropologist Kenneth Chapman.[3] Tellingly, the term *authentic* was applied to archeological artifacts in a description of Dunn's painting program in a 1935 Santa Fe Indian School publication: *"Work is developed from memory and from research in authentic records."*[4] Thus, the Studio connected authenticity with records and memories of the past, perhaps more than students' day-to-day experiences in the Santa Fe Indian School. In 1938, the Director of Education Willard Beatty questioned whether Dunn's students painted from their lived experiences: *"To have meaning, ideas must be experienced. . . . The thing I criticize . . . in the work of some of these students is their attempt to draw something which they have not seen or experienced."* Contemporary scholars have echoed Beatty's concerns. Bernstein (1999) suggested that Anglo activists and scholars, including Kenneth Chapman, Edgar Hewett, and Dunn, *"wanted to build a re-created past through archeology"* (p. 58).

While Dunn drew much of her source material from historical artifacts, contemporary artists influenced the work produced in her Studio as well. The aesthetic lineage of Studio paintings owes a great deal to commissioned paintings that San Ildefonso artists, including Alfonso Roybal (Awa Tsireh) and Crescencio Martinez, produced for anthropologists like Edgar Lee Hewett in the late 19th and early 20th centuries (Smith, 1999). In the 1910s, Hewett, the Director of the Museum of New Mexico, commissioned depictions of community rituals, dances, and ceremonies (Smith, 1999). For Bernstein (1999), the burgeoning Santa Fe art market, encouraged by anthropologists, represented cultural appropriation: *"While the promoters insisted that the paintings and pottery they encouraged were infused with the high principles of art, they were nonetheless an invention and another means by which the non-Pueblo world appropriated Pueblo culture"* (p. 58). Commissioned paintings represented a major shift from pre-Contact painting, a form of *"visual auto-ethnography"* produced for the purposes of a colonizing group (Penney, 2004, p. 196). Smith (1999) posited that anthropologists and archeologists prompted a shift from community-centered art to individual, portable paintings produced for sale, much like the paintings of Dunn's Studio students. When Dunn founded the Studio program in 1932, she, like the Anglo activists of the previous two decades, promoted market-based commoditization of Native American paintings by encouraging and facilitating sales of student artwork.

The Studio Style

Dunn applied an emphasis on cultural authenticity to the work of Studio students from diverse Native nations, including Pueblo, Apache, Navajo (Diné), Kiowa, and Sioux communities. Dunn (1968) swayed students from copying *"unworthy exotic influence . . . by suggestion of a variety of choices of tribal elements which might make a particular painting more authentic"* (p. 261). She presented students with images of ancient and contemporary objects from Native communities to be *"studied by the classes for authenticity of spirit and style"* (p. 283). The Studio program reinforced the categorization of Native American painting as distinct from mainstream contemporary art. Dunn also claimed that Native American art could contribute to the art of the United States, but discouraged her students from borrowing from European and Anglo artistic conventions. Dubin (2001) viewed that distinction as emblematic of Dunn's conception of *"Native American painting as a natural outgrowth of a primitive artistic tradition"* (p. 106). Such an understanding of Native American painting, which assumed that the authenticity of a piece required adherence to a particular visual style, likely contributed to the marginalization of Native artwork within 20th century art markets.

Although Dunn wanted her students to follow the artistic traditions of their unique communities, scholars have noted stylistic similarities among Studio paintings as a whole. Rushing (1995, in Bernstein & Rushing, 1995) has pointed out that because of Dunn's requirement that her students rely upon memory, imagination, and pictographic figures to create imagery, *"she virtually assured that the paintings would be more conceptual than perceptual"* (p. 33). Studio paintings shared similarities in style and content, which Rushing characterized as *"flat, decorative watercolors featuring semiabstract elemental figuration that emphasized rhythmic linearity and usually depicted dances, hunting, or genre activities"* (p. 29). Thus, while Dunn intended each of her Studio students to work in the traditions of their own communities, she also viewed students as collectively working within a pan-Indian painting genre—a genre that Dunn herself helped to create.

Dunn's Authority in the Studio: *"The choice to be or not to be"*

Dunn taught color mixing and the principles of design in relation to line and shape that she most likely learned in her own formal schooling (Eldridge, 2001). However, Dunn (1968) rejected other techniques, such as perspective and modeling, which she considered characteristic of *academic* art. Dunn (1968) wrote that during her first year at the Santa Fe Indian School, another teacher offered a class in portraiture for students interested in what Dunn called *academic* painting, a type of instruction she strongly opposed. During her Studio years, Dunn (1935) claimed that although *"many young Indian artists . . . ask to be taught drawing and design 'like the American artists do,' the Indian schools must refuse to do so"* (p. 20). In 1936, Dunn asserted that *"the Pueblo painter . . . poses no models, studies no drawing, anatomy, perspective, or complex color theory"* (p. 31). Her sweeping characterization of Pueblo painters in 1936 thus ignored the interests of Pueblo students enrolled in the 1932 portraiture class. This apparent contradiction may be explained by Dunn's (1959) definition of an *"Indian artist"* (p. 1). According to Dunn, a Native American individual who painted was not necessarily a Native American painter: *"An Indian artist . . . is one who utilizes the peculiar art backgrounds of his own tribal group. . . . The choice to be or not to be an Indian artist is the Indian's own"* (p. 1). Dunn's claim that a person belonging to a Native community could create art yet not be a Native American artist highlighted her sense of authority in defining authenticity in Native art.

Brody (1971) noted that Native artists of the early 20th century often rearticulated their cultural expressions in response to Euro American art paradigms. According to Dubin (2001), these paintings must be contextualized *"against a backdrop of severe social and economic depression in Indian country, [where] wealthy immigrant whites easily assumed the dominant role in patronage relationships in which Indians were encouraged to paint images of their traditional activities"* (p. 105). Nevertheless, Studio paintings also demonstrated students' skillful self-representation within a colonial system. Students worked within many constraints, including Dunn's demands for specific stylistic conventions, but paintings produced in the Studio also reflected students' efforts to take ownership of public representations of their communities.

Tensions in the Studio

Dunn (1960b) described herself as more of a guide than a teacher, claiming that her "guidance was through question, suggestion, commendation, and the gradual instilment of resourcefulness, discernment, and self-reliance" (p. 5). Concurrent Bureau of Indian Affairs reforms and educational reform movements emphasized child-centered learning. In keeping with the Progressive Education movement and Indian New Deal goals, Dunn (1968) believed that art education served as a means for students to engage in self-expression and connect with their communities. These values aligned with the writings of prominent Bureau of Indian Affairs administrators, including Director of Education Carson Ryan (1938) and Supervisor of Elementary Education Rose K. Brandt (1935). Although Dunn encouraged students to express their individuality, she simultaneously expected students' artworks to reflect their cultural identity. For instance, a painting might reflect a student's cultural identity by adhering to stylistic conventions Dunn believed to be traditional to that student's community (Hahn, 2011). By limiting students' painting to prescribed conventions, Dunn exerted significant influence over Studio artwork, despite her interest in child-centered art education.

Amplifying the tension between her interest in a child-centered curriculum and her emphasis on cultural authenticity, Dunn's position as a teacher employed by the U.S. federal government endowed her with institutional authority. Dunn's role as a representative of a colonial government was at odds with her support of student autonomy. However, Dunn's approach may be interpreted as a reaction against the extreme policies of assimilation, which sought to strip Native Americans of their cultural traditions altogether. Dunn and her fellow reformers sought to incorporate Native American cultures into a culturally pluralistic United States (Hahn, 2011). Within the context of a colonial system, Dunn attempted to promote social and economic agency for her Native American students. Nevertheless, Dunn and her reform-minded colleagues failed to disrupt the dominance of the U.S. government. In describing Dunn's counterparts in Santa Fe, Penney and Roberts (1999) adapted Mary Louise Pratt's concept of the anti-conquest, "the strategies whereby European bourgeois subjects seek to secure their innocence in the same moment they assert European hegemony" (p. 22). Dunn's (1968) insistence on the beneficence of the Studio program may be read as a proclamation of her innocence in

the U.S. colonial system. Further, the Studio's commoditization of student artwork may have demonstrated the "hegemonic prerogative to claim colonized cultures as national possessions" (Penney & Roberts, 1999, p. 23).

Just as Dunn grappled with divergent goals within her teaching practice, she also confronted external pressures within the Santa Fe Indian School and in the Bureau of Indian Affairs. Conflicts with administrators likely led to her resignation as Studio director in 1937 (Bernstein & Rushing, 1995). Soon thereafter, Dunn married her colleague Max Kramer, and the couple relocated to Taos, New Mexico (Hahn, 2011). Studio alumna Gerónima Cruz Montoya (San Juan/Ohkay Owingeh) took over the directorship of the Studio until its closure in 1962 (Hyer, 1990). Dunn continued to correspond with former students, conduct research, and write about Native art during the following decades, as indicated in the Kramer archives.[5]

Located in a time and a place where Native American art forms were often viewed as inferior to European artistic traditions, Dunn advocated for elite U.S. art markets to recognize the value of Native painting. The Studio was a site filled with both internal and external tensions, where Dunn attempted to synthesize disparate goals drawn from political and educational reform movements in her teaching practice. Ultimately, as Dunn combined her own understanding of the authentic in Native American art with her authority as a Bureau of Indian Affairs employee, her progressive ideals became contradictory with her teaching practice in the Studio.

References

Bernstein, B. (1999). Contexts for the growth and development of the Indian art world in the 1960s and 1970s. In W. J. Rushing (Ed.), *Native American art in the twentieth century* (pp. 57-71). New York, NY: Routledge.

Bernstein, B., & Rushing, W. J. (1995). *Modern by tradition: American Indian painting in the studio style.* Santa Fe, NM: Museum of New Mexico Press.

Brandt, R. K. (1935). Environmental experiences of Indian children and the elementary school curriculum. *Indians at Work, 3*(1), 15-19.

Brody, J. J. (1971). *Indian painters and white patrons.* Albuquerque, NM: University of New Mexico Press.

Brookings Institution. (1928). *The problem of Indian administration: Report of a survey made at the request of Hubert Work, Secre-*

tary of the Interior, and submitted to him, February 21, 1928. Baltimore, MD: Johns Hopkins Press.

Collier, J. (1934). Does the government welcome the Indian arts? *Indians at Work, 1*(21), 4-10. Washington, DC: Office of Indian Affairs.

Dubin, M. (2001). *Native America collected: The culture of an art world*. Albuquerque, NM: University of New Mexico Press.

Dunbar-Ortiz, R. (2014). *An Indigenous peoples' history of the United States*. Boston, MA: Beacon Press.

Dunn, D. (1935). Indian art in the schools. *Indians at Work, 3*(1), 20-21. Washington, DC: Office of Indian Affairs.

Dunn, D. (1936). Pueblo Indian painting. In *Indians at work: Contemporary arts and crafts* (pp. 30-31). Washington, DC: Office of Indian Affairs.

Dunn, D. (1959). Guidance and evaluation of the Indian artist. Unpublished manuscript, Dorothy Dunn Kramer Collection (Box 11, File 93.DDK.122). Laboratory of Anthropology Archives, Santa Fe, NM.

Dunn, D. (1960a, February). The studio of painting, Santa Fe Indian School. *El Palacio, 67*(1), 16-27.

Dunn, D. (1960b, May). Influences on painting in the Santa Fe Indian School. *Smoke Signals, 34*, 1-8. Washington, DC: Indian Arts and Crafts Board.

Dunn, D. (1968). *American Indian painting of the Southwest and Plains areas*. Albuquerque, NM: University of New Mexico.

Eldridge, L. (2001). Dorothy Dunn and the art education of Native Americans: Continuing the dialogue. *Studies in Art Education 42*(4), 318-332.

Gritton, J. (2000). *The Institute of American Indian Arts: Modernism and U.S. Indian policy*. Albuquerque, NM: University of New Mexico Press.

Hahn, M. (2011). *The studio of painting at the Santa Fe Indian School: A case study in modern American identity*. (Unpublished doctoral dissertation). University of Texas, Austin.

Hyer, S. (1990). *One house, one voice, one heart: Native American education at the Santa Fe Indian School*. Santa Fe, NM: Museum of New Mexico Press.

Penney, D. W. (2004). *North American Indian art*. New York, NY: Thames & Hudson.

Penney, D. W., & Roberts, L. A. (1999). America's Pueblo artists: Encounters on the borderlands. In W. J. Rushing (Ed.), *Native American art in the twentieth century* (pp. 21-28). New York, NY: Routledge.

Ryan, C. (1938). *Mental health through education*. New York, NY: The Commonwealth Fund.

Santa Fe Indian School. (1935). Annual announcement [Brochure]. Santa Fe, NM: Department of the Interior. Dorothy Dunn Kramer

Collection (Box 13, File 93.DDK.170). Laboratory of Anthropology Archives, Santa Fe, NM.

Smith, P. (1999). The unexplored: Art education historians' failure to consider the Southwest. *Studies in Art Education, 40*(2), 114-127.

Szasz, M. (1999). *Education and the American Indian* (2nd ed.). Albuquerque, NM: University of New Mexico Press.

Takaki, R. (2000). *Iron cages: Race and culture in 19th-century America* (3rd ed.). New York, NY: Oxford University Press.

Endnotes

[1]In this paper, *Native American* refers to people and descendants of people who lived in the continent now known as the United States before European immigration. This term has complex connotations, as the term *American* came into usage only through processes of conquest and colonization.

[2]Dunn taught students who were members of many Native nations. Due perhaps to the proximity of the Santa Fe Indian School to Pueblo communities, Dunn's writing from the Studio period often referred specifically to Pueblo art.

[3]From the Dorothy Dunn Kramer Archives, Laboratory of Anthropology, Santa Fe, NM. See Dunn's assignments and Studio posters in files 93.DDK.155, 93.DDK.171, 93.DDK.158.1, and 93.DDK.158.2.

[4]From the Dorothy Dunn Kramer Archives, Laboratory of Anthropology, Santa Fe, NM. See file 93.DDK.170.

Dunn continued to correspond with former students, conduct research, and write about Native art during the following decades, as indicated in the Kramer archives.[5]

[5]From the Kramer Archives, Laboratory of Anthropology, Santa Fe, NM. See letter from Beatty to Dunn dated February 11, 1938 in file 93.DDK.165.

Chapter 5

MATTERS OF TASTE, MEASURES OF JUDGMENT: THE *McADORY ART TEST*

Mary Hafeli

I recently remodeled and furnished an old home in Connecticut. Within an aesthetic mash-up of 1890s Victorian-meets-shabby-chic-meets-contemporary-art, I chose from assorted styles of tables, chairs, sofas, knobs and other decorative hardware, light and plumbing fixtures, curtains, and rugs. I made decisions about wall colors and coverings, floor finishes, and kitchen cabinets and countertops. I collected interesting things to display. I wanted to find, to my mind at least, the "best" designs—materials, forms, and objects that would make my home an inviting, eclectically juxtaposed, and intriguing mix. This morning, as I got dressed, I had to decide whether to go with a mid-length or short skirt, or a dress, or pants. Patterns or solids, bright or muted tones, shoes or boots in black, brown or red, shiny or matte leather, or suede. Again, I had to consider what looked good together and what felt right according to my mood and sensibilities. How do people develop these ways of judging goodness or rightness in their aesthetic choices? What makes one fashion selection or furniture design better than another, and whose role is it to decide what is best?

At the beginning of the 20th century, learning and practicing "good" taste in the everyday life of house and home fell to Victorian women, who were in charge of setting the aesthetic standard and cultural tone for their families. In picking out furniture, decorating their parlors, and choosing fashionable clothing, women could draw on style reference books and advice columns in magazines, and they could learn directly from designers and fashion experts through contemporary style workshops in department stores (Sparke, 2010). These decorating tips drew on, among other sources, teachings and practices of artists and designers of the pe-

riod—such as Arthur Wesley Dow (1899, 1908) and William Morris (1897)—whose ideas about effective composition in painting, sculpture, and decorative arts were codified into 'rules' of 'good' design.

At the same time and well into the first half of the 1900s, a groundswell of innovative, experimental psychologists in continental Europe, Great Britain, and the United States sought to *test* people's aesthetic judgment objectively and scientifically, within a wider research program that focused on measuring a range of human physical and mental capacities. Margaret McAdory, an art educator and doctoral student at Teachers College, Columbia University, was one of these researchers. Within a burgeoning field of general psychological measurement in the United States, art education researchers like McAdory sought to develop valid and reliable instruments to measure aesthetic judgment as an indicator of art aptitude. Among the aesthetic judgment tests developed during this period, the *McAdory Art Test* (McAdory, 1929b) and the *Meier-Seashore Art Judgment Test* (Meier & Seashore, 1929), based on the work of Norman Meier, were used widely.

While art education scholars such as Clark (1987), Zimmerman (1987), and Zurmuehlen (1987) have examined and critiqued Meier's early work in art testing, there is no such detailed consideration of McAdory's equally noteworthy work in the same area. Studies of McAdory's contributions to the field of art education are also missing from art education texts that have chronicled the field's general history as well as from those that have focused specifically on the lives of influential women art educators. This chapter examines McAdory's pioneering research, specifically as seen in the *McAdory Art Test*. It documents her development of the test in light of the aesthetic trends and tastes of the period, and describes the historical and cultural conditions that persist in the quest to quantify artistic thinking and practice. The aspect of the study I focus on in this chapter is the creation of the test itself and general responses to it in the years that followed its publication in 1929.

In conducting the research, I drew on primary documentation—including all of the plates from the original *McAdory Art Test*, McAdory's doctoral dissertation, and a subsequent technical report she and her colleagues issued (Siceloff et al., 1933). I also consulted several published reviews of the test (Carroll, 1933; Meier, 1941; Tyler, 1930) as well as early publications and later studies that described the development of art testing in the United States (Bamos-

sy, Scammon, & Johnston, 1983; Blake, 1919; Thorndike, 1916); the historical cultural context of the post-Victorian era; and the art and design trends that framed the period of early Modernism (Eastlake, 1878; Feldman, 2002; Naylor, 1971; Sparke, 2010; Varnum, 1995).

Historical Influences on the *McAdory Art Test*

In 1929, Margaret McAdory completed her Doctor of Philosophy degree at Teachers College, Columbia University with a dissertation project titled *The Construction and Validation of the McAdory Art Test* (McAdory 1929a).[1] She developed the test as a student in the Division of Psychology, Institute of Educational Research.[2] The *McAdory Art Test* (McAdory, 1929b) was designed to measure aesthetic judgment as a predictor of artistic aptitude, to identify future artists and designers, and to test the design sensibilities of consumers and collectors of art and design. It was published that same year as a standardized test and later adopted by schools and universities.[3]

Early Testing in the Arts

According to Bamossy et al. (1983), the turn toward empirical research on art judgment and aesthetic preference began in Germany with Fechner (1876), who asked art gallery visitors to state their preferences and reasoning for judging one original and one altered painting in experiments he conducted in Dresden. In the United States, both during this time and soon after, psychological testing in general sought to examine a breathtaking number of human attributes and capacities, including human intelligence—and many of the early art perception tests sought to correlate their results with scores on non-art tests of mental ability (Redensek, 2011). The application of scientific principles to art making and aesthetic judgment was encouraged in the first decades of the 20th century (Blake, 1919) and several standardized tests of aesthetic judgment, or art appreciation, were developed between 1916 and 1942. In addition to the McAdory and Meier-Seashore tests are Thorndike's (1916) *Test for Aesthetic Appreciation*, the *Pintner Primary Mental Test* (Pintner & Paterson, 1917), Christensen and Karwoski's (1926) *Test for Art Appreciation*, and Graves's (1939) *Design Judgment Test*. The *McAdory Art Test*, along with the *Meier-Seashore Art Judgment Test*—developed at the University of Iowa and also published in 1929—grew out of these heady years of psychological experimentation and testing and marked, according to Carl Seashore (1929), *"the*

introduction of scientific procedure into a new field, namely, that of analysis and measurement of art talent" (p. 38).[4]

Two other related historical-sociocultural movements are key to McAdory's story. First, she was developing her test during the continuing proliferation of industrial production, which moved the manufacture of clothing, furniture, textiles, and decorative objects of all kinds from the workshops of individual craftspeople—and homes of art hobbyists—to factories that could accommodate the mass production of household and personal goods. The growing easy availability and wide variety of designs for clothing, rugs, candlesticks, pottery, glass, metalware, and other items, along with two other conditions—the perceived inferiority of mass-produced fashion and crafts and a growing middle class with the means to buy them—led to a need for consumer education in principles of 'good' taste in design (de Wolfe, 1913; Sparke, 2010). In this light, McAdory and others—including Arthur Wesley Dow (1899, 1908), whose ideas about art and design inspired her own (McAdory, 1929b)—saw the need for the masses to be educated about what constitutes goodness in judging designed items, even as they sought to test those capacities.

Regarding Dow, whose considerable influence on McAdory's work I discuss later in this chapter, a second interesting contextual element at play during this time was the shift from Victorian (and perceived feminine) aesthetic sensibilities to modernist (male) ones. Penny Sparke (2010), in her study of the sexual politics of taste, described the complex network of women's roles in setting and upholding Victorian taste and influencing the design of household items. Women were charged with—and initially appreciated for—creating a welcoming and comfortable, yet tasteful and sophisticated, home. Manuals such as Charles Eastlake's (1878) *Hints on Household Taste in Furniture, Upholstery, and Other Details* offered meticulously detailed descriptions of how to select and arrange everything from Indian ginger jars to Japanese fans to drawing room furniture to wall sconces. Earlier Victorian aesthetics had to do with overstuffed and ornately carved furniture and covering and layering surfaces with excesses of textiles and collections of knick-knacks—largely seen as a feminine and inferior aesthetic. By contrast, reductionist modernist principles, developed within the turn toward control provided by scientific rationalism (which in itself was a response to the chaos of change brought about by industrialism), were seen as male and superior (Sparke, 2010). In his 1925

polemic against the design of household wares sold in department stores and their promotion of what he and other modernists considered an egregious excess of feminine and bourgeois decoration, Le Corbusier (in Sparke, 2010) wrote:

Decoration on all fabrics (curtains, furnishings, fashions).

Decoration on all white linen (tablecloths, underwear, bed linen).

Decoration on all papers.

Decoration on all pottery and porcelain.

Decoration on all glassware.

Decoration in all departments! Decoration, decoration: yes indeed, in all departments; the department store became the "ladies' joy"! (p. 75)[5]

Seen in this context, McAdory was developing her test within a well-established, male-driven movement of design reform, which also contextualized Arthur Wesley Dow's (1857-1922) work.[6] The design reform movement sought to re-educate the masses in what constituted good taste in design, in the cultural turn from Victorian decorative aesthetics to Modernist streamlined form.

Developing the McAdory Art Test

McAdory's time as a doctoral student at Teachers College followed Dow's tenure as head of the visual arts program there, but, as Wygant (1959) reported, Dow's colleagues felt the influence of his ideas and teaching long after his passing in 1922.[7] McAdory's test of art judgment flowed directly from Dow's principles of best practice in composition. In her dissertation, she cited Dow's singular influence on her choice and manipulation of design elements as she constructed each item, or problem, for the test taker to solve.[8] Each test item contains four illustrations of a single subject. The illustrations differ from one another according to the manipulation of one or more of Dow's

three compositional elements—color, light/dark value (which Dow called *notan,* after the Japanese concept), and line.

McAdory's (1929b) dissertation described the procedures she used to develop the test items and establish the correct answers for each item. Her dissertation sponsor was Professor Frederick G. Bonser, who was a leading advocate for industrial arts education in the elementary school curriculum (Bonser, 1914, 1922). Like Dow, Bonser believed that art should be taught not necessarily to develop individuals as producing artists, but rather to develop their aesthetic taste and appreciation as consumers of designed products— furniture, textiles, decorative items, even automobiles—as well as artworks. Although McAdory's test was used as a tool for evaluating art aptitude, one of the original purposes, again, was rooted in consumer taste. As McAdory (1929a) put it: *"Many articles to be manufactured for sale might well be submitted in design to groups of competently trained people for comparison so that the greatest satisfaction may be assured for those who will purchase the article"* (p. 32). In addition to focus groups for product design, McAdory intended the test to identify competent designers, art teachers, stylists, buyers, and sales people. More than anything, though, McAdory, influenced by Dow and Bonser, hoped that the test would bring art into the everyday lives of regular citizens, making them, in her words, *"more conscious of differences in form and color The individual ought to have within him an independence of judgment which will enable him to make his environment satisfying, whatever the whims of changing style or fashion may attempt to dictate"* (p. 33). McAdory wrote that *"consumers of art products . . . need to have their judgment developed in the selection of things they use or enjoy in the home or in activities outside"* (p. 2).

Also being at Teachers College at the same time as Edward Thorndike, who is considered the father of educational psychology, testing, and measurement, McAdory would have been familiar with Thorndike's (1916) *Test of Aesthetic Appreciation,* which asked test subjects to rank a series of geometric shapes as *"best looking," "next best looking,"* and so on based on aesthetic merit. The correct order of these judgments was determined by consensus, and this was the method McAdory used in her test—although her judges were considered art experts of the time and Thorndike used college students. Moreover, whereas Thorndike's test used rectangles and other geometric shapes, McAdory's images focused on illustrations of everyday objects—furniture, utensils, dinnerware and serving dishes,

clothing, textiles, graphic design, landscape architecture, automobiles, painting, and sculpture.[9] In developing the test items, she used pictures from magazines, department store advertisements, art books, museum catalogues, and objects from museum collections (p. 2). In most cases, she made a single drawing from a picture or objects and then created four versions of the image, each slightly altered in color, dark/light value, and/or line and sometimes shape. The versions were designed to move from *"best"* to *"worst"* in four approximately equal, incremental steps, or *"degrees of merit"* (p. 4).

Figure 5.1, showing four contour drawings of a keyhole escutcheon in which proportion, relation of parts, and degree of elaboration are manipulated differently in each drawing, is an example of an early test item taken from McAdory's dissertation.[10] According to McAdory

Figure 5.1

Sample test item from *The Construction and Validation of an Art Test*

FIG. I. SAMPLE TEST ITEM

McAdory, 1929a, p. 6

(1929a), the original drawing was made, as faithfully as possible, of an escutcheon in the collection of the Museum of Fine Arts, Boston. In each of the three other versions, the contours of the inner and outer shapes are elongated, condensed, or made more elaborate, changing both the overall forms and the proximity and proportion of interior parts and exterior form. The correct order of answers here, from *"best"* to *"worst,"* is B (most faithful rendering of the original), A (*"retains the simplicity of contour"* but *"the change of proportion makes it less pleasing than B"*), D (*"restless contour and poorly related parts"*), and C (p. 7). This early test item was not among those in the final version of the test.

Selecting Items, Establishing Scoring, and Reporting Norms of the Test

McAdory's dissertation described in detail how she worked with 100 judges to select the final test plates and determine the correct ranking of the images on each plate. The judges were considered art experts of the time—craftspeople, painters, illustrators, color specialists, architects, art buyers and collectors, art directors, art editors and publishers, art advisors of department stores, art teachers, supervisors, college professors, museum curators and lecturers, and advanced art students. Working as a group over a two-day period, they established the scoring and reached consensus on the rankings. From a pool of over 70 test items, 61 items received agreement of at least 64%, and this level of agreement—given that there were 100 judges—was considered acceptable to establish reliability. Other criteria for selection of test items included percentage of deviation from the agreed order (low percentage of deviation was optimal); the judges' preference for particular test items; and the need to include a representative range of subjects such as clothing, textiles, furniture items, tableware, and other categories, as well as a range of design elements and relationships such as line/shape, dark/light, and color. Figures 5.2, 5.3, and 5.4 illustrate a small sample of the range of subjects and design elements McAdory featured in the test.

Figure 5.2

Sample test item from the *McAdory Art Test*

McAdory, 1929b

Figure 5.3

Sample test item from the *McAdory Art Test*

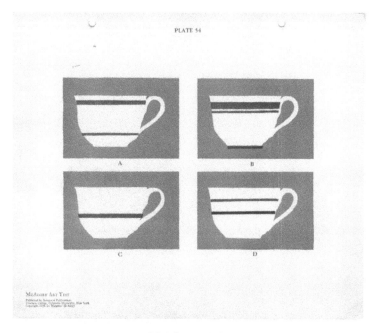

McAdory, 1929b

Figure 5.4

Sample test item from the *McAdory Art Test*

McAdory, 1929b

Although McAdory suggested that the test took approximately 90 minutes to complete, it was essentially considered untimed in its implementation, as there was no prescribed restriction for completion of all of the test items. McAdory determined the scoring to be 1 point for each correct answer. In a subsequent publication, *Validity and Standardization of the McAdory Art Test* (Siceloff et al., 1933), McAdory, Ella Woodyard, and their Teachers College colleagues established scoring norms that allowed for the standardization of

the test. They administered the test to 5,173 people in New York City ranging from children to adults and calculated average scores for females and males by grade for Grades 3-12, by age for ages 8-21, and for adults. These norms allowed the test to be used in a standardized way, so individual and group scores could be compared to average scores, or norms, for specific ages and grades.

Critical Response to the Test

Psychology departments and research institutes, such as those at Teachers College and the University of Iowa where the *Meier-Seashore Art Judgment Test* was developed, produced tests of many kinds and enjoyed significant financial support (both the *McAdory Art Test* and the *Meier-Seashore Art Judgment Test* were funded by the Carnegie Corporation). The high profile of this work led scholars at the time to herald both art judgment tests in the leading scientific and psychology journals (Seashore, 1929). But in the years and decades following their publication, others challenged the validity of the tests. For example, in *Validity and Standardization of the McAdory Art Test,* Siceloff et al. (1933) reported that for 15 of the 72 test items (21%), a large number of teachers who implemented the test found fault with the scoring. In response to this feedback, McAdory Siceloff revisited the original scoring by consulting another group of 'experts,' then revised the ranking order for some items, and recommended not using others because of a lack of consensus on the order.

In an early review, Ralph Tyler (1930) was one of the first scholars to question the validity of the test. He pointed out that while the test purported to measure art appreciation, *"it is possible for a pupil to recognize a painting by a master as one that is considered artistic, and still the pupil might really prefer to see the pictures in the* Police Gazette" (p. 501).[11] This possibility threatened the validity of the *McAdory Art Test* as well as similarly conceived and constructed tests such as the *Meier-Seashore Art Judgment Test.* While these tests ask students to select the example they prefer or *"like best,"* and rank the remaining examples in descending order from there, it is possible instead to rank the examples in the order one believes is correct (and not exercise personal preference at all). Carroll (1933) raised additional issues with the *McAdory Art Test* and the *Meier-Seashore Art Judgment Test* in reporting a very low correlation between students' scores on the tests and their teachers' ratings of the students' artistic ability. In addition to these concerns, researchers

and teachers who used the *McAdory Art Test* with students from outside White, European American cultures also reported content validity problems. Steggarda (1936) used the test with Navajo children and called into question its assumptions about what constitutes universally 'good' design, given culturally specific artistic traditions.[12] But in spite of these issues, the *McAdory Art Test* was received with generally positive response in the field (Meier, 1941; Ziegfeld, 1941). While Tyler (1930) wrote early on that the test *"would be useful in providing a measure for the development of pupils' judgment of artistic merit"* (p. 502), Ziegfeld (1941) later wrote that the *"McAdory Art Test measures well what it measures, but it is not certain what this trait is"* (p. 141).

A constantly shifting consensus of artists and designers, educators, and critics, along with tastes relative to time and sociocultural experience, and a seeming conflation of judgment (goodness) and taste (preference) highlight both the early challenges of art testing and the enduring problems in quantifying artistic and aesthetic production and sensibilities today. Seen in light of our own standardized testing culture in schools and considering the absence of any widely accepted, standardized test of aesthetic judgment—or any widely adopted test of any aspect of art practice—McAdory's work can be seen as groundbreaking. While the *McAdory Art Test* is no longer in use today, no art tests have been developed since McAdory's time that instill broad confidence in their ability to quantify essential aspects of creating and judging the merit of works of art and design. McAdory's bold and singular work should spur art educators and researchers to take up new and current questions around evidence-based teaching and learning in the visual arts. Circling back on questions I posed at the beginning of this chapter and expanding them as provocation for future research: What makes one composition or design better than another, and who gets to make this pronouncement? How do people develop ways of judging goodness or rightness in their aesthetic choices? Is broad consensus about goodness in art and design even possible, or desirable? How might these questions inspire the work of students and teachers in diverse art learning contexts?

References

Bamossy, G., Scammon, D., & Johnston, M. (1983). A preliminary investigation of the reliability and validity of an aesthetic judgment test. *Advances in Consumer Research, 10,* 685-690.

Blake, E. M. (1919). The necessity of developing the scientific and technical bases of art. *The Art Bulletin, 2*(1), 31-38.

Bonser, F. G. (1914). The industrial arts in the elementary school. *School Arts, 13*(3), 183-186.

Bonser, F. G. (1922). Industrial arts as a factor in the education of the citizen. *Teachers College Record, 23*(2), 121-125.

Carroll, H. A. (1933). What do the Meier-Seashore and the McAdory art tests measure? *The Journal of Educational Research, 26*(9), 661-665.

Christensen, E. O., & Karwoski, T. F. (1926). A test in art appreciation. *Art Psychology Bulletin, 3,* North Dakota University.

Clark, G. (1987). Norman C. Meier: A critique of his tests and research. In G. Clark, E. Zimmerman, & M. Zurmuehlen (Eds.), *Understanding art testing* (pp. 46-59). Reston, VA: National Art Education Association.

de Wolfe, E. (1913). *The house in good taste.* New York, NY: Century.

Dow, A. W. (1899). *Composition: A series of exercises selected from a new system of art education: Part 1.* New York, NY: Baker and Taylor.

Dow, A. W. (1908). *The theory and practice of teaching art.* New York, NY: Columbia University Press.

Eastlake, C. (1878). *Hints on household taste in furniture, upholstery, and other details* (4th ed.). London, UK: Longmans, Green.

Fechner, G. T. (1876). *Vorschule der aesthetik.* Leipzig, Germany: Beritkopf & Haertel.

Feldman, J. R. (2002). *Victorian modernism: Pragmatism and the varieties of aesthetic experience.* Cambridge, UK: Cambridge University Press.

Goodenough, F. (1926). *Draw-a-man test.* New York, NY: World Book.

Graves, M. (1939). What is your I.Q. in design? *Art Instructor, 4*(1), 11-14.

Kline, L. W., & Carey, G. I. (1922). *A measuring scale for freehand drawing.* Johns Hopkins University Studies in Education, 5a. Baltimore, MD: Johns Hopkins University Press.

McAdory, M. (1929a). *The construction and validation of an art test* (Doctoral dissertation). Teachers College, Columbia University, New York.

McAdory, M. (1929b). *The McAdory art test.* New York, NY: Teachers College, Columbia University.

McCarty, S. A. (1924). *Children's drawings: A study of interests and abilities.* Baltimore, MD: Williams and Wilkins.

Meier, N. C. (1941). McAdory art test (Review). In O. K. Buros (Ed.), *The 1940 mental measurements yearbook* (p. 146). Highland Park, NJ: The Mental Measurements Yearbook.

Meier, N. C., & Seashore, C. E. (1929). *The Meier-Seashore art judgment test.* Ames, IA: Bureau of Educational Research and Service, University of Iowa.

Morris, W. (1897). *The art of William Morris.* London, UK: Bell and Sons.

Naylor, G. (1971). *The arts and crafts movement: A study of its sources, ideals, and influence on design theory.* Cambridge, MA: MIT Press.

Pintner, R., & Paterson, G. G. (1917). *Pintner-Paterson performance test series.* Chicago, IL: C. H. Stoelting.

Redensek, J. (2011, March). Art is good for nothing. Paper presented at the Art as a Way of Knowing conference of the Exploratorium, San Francisco, CA.

Seashore, C. (1929). Meier-Seashore art judgment test. *Science (New Series), 69*(1788), 380.

Siceloff, M. M., Woodyard, E., & Staff of the Division of Psychology, Institute of Research (1933). *Validity and standardization of the McAdory art test.* New York, NY: Teachers College, Columbia University.

Sparke, P. (2010). *As long as it's pink: The sexual politics of taste.* Halifax, Nova Scotia: The Press of the Nova Scotia College of Art and Design.

Steggarda, M. (1936). The McAdory art test applied to Navajo children. *Journal of Comparative Psychology, 22*(2), 283-285.

Steggarda, M., & Macomber, E. (1938). A revision of the McAdory art test applied to American Indians, Dutch whites, and college graduates. *Journal of Comparative Psychology, 26*(2), 349-353.

Thorndike, E. L. (1916). Tests of esthetic appreciation. *Journal of Educational Psychology, 7*(10), 509-522.

Tyler, R. (1930). The construction and validation of an art test by Margaret McAdory (Review). *Educational Research Bulletin, 9*(17), 501-502.

Varnum, W. (1995). *Arts and crafts design.* Layton, UT: Gibbs Smith.

Waters, S. (2014). *The paying guests.* New York, NY: Riverhead Books.

Wygant, F. (1959). *A history of the Department of Fine and Industrial Arts of Teachers College, Columbia University* (Doctoral dissertation). Retrieved from http://pocketknowledge.tc. columbia.edu/home.php/viewfile/10782

Ziegfeld, E. (1941). McAdory art test (Review). In O. K. Buros (Ed.), *The 1940 mental measurements yearbook* (pp. 146-147). Highland Park, NJ: The Mental Measurements Yearbook.

Zimmerman, E. (1987). Norman C. Meier's story of frustrations and accomplishments. In G. Clark, E. Zimmerman, & M. Zurmuehlen

(Eds.), *Understanding art testing* (pp. 19-26). Reston, VA: National Art Education Association.

Zurmuehlen, M. (1987). Questioning art testing: A case study of Norman C. Meier. In G. Clark, E. Zimmerman, & M. Zurmuehlen (Eds.), *Understanding art testing* (pp. 60-67). Reston, VA: National Art Education Association.

Endnotes

[1]Margaret McAdory was born in Alabama in 1891. Prior to her studies at Teachers College, where she received her doctorate at the age of 38, she worked at State Teachers College in Harrisburg, Virginia. There, McAdory developed and field-tested early aesthetic judgment test problems that led to her development of the *McAdory Art Test* at Teachers College (McAdory, 1929a). She married Louis Siceloff between her graduation in 1929 and 1933 when she co-published, as Margaret McAdory Siceloff, *Validity and Standardization of the McAdory Art Test*. A 1940 census showed her living in Manhattan, although there is no record of her publishing anything after 1933.

[2]According to Wygant (1959), all doctoral students at Teachers College during that time were majors in educational research, regardless of their disciplinary specialty.

[3]In addition to predicting art aptitude, McAdory (1929a) also expected the test to measure student learning and achievement. She hoped the test would *"[prove] that there is growth in the power to distinguish fine from poor examples"* and that *"some of the characteristics of this growth could be learned and the results of art training measured"* (p. 1).

[4]A number of drawing tests were also developed during this time, including the *Kline-Carey Measuring Scale for Freehand Drawing* (Kline & Carey, 1922), Goodenough's (1926) *Draw-A-Man Test*, and the *McCarty Drawing Scales* (McCarty, 1924).

[5]For an absorbing and illuminating literary depiction of bourgeois home decorating at the beginning of the 20th century, see Sarah Waters' (2014) *The Paying Guests*.

[6]Dow, in partnership with Ernest Fenellosa, is widely credited with developing and popularizing the first elements and principles of design or composition in the United States.

[7]Dow published his landmark work on formalist elements and principles in the books *Composition* (1899) and *The Theory and Practice of Teaching Art* (1908).

[8]McAdory referenced both Dow's early publication *The Theory and Practice of Teaching Art* (1908) and his earlier book *Composition* (1899). In developing the test content, McAdory (1929a) described line as *"an element which gives definition to forms, composing the contours and shapes of objects and the breaking up of spaces and varied arrangements of parts of a whole"*; *"dark and light"* (Dow's *notan*) as *"an art element that has to do with the use of amounts and distribution of black and white and all transitional values of light and dark"*; and color as *"derived from light, having to do with hues of red, yellow, green, blue, and purple, and all intermediate hues in various value of light and of degrees of chroma"* (p. 5).

[9]McAdory's test also differed from the *Meier-Seashore Art Judgment Test* published in the same year. Both tests used Thorndike's approach of rank ordering multiple versions of a subject from best to worst, but the *McAdory Art Test* used subjects and items from everyday life while the *Meier-Seashore Art Judgment Test* used works of art.

[10]This example is not one of the final items contained in the *McAdory Art Test.*

[11]Tyler (1930) also questioned the accuracy of the scoring method, stating that a test taker could correctly identify the descending order of several of the illustrations in an item without ranking them in total from best to worst; in this case, the score would be 0.

[12]Steggarda and Macomber (1938) revised the test in an effort to make it more relevant for Native American students.

Chapter 6

THE LIFE AND WORK
OF HELEN GARDNER

Kirstie Parkinson

Helen Gardner is listed as the primary author for the first four editions of *Art Through the Ages*, even though she only lived to see the first two editions of the book published. She was born on March 17, 1878, in Manchester, New Hampshire, to Martha W. (Cunningham) Gardner of Swanville, Maine, and Charles Frederick Gardner, of Hingham, Massachusetts. She had two older sisters, Effie and Louise (Kader, 2000). When Helen was 13, she and her family moved to Chicago, Illinois. This was the place Gardner would forever call home.

School was a very strong learning experience for Gardner in many ways. According to the 1901 *Cap and Gown*, Gardner spent her undergraduate years at the University of Chicago. When she entered the school in 1897, she was awarded the Entrance Scholarship. As a senior, she lived in Spelman House, was Treasurer of the Young Women's Christian Association (YMCA), and served on the Executive Committee of the Senior Class. She graduated in 1901 with an A.B. degree with honors in Latin and Greek. Harold Allen, a former colleague and friend of Gardner, stated in an interview conducted by Sarah Tormollan in 1994:

> *When she first went to college she had studied Latin and Greek upon layers and layers of English. But when she went back after she decided to be an art historian, she studied Italian because she knew she couldn't get along without it. (p. 80)*

After graduation in 1901, Helen Gardner became a teacher at the Brooks Classical School, and eventually the assistant principal there from 1905-1910 (Brzyski, 2007, p. 210; Kader, 2000, p. 165). The Brooks Classical School first opened in 1890 on Adams Street in

downtown Chicago (Myers, 1908, p. 81). Gardner continued her
involvement with the University of Chicago when, in 1906, she was
part of the committee that helped with Alumni Day for the June 9,
1906, convocation. During her lifetime, Gardner lived on 5749 Dor-
chester Avenue, which was less than half a mile from the University
of Chicago: she seemed to have been well connected to this univer-
sity in ways that were both social and geographic. Gardner had a
strong dedication to the educational institutes with which she was
affiliated throughout her life.

As he spoke about his life in Tormollan's interview, Harold Allen
provided many statements about Gardner. He claimed that her
travels in the early 1900s directly affected why she decided to write
and teach about art history:

> *Something happened that made her want to not
> teach anymore [at the Brooks Classical School]
> but the visit to Europe and to collect photographs
> and to write about art. . . . She must have got in-
> terested in art while she was teaching. That must
> be what made her stop teaching and do these oth-
> er things. . . . I don't know whether it was a per-
> son or something in herself or what. She certainly
> had a talent for it, but it makes a combination of
> talent to do what she did. I don't think you can
> overestimate how important what she learned
> about how to write was to her. . . . I have heard
> her speak of going to Europe, and I think Egypt
> was included both times. A couple of times she
> went with her mother. Her sister Louise was al-
> ways resentful of the fact that she had to stay
> home and take care of her house. (Tormollan in-
> terview, 1994, pp. 120, 230, 229)*

In 1915, Gardner became a graduate fellow in the Department of
Art History at the University of Chicago. This department was first
established at the University of Chicago in 1902. According to re-
searcher Barbara Jaffee (2007), the offerings by the Department of
Art History were varied:

Early offerings in art history at Chicago drew on faculty whose primary appointments were with other departments, notably archaeology and the Semitic languages and literature. They also included courses on "modern art" of the Renaissance and after, and American art taught by George B. Zug. (p. 211)

The subject of art history was being established as a professional area of study during the early 20th century. In the 1996 book *The Early Years of Art History in the United States: Notes and Essays on Departments, Teaching, and Scholars*, Craig Hugh Smyth and Peter M. Lukehart discussed the origins of academic art history study in America and provided an overview of major figures who contributed to teaching art history. The authors claimed that the first actual classes in art history began in Princeton, New Jersey, in 1912. Helen Gardner initiated her education in languages, and returned to the University of Chicago to study art and Italian. Themina Kader (2000) has suggested that Gardner returned because she was influenced by the emphasis that was placed on art at the Brooks Classical Institute and by her travels with her mother. I believe that Gardner's love of art history occurred not only for these reasons, but also because of her time in the Department of Art History and her interests in aesthetics.

Gardner spent two years studying at the University of Chicago during the exciting emergence of the Department of Art History. In her coming back for study, *"After more than a decade of teaching, Gardner returned to the University of Chicago, where she received a Master's Degree in art history in 1917. Her thesis was entitled* A Critical Chart of Florentine Painting of the Fifteenth Century" (Kader, 2000, p. 165). According to university records, Gardner continued to be involved with the University and was awarded fellowships in 1917 by the Department of Art History to pursue her Ph.D. in art history. Gardner continued to take art history courses until 1922, but never completed her doctoral degree. As she began her tenure teaching in 1920, Gardner was involved in developing her own theories and techniques about teaching art history. By 1922, she had realized that the ideals of teaching about art through chronology, date identification, and noted artistic masters, as was done at the University of Chicago (Tormollan interview, 1994, p. 417), was

not the way she believed art history should be taught. Teaching the idea of aesthetics as a universal possibility (Tormollan interview, 1994, p. 415) to her students became a critically important goal for Gardner.

For example, Gardner instructed her students in her History of Art class to go to the Field Museum and search throughout its galleries to find objects that piqued their interest. She wanted her students to locate works there that they found intriguing, rather than just identify works she told them were important to know. Obviously, in her book and during her classes, Gardner included the names and dates of artists, along with very popular works of art, but she wanted the study of art history to go beyond the memorization of particular art works, as Harold Allen indicated in the 1994 Tormollan interview: *"Helen Gardner said that—the very first day I was in school she said that they wouldn't put much emphasis on dates and names"* (p. 438). From the start of the class, it was clear to her students that Gardner was most interested in how they understood the art, not how they memorized facts and dates. Gardner then motivated students to make and support their own beliefs and identify why some works of art from the Western world and beyond were viewed as aesthetically pleasing, while others were not.

Gardner became the first hired art history professor at the School of the Art Institute of Chicago. Kader (2000) noted that *"in the autumn of 1920 she inaugurated an art history lecture course called 'Survey of Art' at the School of the Art Institute of Chicago"* (p. 165). Tormollan (1994) wrote that any studies of art *"were not organized into a regular course"* (p. 121) until Gardner began teaching there. In 1926, Gardner published the first edition of *Art Through the Ages*.

The School of the Art Institute of Chicago was established in 1866 and founded as the Chicago Academy of Design. The 35 founding artists of the Academy intended to run a free school with its own art gallery. Six years later, the school assembled its first collection of art objects. In 1882, the name was changed to the Art Institute of Chicago to accommodate a distinct museum and school.

Gardner spent nearly her entire professorial life at the School of the Art Institute of Chicago. In 1919, she was appointed head of the Photography and Lantern Slide Department in the Ryerson Library at the Art Institute of Chicago, and taught there from 1920 to 1943. Similar to her continual strong bond to the University of Chicago, Gardner was passionately dedicated to the Art Institute of Chicago through her position as a faculty member. She was continually

willing to help students and other faculty members at the school, as Gardner, according to Harold Allen, *"was always working on projects, some of which involved other teachers. . . . I never heard of anybody who didn't [like her]"* (Tormollan interview, 1994, p. 88). Gardner was involved in one of the earliest classes with art history Ph.D. candidates at the University of Chicago, and became the first hired art historian at the School of the Art Institute of Chicago. This engagement reflected Gardner's passion for excellence, and her ground-breaking performance continued to push the professional boundaries of her work throughout her career and life. Gardner's unique teaching and writing style made both her and her books popular. According to Harold Allen, Helen Gardner was esteemed by all she met:

> *She was a small woman with brown hair. . . . And she wore pince-nez glasses. . . . She had a very good speaking voice, very clear and friendly and enthusiastic. I think the one thing that made her writing so successful for so long is that it was friendly and enthusiastic and clear. I once heard her say that the thing she valued most when she was writing was clarity. . . . she never tried to awe people or use words that would show that she went through high school. (Tormollan interview, 1994, pp. 79-80)*

Helen Gardner was particularly close with two students who became faculty members: Harold Allen (1912-1998) and Kathleen Blackshear (1897-1988). In his long, detailed, and unpublished interview about his life, Allen gave Tormollan an unprecedented look not only into his own activities and experience, but also those of Helen Gardner. As her student after 1936, Allen claimed that Gardner taught him using the second edition of *Art Through the Ages*.

Allen was the first teacher of photography as fine art at the School of the Art Institute. He taught there on two separate occasions, from 1948 to 1960 and from 1966 to 1977. Not only was Allen a close friend and student of Helen Gardner, but he was also editor of the third edition of *Art Through the Ages,* which was published in 1948 (Tormollan interview, 1994, p. 567). Allen gave many accounts of Gardner in different publications and interviews.

At the time she taught at the Art Institute of Chicago, Gardner also connected with artist Kathleen Blackshear. One of Blackshear's early teachers was Gardner, who stimulated her interest in Asian and African art subjects. In 1926, Blackshear was hired to teach art history under Gardner's direction, and the two women formed a close relationship that lasted until Gardner's death in 1946. Both women took their students to the Oriental Institute and the Field Museum of Natural History, thus affirming the value of African and Asian art at a time when non-Western art was usually studied from an anthropological viewpoint (Curlee, 2010).

Gardner struggled with breast cancer toward the end of her life and eventually succumbed to bronchopneumonia on June 4, 1946 (Kader, 2000). During her lifetime, Gardner was a *"woman who was extremely dedicated to what she had identified as her main interest in life"* (Kader, 2000, p. 166), which was the study of art history. The first two editions of her book *Art Through the Ages* (1926, 1936) were the only two editions that Gardner lived to see published.

Only six years after Gardner began teaching at the School of the Art Institute of Chicago, she published her first book *Art Through the Ages*. As the author, she effectively propelled herself into the early and noteworthy group of newly formed publishing art historians in America. It is most likely that Gardner began writing this book as early as 1920 when she initiated work on a book that she could use in teaching her art history class.

Gardner taught and wrote during an exciting period of American history—the Roaring Twenties. During this time, women were granted the right to vote with the 19th Amendment to the Constitution, World War I had recently ended, and jazz emerged for the mainstream public. All these successes were abruptly halted by the stock market crash of 1929 and the Great Depression that followed. Gardner wrote and published her first book in 1926, at the pinnacle of American post-war opulence and success.

The School of the Art Institute of Chicago was also in a soaring position during the 1920s. At this time, the school was actively evolving into a center for great young artists and had an impressive art collection. Charles Hutchinson was president of the Art Institute's Board of Trustees until his death in 1924. He believed the Art Institute was a place not only for collecting great artworks, but *"a tool of social reform and improvement"* (Art Institute of Chicago Museum Studies, 1992, p. 6). The school was rapidly expanding its collection. One of its most important donations came from Frederic Clay Bar-

tlett (1873-1953) and his second wife, Helen Birch Bartlett (1883-1925) (http://www.artic.edu/research). In 1920, Bartlett became a trustee of the Art Institute and began generously donating to this institution. The couple traveled frequently to Europe and acquired paintings by Paul Cézanne, Paul Gauguin, Vincent van Gogh, and Henri de Toulouse-Lautrec, as well as important works by other modern masters such as Pablo Picasso and Henri Rousseau. One of the many significant works they donated was Georges Seurat's *Sunday Afternoon on the Island of La Grande Jatte* (Interpretive Resource). The Art Institute was rapidly gaining stunning works of art throughout the 1920s, which enabled Helen Gardner to teach from the Institute's very own resources (Exhibition History, 1934).

Gardner's life was a balancing act of scholar and educator. As she rose in the academic ranks as an undergraduate and a graduate student, Gardner was determined to learn what she thought would best serve her needs as a scholar. Although she had settled into a role of educator at The Brooks School, she soon left, perhaps not because she wanted to but because she knew that she needed to leave in order to become a more robust scholar. As Allen suggested in his interview, Gardner's painstaking attention to detail was both her greatest strength and her greatest weakness. Barbra Jaffee (2005), a modern, well-known researcher of Helen Gardner, stated her opinion of the first edition of *Art Through the Ages* in her paper "Before the New Bauhaus":

> *Though later formalists would seek to isolate and divide the products of visual culture into decorative or expressive, popular or avant-garde, and to provide access to them only through cryptic directives and appeals to higher authority, Gardner strove to integrate all the arts in her discussion (including those to which she referred quaintly as "minor"), and to provide clear methods for their appreciation and understanding. The first two editions of Art Through the Ages were admirable though hardly unconventional attempts to survey the world history of art in a single volume for the interested general reader. (p. 56)*

In the preface to her 1926 edition of *Art Through the Ages,* Gardner suggested that this book would prove useful for students of the Institute as well as of the world:

> *The material as here presented has been developed from the History of Art course given in the School of Art of the Art Institute of Chicago; and while the book has been written primarily for an introductory course in educational institutions, it is hoped that it will prove useful also for the general reader and traveler. (p. iii)*

In other written reviews, opinions of the book are similar. Gardner's ability to condense into readable form many thousands of years of art historical information is laudable. Her past helped shape the way this first edition of the textbook was written. Although several texts were available at the time for her to use, she could not find one that suited her needs when she began teaching her survey of art history course "Art Through the Ages" in 1920. By 1926, the year Gardner's book appeared, the School's catalogue was describing art history in unabashedly compensatory terms: it was *"an intensive study of certain phases of art so presented as to be of particular value to students as their training becomes more specialized"* (Jaffee, 2005, p. 55).

Bound in navy blue with glistening gold lettering and a flying crane adorning the cover page, Gardner's first edition of *Art Through the Ages* was published in New York by Harcourt, Brace, and Company. Art history students at the School of the Art Institute of Chicago likely walked in that first day of class in the Fall of 1926 clutching this small, 506-page book (5.5" x 8" x 2") and not perceiving in any way Helen Gardner's forthcoming legacy that continues today. This is one of the most popular art history textbooks ever sold, with many differences that set her textbook apart from others, including image quality and content selections.

While studies of ancient Greece, Impressionism of the 20th century, or the 'great masters' from Italy and France were commendable art history subjects to write about, Helen Gardner pushed the limits in her textbook of what subjects of art history should be considered important to teach to students of art and art history. Opening to the first page on the left, the viewer encounters a full-page,

colored image of a life-sized bust of 'Queen Nofretete.' By using this Egyptian image, Gardner is acknowledging that her travels to Egypt may have triggered her increased interest in art history. This image is perhaps a 'thank you' to the art and people who initiated her lifetime of engagement with art history. This bust of Nofretete is the only image reproduced in color in the book. In 1926, Gardner wanted to make sure any reader who opened her book would quickly realize that this journey into the collection at the Art Institute and art history would be vastly different from any other travels into art history.

Gardner's textbook *Art Through the Ages* continues to be one of the most popular art history textbooks in use today. The contract with her publisher required that she write a new edition every 10 years, and she did complete a second edition in 1936. Shortly after her second edition was released, Gardner was diagnosed with cancer and died prior to the publication of the third edition. Today, this textbook continues to shape and educate students in learning art history throughout the world. Gardner's essential textbook is a reminder that we must continue to study not only the history of art, but the lives of those who write the history of art because they are the ones who shape it for future generations.

References

Alumni Day at the Fifty-Ninth Convocation at the University of Chicago. (1906). *University Record, 11*(1), 34.

Art Institute of Chicago Museum Studies. (1992). Photographs of the Art Institute of Chicago, 1893-1933. *Art Institute of Chicago Museum Studies, 19*(1), 5-29. Retrieved March 29, 2014, from the JSTOR database.

Brzyski, A. (2007). *Partisan canons.* Durham, NC: Duke University Press.

Curlee, K. (2010, June 12). Blackshear, Kathleen. *Handbook of Texas online.* Retrieved June 29, 2014, from http://www.tshaonline.org/handbook/online/articles/fbl72

Exhibition History. (1934). The Art Institute of Chicago. Retrieved March 28, 2014, from http://www.artic.edu/research/1934-exhibition-history

Gardner, H. (1926). *Art through the ages.* New York, NY: Harcourt, Brace & Company.

Gardner, H. (1936). *Art through the ages* (2nd ed.). New York, NY: Harcourt, Brace & Company.

Jaffee, B. (2005). Before the New Bauhaus: From industrial drawing to art and design education in Chicago. *Design Issues, 21*(1), 41-62. Retrieved August 18, 2014, from the JSTOR database.

Jaffee, B. (2007). "Gardner" variety formalism: Helen Gardner and *Art Through the Ages.* In A. Brzyski (pp. 203-223). *Partisan canons.* Durham: NC: Duke University Press.

Kader, T. (2000). The bible of art history: Gardner's *Art Through the Ages. Studies in Art Education, 2*(41), 164-177.

Myers, H. (1908). *College and private school directory of the United States* (2nd ed.). Chicago, IL: Educational Aid Society.

Chapter 7

UNCOVERING HIDDEN HISTORIES: AFRICAN AMERICAN ART EDUCATION AT THE HAMPTON INSTITUTE (1868-1946)

Jessica Baker Kee

Art education in the United States has recently expanded to include multicultural and culturally responsive approaches to curriculum, yet the contributions of communities of color remain underrepresented in historical accounts of the field's origins. For example, the introductory chapter of my master's-level art education history textbook stated: *"Western culture dawned in Greece, and her great philosophers, Plato and Aristotle, wrote not only about education but also about the place of the arts within it; thus the story of art education begins here"* (Efland, 1990, p. 8). Such assertions may unintentionally reinforce Eurocentric perspectives and marginalize *other* histories as 'special topics' or perfunctory add-ons to a 'mainstream' art education history implicitly marked as Western, White, and middle class. Other studies found similar results across texts. Grant and Kee (2013) analyzed Western art survey textbooks and identified underrepresentation and tokenism as major concerns with representing African American artists and art movements. Brown and Au (2014) focused more broadly on U.S. curriculum studies history in their critical review of synoptic texts and edited collections, identifying a 'metanarrative' centering on Whiteness and excluding communities of color from mainstream historical accounts; *"despite the expansion of curriculum studies to include a wider range of politics, cultures, and viewpoints . . . communities of color are notably absent from the typical narrative of the founding of the field"* (p. 365). Since the 1960s, many historical accounts have moved away from such grand narratives solely discussing 'key figures' and mainstream movements to address the social and cultural

impacts of art education; however, understanding in the field of how diverse communities responded to, were affected by, and influenced curriculum, pedagogy, and policy in every era remains incomplete (Burke, 2001b; Chalmers, 2004; Cox, 2007).

This marginalization also appears in the histories of Viktor Lowenfeld, widely described as one of the most influential figures in 20th century art education (Lowenfeld & Michael, 1982; Smith, 1996). Accounts tend to focus on his developmental stage theories of art and overlook the groundbreaking theories of social justice persistent throughout his writings, influenced by his experiences as a Jewish scholar in Nazi-era Austria and at a pre-Civil Rights era, historically Black and Indigenous institution (Edgcomb, 1993; Holt, 2012; Kee, 2013). Furthermore, accounts of Lowenfeld's scholarship at the Hampton Institute tend to focus solely on its impact on his foundational text *Creative and Mental Growth* (1947) rather than contextualizing it within the Institute's rich intellectual tradition of Black aesthetic and narrative histories.

Acuff, Hirak, and Nangah (2012) described the long-standing tendency of historical scholarship to develop linear *"Master Narratives,"* which offer people of color *"an explicit, single entry point"* into the history of art education (p. 7). Multiculturalism has been incorporated into curriculum since the 1980s, but art education scholars have criticized approaches that merely celebrate 'diversity' while ignoring the disparate impacts of institutional racism and classism on understanding how communities of color were historically granted or denied access to art education (Bailey & Desai, 2005; Desai, 2005; Desai & Chalmers, 2007). There is a need for research that more deeply examines how the policies and theories developed by major figures and movements affected (and were themselves impacted by) their practice in diverse communities of learners.

Bolin, Blandy, and Congdon (2000) identified this need and advocated for more historical research uncovering hidden and marginalized narratives in order to challenge ethnocentric master narratives of art education history. This chapter addresses their call by employing historical research and visual analysis to complicate master narratives about Lowenfeld's work at the Hampton Institute—a period of time that merits only brief mention in many accounts of his career in art education texts, despite its profound impact on his American scholarship (Hollingsworth, 1990; Holt, 2012). In this research, I examine the historical intersections of art education

theory, African diaspora art, and African American folkloric history at the Hampton Institute in Virginia from the late 19th century leading up to Lowenfeld's tenure as professor and curator (1939-1946) in order to understand more deeply an underrepresented aspect of American art education. I argue for the centrality of the work of African American students and faculty within the field's earliest origins, and suggest the need for interdisciplinary scholarship to reconstruct other marginalized and excluded narratives to provide a more complex and nuanced understanding of art education history.

Methodology

Bolin et al. (2000) have asserted that "there is no single 'history' of anything; history is multi-dimensional and interpreted from many and often obscure experiences from the past" (p. 2). For this study, I first reviewed existing literature discussing Lowenfeld's work at the Hampton Institute, positioning his contribution as part of an ongoing institutional tradition of aesthetic and cultural education rather than discussing it as an isolated historical intersection. I also examined the earlier work of the Hampton Folklore Society to collect and preserve aesthetic epistemologies of the African diaspora, recontextualizing Lowenfeld's work into a longer history of African American scholarship at Hampton and challenging suggestions that he introduced such scholarship or exposed Hampton's students to African and African American aesthetics for the first time. In addition to exploring Lowenfeld's impact on Hampton, I also assessed Hampton's influence on Lowenfeld and the instrumental roles its African American community played in developing his scholarship.

Next, I conducted archival research at Penn State University Special Collections, which holds many of the student artwork and drawing exercises Lowenfeld brought with him from Hampton. I also examined images of student artwork from the Hampton University archives, which Dr. Ann Holt helpfully shared with me from her own archival research. Historian Peter Burke (2001a) argued that far beyond merely illustrating textual knowledge, archival images can fill gaps in our historical texts: "The testimonies about the past offered by images are of real value, supplementing as well as supporting the evidence of written documents. . . . Their testimony is particularly valuable in cases where texts are few and thin" (p. 184). In this case, archival images of Hampton students' artwork help to enrich and complicate our sparse textual understandings of how Lowenfeld spent his tenure there (1939-1946), deepening our

knowledge of his early career and the influence of Hampton's African American community on his foundational scholarship. Collier (2004) described the direct analysis of artistic and photographic images as a method derived from visual anthropology to "examine the content and the character of images as data" (p. 38). Direct analysis is a multistage process that involves first observing the images to discover patterns and emergent questions; then, using these questions to structure analysis and produce detailed descriptions; and finally, contextualizing information gathered from the images to develop new understandings about the research topic. Through a discussion of existent historical (textual) research and archival (visual) images of African American art education at Hampton Institute, I argue for the recognition of marginalized art education histories as both central and vital to the field's historical development.

Historical Discussion

African American Art Education at the Hampton Institute (1868-1939)

The story of art education at the Hampton Institute mirrors the broader narrative of art education in the late 19th century United States after the Civil War, when policymakers advocated industrial and vocational training as a form of human capital development to build a working-class labor force characterized by *"industrious habits, docile temperaments, and useful skills"* (Stankiewicz, 2001, p. 46). Such training was heavily promoted among Black, Indigenous, and immigrant communities, both to indoctrinate them into mainstream Protestant American values and to prepare them for low-paying manual and industrial labor. Institutions catering to these demographics offered mechanical, mathematical, and map-drawing courses, but fine arts, art history, and studio education were limited to the wealthier classes.

The Hampton Normal and Agricultural Institute, founded by the American Missionary Association in 1868, helped to pioneer this pedagogical model. Although it first enrolled African American students seeking vocation in the racially volatile post-Reconstruction South, it began accepting Native American students in 1877 after the Western Indian removal project. Hampton students received education focused on social accommodation and industriousness: *"The goal of the new institution was to prepare teachers,*

farmers, and mechanics, rather than liberally educated professionals and leaders" (Stankiewicz, 2001, p. 50). Co-founder Samuel Chapman Armstrong based the Hampton model on his father's colonial missionary work in Hawai'i, which stressed the necessity of industrial education *"as a means of instilling Protestant values in non-Western populations"* (Moody-Turner, 2013, p. 49). While the Hampton Institute was designed to erase Black and Native American aesthetic and cultural traditions and replace them with those of middle-class White Americans, it instead served as an intellectually fertile ground for the historic preservation of these traditions.

The Hampton Folklore Society, founded by instructors and students in 1893 as the first African American folklore society in the country, was largely responsible for this initial effort and represented *"a story about modes of resistance and agency within the dynamics of asymmetrical power relations"* (Moody-Turner, 2013, p. 46). Teachers, alumni, and students engaged with local Black communities to collect conjure narratives, folktales, courtship stories, slave spirituals, and religious songs, amassing a wide variety of African American aesthetic narratives and genres (Waters, 1983). These resources were widely circulated in the popular "Folk-Lore and Ethnology" column of the *Southern Workman*, a journal published by the Hampton Institute from 1872 to 1939. Armstrong supported the society's efforts to expose what he viewed as the 'primitive' superstitions of conjure narratives, gauge the relative moral progress of African Americans enrolled in his institution, and encourage Black students to critique and ultimately dismiss the traditions of their own rural cultural heritage through rigorous intellectual scrutiny. Perhaps ironically, the efforts of the Hampton Folklore Society (and their warm reception from the American Folklore Society) instead created a surge of public interest in traditional Black folklore and narrative traditions that continued well into the 1940s (Chireau, 2003). Thus, African American students at the Hampton Institute had already developed a rich history of Black aesthetic and cultural research and curation that predated Lowenfeld's arrival by over half a century.

Faculty at the Hampton Institute also established a collection of African art in 1868 that became the earliest and one of the most comprehensive permanent collections of any historically Black college. This collection represented a rare and valuable pedagogical resource, enabling students to study both the aesthetic aspects of the objects and their ceremonial cultural meanings. While art edu-

cation texts imply the collection was neglected until Lowenfeld arrived at Hampton (Smith, 1988), other historical research has suggested their continued usage as a pedagogical resource (Coleman, 2010). These efforts place Hampton, in spite of the more repressive impulses of its founders, within the tradition of historically Black American universities as *"the most important institutions contributing to the visualization of African American identity"* (p. 38). Such institutions provided access to African aesthetic traditions countering harmful media stereotypes of African Americans in mainstream visual culture, educated some of the most prominent Black artists and intellectuals in the country's history, and preserved fragile and irreplaceable visual and cultural traditions. They also played an irreplaceable function in educating the freed population post-Reconstruction and preparing them for citizenship (Waite, 2015). While Lowenfeld's work at Hampton was both remarkable and groundbreaking, it must be understood within the historical context of African American aesthetic education that was *already* in process long before his arrival.

Lowenfeld at the Hampton Institute (1939-1946)

As a foundational scholar of 20th century art education, Lowenfeld's tenure at the Hampton Institute from 1939 to 1946 "has been abundantly recognized in African American art history literature . . . [but] largely understated in mainstream art education texts" (Holt, 2012, p. 7). When this period in his career is mentioned, it is often treated as a perfunctory footnote and disconnected from his later scholarly developments at Penn State. However, closer examination reveals its foundational influence on his theoretical and cultural understandings—and thus on broader advancements in the field, because so many other scholars have developed theory based on his work. Born in Austria in 1903, Lowenfeld studied art at the Academy of Fine Arts, the School of Applied Arts, and the University of Vienna. He taught at Hohe Warte Institute for the Blind from 1926 to 1938 before fleeing Austria during Hitler's rise, and teaching at the Hampton Institute from 1938 to 1946, and then at Penn State University from 1946 until his death in 1960. His book Creative and Mental Growth, published in 1947 and now in its eighth edition, laid out a comprehensive working theory of art expression and human development that remains relevant in the field today. Much of the research and teaching groundwork for this text was initiated during his tenure at Hampton.

Having experienced the devastating effects of bigotry in Austria, Lowenfeld was by all accounts horrified by the institutional racism and segregation of the pre-Civil Rights South, and insisted on using non-White facilities in solidarity with his students (Smith, 1988). Although Hampton had no fine arts instruction program, Lowenfeld was permitted to teach a non-credited, uncompensated evening studio art class which soon became very popular, with over 60 students in attendance. His classes also drew mainstream attention, with his students exhibiting work at nationally recognized venues such as the Virginia Museum of Fine Arts and the Museum of Modern Art's Young Negro Art. A number of his students, including John Biggers, Samella Sanders Lewis, Charles White, and Elizabeth Catlett, became highly influential African American artists, and many eventually founded their own art education programs. Lowenfeld was made curator of Hampton's African art collection in 1945, and rather than teaching a standard European fine arts curriculum, he used the collection to introduce students to their own historical heritage and aesthetic traditions. John Biggers poignantly described Lowenfeld's mentorship in this area:

> *In our culture, when black represents something that's terrible and bad and the devil, he picked up these beautiful, these very . . . glistening black things—and started telling us the profound meaning . . . I realized that I had a heritage, an inheritance that I was entirely unaware of before coming there. (Edgcomb, 1993, pp. 98-99)*

Despite Lowenfeld's influence on such major figures in African American art education—and their reciprocal influence on him, his work at Hampton, which comprised one third of his American career, has often been treated as a footnote or piece of trivia (Smith, 1998). In addition, existing scholarship has frequently failed to problematize his contributions at Hampton, or to draw explicit historical connections between Lowenfeld's work in art education and the broader aesthetic and cultural histories of historically Black colleges, thus relegating African American research and scholarship to the margins of art education history. This has led to an excessive paternalism in some accounts (including Lowenfeld's own writings) that portray him as introducing art education to a group of people *devoid* of aesthetic history:

Throughout the short history of Negro Art . . . [it]
was entirely under the influence of the same Eu-
ropean tradition. . . . The Negro at that time was
entirely unaware of his cultural potentialities, of
his rich heritage, that he was completely "hiding"
behind the "superior" white tradition of Art. (Lo-
wenfeld, 1944, p. 20)

In his belief that Black art could achieve an authentic vision only by connecting its lost heritage directly back to African art, it appears Lowenfeld was unaware of existing African American visual traditions at his own Institute and elsewhere. In addition to the extensive research done by the Hampton Folklore Society and other groups dedicated to preserving diasporic aesthetic traditions, Black artists and art educators associated with the Harlem Renaissance and the 'New Negro' art movement (1919-1930) had also developed uniquely African American visual, musical, and artistic sensibilities that went far beyond mere mimesis of the Western art canon.

Perhaps Lowenfeld's exposure to a primarily rural, Southern student community led to the broad, generalized observations about 'Negro art' that appear in his writings. At times he seemed to extend his theory of *visual-haptic* polarity[1] into racial self-consciousness, arguing that *"New Negro Art in its pureness must necessarily be extremely haptic"* (Lowenfeld, 1944, p. 21), and that *"an individual without any restrictions does not know boundaries and his eyes easily can rest on the horizon. The horizon of the sharecropper is his cottonfield, the horizon of a laundrywoman her tub"* (p. 29). This idea of haptic polarity as socially influenced by trauma suggested that Lowenfeld was willing to engage racial issues in his theories of art education, but perhaps lacked access to existing African American art education histories that might have brought greater depth and nuance to his understanding of his students' pre-existing aesthetic and cultural heritage of arts-based critique, preservation, and resistance. An analysis of key images produced by Lowenfeld and his students between 1939 and 1946 revealed both the remarkable strength and potential cultural limitations of his teaching vision.

Visual Discussion

In this section, I analyze several key images from the Penn State University and Hampton University archives that reveal important thematic aspects of Lowenfeld's work with his students, and discuss connections to his ongoing art education scholarship.

In Figure 7.1, a Hampton student works on a mural depicting scenes from Black history. These large-scale monumental murals symbolizing the historical and spiritual struggles of African American people are typical of the work produced by Hampton students under Lowenfeld's mentorship. These murals, most of which no longer physically exist, are preserved in a series of photographic images in both university archives. This mural is stylistically and aesthetically similar to many other murals composed by Lowenfeld's students, as depicted in photographic images in the Penn State and Hampton university archives. Lowenfeld encouraged his students to move away from copying traditional Western-canon aesthetic styles and to develop expressive styles more aligned with his own vision of the 'new Negro art.' In these murals, large groups of African American people are depicted working, living, and struggling for equality in the face of racial oppression in a muscular, visually dynamic style depicting sweeping movement. Note the size of the hands relative to the figure's overall proportions; this emphasis fit well with Lowenfeld's theory of *haptic* polarity, which focused more on subjective, tactile, and relative emphasis rather than on visual accuracy. In this case, the hands, which are tools of freedom and self-determination, are strongly emphasized (Smith, 1998). Thus, these murals display a compelling visual tension in attempting to balance the clear influence of Lowenfeld's unique instructional style with the students' own artistic styles and visions.

Figure 7.1
John Bean at work on his academy building mural (1943)

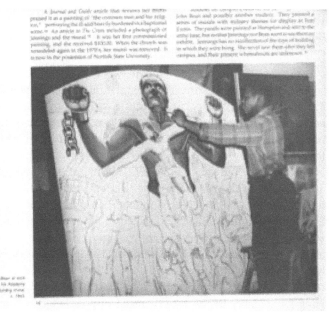

Hampton University archive (Hampton, VA). Reproduced with permission
by Ann Holt.

Another student mural (see Figure 7.2) depicts themes of resis-
tance, racial struggle, and social justice. Although many of Lowen-
feld's students worked in similar styles—large-scale murals depict-
ing African American history in stylized, emotionally expressive
forms—there is evidence that individual students still asserted
agency over their work. Although Samella Lewis spoke of Lowen-
feld's preconceived ideas about what students should do and his
tendency to swamp students' personalities in class with his own
ideas about African American art, she also recalled his increased
respect for her when she held her ground on working in her own
preferred style (Smith, 1988). These accounts suggest a need for
deeper and more sustained research on Lowenfeld's interactions
with students at Hampton, as well as their influence on his later
theoretical developments, to both problematize and centralize this
vital period of cross-cultural interaction within art education history.

Figure 7.2

Detail from unidentified student mural (1940s)

Hampton University archive (Hampton, VA). Reproduced with permission
by Ann Holt.

Shown in Figures 7.3 and 7.4 is an example of sequential drawing
exercises that students at Hampton practiced in order to gain con-
fidence and demonstrate self-expression. Hundreds of these images
are archived at Penn State University, and were carefully labeled on
the reverse side by Lowenfeld himself as he described his students'
progress according to his developmental stage theories. These
drawing exercises were generally executed in a sequential fashion in
a charcoal sketch style on large sheets of butcher paper, and display
a careful building of line and shape over time from simple to more
complex forms. Most of the images are highly *haptic*, with students
expected to first draw broad, sweeping abstract charcoal lines to
develop bodily self-expression, and then slowly evolve into figura-
tive images of rural pastoral scenes depicting the everyday labor
and struggles of ordinary people. A clear aesthetic and visual link is
evident between these initial drawing exercises and the later style,
content, and subject matter of his students' mural paintings.

Figure 7.3

"Climbing" of a motion introduces stronger consciousness of bodily feelings

Penn State University Special Collections (State College, PA). Reproduced with permission by Jessica Baker Kee.

Figure 7.4

Exercises to show drawing development (1944)

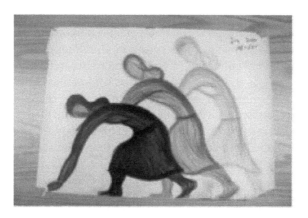

Penn State University Special Collections (State College, PA). Reproduced with permission by Jessica Baker Kee.

While we see a definite style developing here in terms of Lowen-feld's teaching methods, individual students were still able to break away and form their own unique visual styles even as they learned from him. Also apparent are Lowenfeld's developmental stage theories, later explicated in *Creative and Mental Growth* (1947), emerging within these student efforts and suggesting that the work of art students at Hampton University was not marginal but *central* to the early theoretical development of the field. More research into these images is needed in order to understand the full impact of these students' efforts both on Lowenfeld's theoretical orientations and on his influence over the broader field of art education.

Pulling the Margins In

Narratives of African American research and art practice, such as those that emerged from Hampton Institute in the late 19th and early 20th centuries, are too often omitted from mainstream art education histories or relegated to brief marginal asides. However, these overlooked accounts provide compelling information about how sweeping historical reforms such as industrial and vocational education worked 'on the ground'; as well, they reveal the wide-ranging impact these practices had on some of America's most vulnerable communities. Similarly, research around Lowenfeld's influence on art education has often either marginalized his important work at Hampton or decontextualized it from the rich cultural traditions of aesthetic education in historically Black colleges that laid the foundation for his scholarship before he arrived in the United States. Rather than omitting African American and Indigenous contributions to art education history or treating them as 'special topics,' future scholarly research should acknowledge them as vital and foundational to American art education history.

If, as Acuff et al. (2012) contended, mainstream Western art education history has become too 'linear' with too few incomplete spaces for marginal voices to intervene (p. 8), it can also be argued that the art education histories of communities of color are still too fragmented, ephemeral, and marginal within the discourse of our field. There still remains a need for *"historical perspectives on art education that are inclusive of stories, experiences, teaching methods, and cultural groups whose histories have not been fully explored and documented"* (p. 8). Rebuilding these histories, many of which have not been adequately researched in our field, may also require *"opening up a dialogue with individuals from other disciplines,*

especially folklorists" (Bolin et al., 2000, pp. 4-6). It is my hope that this chapter offers a tentative path toward the interdisciplinary dialogues that are needed to fill in the knowledge gaps in our African American art education histories, and set in motion new explorations of people and practices that have been overlooked for too long. It is also important to acknowledge that historical research, when it reinforces singular approaches to history focused on mainstream movements and figures without acknowledging their lived interactions with diverse communities and peoples, can reinforce rather than illuminate these epistemological gaps (Acuff et al., 2012).

In addition, the stories of the students and teachers who worked to preserve African American folk traditions with the Hampton Folklore Society, as well as the art students who sought (along with their mentor Lowenfeld) to reconnect their work with African diasporic art traditions, can also function as *resistance narratives* against the overarching 'Master Narratives' of American art education. Rolling (2011) defined resistance narratives as *"stories from the margins of consideration, stories that erode the center and its certainties—that cause institutional grand narratives to fall apart"* (p. 99); thus, research that engages with such stories *"seeks not to prove or disprove, but rather to create movement, to displace, to pull apart and allow for resettlement"* (p. 99). These resistance narratives will not be developed by following singular and well-trodden paths of art education history scholarship; rather, they will develop new paths through interdisciplinary and cross-disciplinary efforts to reconstruct narratives, theories, and histories of individuals and communities whose voices have not yet been heard in our scholarly discourse. This research represents such an attempt to open up mainstream narratives about 19th century art education, both to enable stories of individual struggle and resistance to enter, as well as to pull at the disciplinary boundaries of art history, allowing other aesthetic traditions such as folklore to enrich its cultural history. It also seeks to complicate the mythologies built up around influential figures such as Viktor Lowenfeld and re-contextualize them as vital yet interconnected components of living, evolving, and history-making communities.

References

Acuff, J. B., Hirak, B., & Nangah, M. (2012). Dismantling a master narrative: Using culturally responsive pedagogy to teach the history of art education. *Art Education, 65*(5), 6-10.

Bailey, C., & Desai, D. (2005). Visual art and education: Engaged visions of history and community. *Multicultural Perspectives, 7*(1), 39-43.

Bolin, P. E., Blandy, D. E., & Congdon, K. G. (2000). *Remembering others: Making invisible histories of art education visible.* Reston, VA: National Art Education Association.

Brown, A. L., & Au, W. (2014). Race, memory, and master narratives: A critical essay on U.S. curriculum history. *Curriculum Inquiry, 44*(3), 358-389.

Burke, P. (2001a). *Eyewitnessing: The uses of images as historical evidence.* Ithaca, NY: Cornell University Press.

Burke, P. (2001b). *New perspectives on historical writing.* University Park, PA: Penn State University Press.

Chalmers, F. G. (2004). Learning from histories of art education: An overview of research and issues. In E. W. Eisner & M. D. Day (Eds.), *Handbook of research and policy in art education* (pp. 11-29). Mahwah, NJ: National Art Education Association.

Chireau, Y. P. (2003). *Black magic: Religion and the African American conjuring tradition.* Berkeley, CA: University of California Press.

Coleman, F. (2010). Black colleges and the development of an African American visual arts tradition. *The International Review of African American Art, 11*(3), 31-38.

Collier, M. (2004). Approaches to analysis in visual anthropology. In T. Van Leeuwen & C. Jewitt (Eds.), *The handbook of visual analysis* (pp. 35-60). London, UK: Sage.

Cox, G. (2007). Some crossing points in curriculum history, history of education and arts education. In L. Bresler (Ed.), *International handbook of research in arts education* (pp. 3-6). Dordrecht, The Netherlands: Springer.

Desai, D. (2005). Places to go: Challenges to multicultural art education in a global economy. *Studies in Art Education, 46*(4), 293-308.

Desai, D., & Chalmers, G. (2007). Notes for a dialogue on art education in critical times. *Art Education, 60*(5), 6-12.

Edgcomb, G. S. (1993). *From swastika to Jim Crow: Refugee scholars at Black colleges.* Malabar, FL: Krieger.

Efland, A. D. (1990). *A history of art education: Intellectual and social currents in teaching the visual arts.* New York, NY: Teachers College Press.

Grant, A. W., & Kee, J. B. (2013). Black artists of the Harlem Renaissance in western survey textbooks: Narratives of omission and re-

presentation. *Visual Inquiry: Learning and Teaching Art, 2*(3), 233-246.

Hollingsworth, C. H., Jr. (1990). *Viktor Lowenfeld and the racial landscape of Hampton Institute during his tenure (1939-1946).* The Pennsylvania State University. Retrieved from http://search.proquest.com/docview/303856512?accountid=13158. (303856512)

Holt, A. (2012). Lowenfeld at Hampton (1939-1946): Empowerment, resistance, activism, and pedagogy. *Studies in Art Education, 54*(1), 6.

Kee, J. B. (2013). Minutes for a meeting that never happened: An imaginary conversation between Viktor Lowenfeld and Miami's Black art educators. Unpublished manuscript, The Pennsylvania State University.

Lowenfeld, V. (1944). New Negro art in America. *Design, 46*(1), 20-21, 29.

Lowenfeld, V., & Michael, J. A. (1982). *The Lowenfeld lectures: Viktor Lowenfeld on art education and therapy.* University Park, PA: The Pennsylvania State University Press.

Moody-Turner, S. (2013). *Black folklore and the politics of racial representation.* Jackson, MS: University Press of Mississippi.

Rolling, J. H. (2011). Circumventing the imposed ceiling: Art education as resistance narrative. *Qualitative Inquiry, 17*(1), 99-104.

Smith, P. J. (1988). The Hampton years: Lowenfeld's forgotten legacy. *Art Education, 41*(6), 38-43.

Smith, P. J. (1996). *The history of American art education: Learning about art in American schools.* Westport, CT: Greenwood.

Smith, P. J. (1998). Lowenfeld teaching art: A European theory and American experience at Hampton Institute. *Studies in Art Education, 29*(1), 30-36.

Stankiewicz, M. A. (2001). *Roots of art education practice.* Worcester, MA: Davis.

Waite, C. (2015). The promise of the Historically Black College and University: Educating citizens, 1865-1920. Lecture, Center on History and Education, Teachers College, Teachers College.

Waters, D. J. (1983). *Strange ways and sweet dreams: Afro-American folklore from the Hampton Institute.* Boston, MA: G. K. Hall.

Endnotes

[1]This theory posits dual aesthetic orientations (*visual* or optic, versus *haptic* or tactile), and was first developed by Riegl to encompass long cultural eras of aesthetic change (Smith, 1987). Lowenfeld extended it to individual psychological makeup in *The Nature of Creative Activity* (1939).

Chapter 8

THE DETRIMENTAL EFFECTS OF McCARTHYISM ON AFRICAN AMERICAN ART INSTITUTIONS

Debra A. Hardy

The term *Red Scare*[1] often conjures images of Soviet spies and Hollywood blacklists. We picture propaganda posters that can be seen as archaic and naïve by today's standards. Yet, they still draw us to envision allegorical stories of mass hysteria that occurred during the Salem witch trials or satire involving alien parasites. We see a time so different from our own that it is hard to imagine the scene. However, far too often we fail to remember the real people who were impacted by the actions of Senator Joseph McCarthy, the House Un-American Activities Committee, and the domino effect these had on conservative post-war American thought and life. Even more, we often fail to recognize the detrimental effects the Red Scare had on African American communities and their leftist leaders. One example in particular, the South Side Community Art Center (SSCAC) in Chicago, Illinois, is used here to illustrate how the Red Scare impacted community art organizations specifically created by left-leaning Black Americans.

The history of art education has typically lacked voices and stories of minority-run organizations and educators. It is important to seek these voices out and listen to what they can teach us about the field of art education. At the same time, however, these histories are complicated by America's own history. Racism and a 1950s fear of Communist activities substantially hindered the early years of the SSCAC, creating problems with which it continues to struggle, even today. The anti-leftist sentiment of the McCarthy era removed artists and allies from the SSCAC during crucial years, creating a deep struggle to keep the Center alive by those who understood its value, but not how to teach art. By understanding the SSCAC's history and struggle during a period of turmoil in the United States, the history of

art education gains insight into a time that is often ignored and populated by voices that are seldom heard within the history of this field.

African Americans Wear Red

In the early 20th century, the Communist Party of America realized that in order to accomplish its mission of uplifting the working class of the United States, it needed to ally itself with the newly developing African American urban population. At the beginning of the century, the Communist Party believed it had nothing to offer Black Americans, despite Marx's beliefs that American slaves fighting towards emancipation were *"the most advanced outpost of labor's fight against capital"* (Lawrence, 1976). Sentiments were altered, however, as demographics changed within many U.S. cities. The first Great Migration during and directly following the First World War saw Black populations in Northern urban cities expand rapidly. Economic opportunity drew hundreds of thousands of African Americans from the rural South to cities such as New York, Chicago, and Baltimore. The economic opportunity, however, placed many Black workers at the bottom rung of the labor force, drastically changing the demographics of the lower class of workers in these large northern cities of the United States.

The Communist Party recognized Black laborers as individuals who could, in their present condition, understand, sympathize, and ultimately become champions of its beliefs about labor equality. According to Asante and Mazama (2004), *"of the many radical and socialist political movements of the 20th century, the Communist Party . . . more than any other, placed black liberation at the top of its agenda"* (p. 14). Communist workers in major cities protested police violence, helped stop unlawful evictions, integrated Black and white unions, and fought alongside antiracist groups such as the NAACP (Washington, 2014). The Communist Party's active desire to desegregate, paired with its belief in the uplift of the proletariat, helped it gain traction with the Black lower and middle classes. During the 1930s and 1940s, no other political party had more commitment to equality for African Americans than did the Communist Party.

There were African American card-carrying members of the Communist Party, yet many African Americans found themselves simply aligned with the Party rather than involved in its specific organizations. The Popular Front, a social and political movement aligned with leftist and communist thinking rather than one partic-

ular ideology, took hold of America during the 1930s and swept many creatives into its ranks (Mullen, 1999). The Communist Party, though an active and driving force of the movement, did not require those aligned with its cause to become members. The Party, however, did generate a large span of influence, and many creatives during this period became affiliated with communist-leaning programs in one way or another, usually through group affiliation. Despite little in the way of electoral gains and modest member numbers, the communist influence touched numerous artists and intellectuals active during the 1930s, many of whom worked under the banner of the Works Progress Administration (WPA).[2]

The WPA became home to many leftist and communist thinkers, and it hired young, previously unemployed workers, many of whom understood and experienced labor inequality firsthand. Left-leaning politics paired easily with the government's subsidized program, and created an acceptance of radical politics with those who worked under the government's banner. Artists employed by the Federal Art Project[3] (FAP) also found themselves interested and a part of communist-aligned groups. It was no secret that those in the ranks of the WPA had leftist or communist ties. As early as 1939, the *Chicago Tribune* ran an article entitled "Communists in the WPA," in which the newspaper accused the WPA of being a hotbed for communist activity, believing communists wanted to keep the WPA in perpetuity and would *"teach [the workers] to become revolutionaries"* (Communists in the WPA, April 21, 1939, p. 12). Despite this and later accusations of communist plots in the WPA, the program continued to gain momentum and engage in new activities along the way, often fueled by leftist ideologies. One example of leftist thinkers in action can be seen through the history of the SSCAC in Chicago.

The South Side Community Art Center

The SSCAC occupies an interesting historical place in the history of the WPA, the history of Black Chicago, and the history of leftist politics. Mullen (1999) stated that *"no black cultural institution better documents both the mid-century absorption and revision of 1930s American cultural and political radicalism into black public space"* (p. 81). The Art Center, a crowning achievement to many on the South Side during the WPA, is both a testament to the commitment to art and art education that many Black Communist artists had,

and a casualty of ideology taken to the extreme in the form of the Red Scare.

The Art Center came into existence through an extraordinary amount of work brought on by South Side residents who saw the creation of a dedicated art space for Black artists as a way towards racial advancement. Up until the SSCAC's founding, artists living on the South Side had to show their works in temporary spaces, churches, and local Young Men's Christian Associations (YMCAs) (Burroughs, 1987). Despite many young artists attending classes and graduating from the School of the Art Institute of Chicago, northern galleries refused to show art by Black artists. Supported through the enduring dedication of nearly 60 individuals over the course of two years, the SSCAC opened its doors in 1940 and was officially dedicated in 1941.

The SSCAC was funded through the FAP's program for community art centers, and became the only such art center established in Illinois. The Center's beautiful renovated brownstone located in the Bronzeville neighborhood was purchased with the help of community donations, and its staff was paid through the FAP, keeping community burden for the Center low through its first few years. Within the first year, nearly 50,000 individuals visited the exhibits or took classes at the SSCAC (Mullen, 1999).

During this period, tensions arose between the working-class artists, who helped drive the Center's creation through passion and labor, and the middle-class Black population, who helped back the venture financially. A great number of the artists involved with the SSCAC were active in communist-aligned circles. Many spent time with the leftist groups that assembled at the SSCAC, including the Negro People's Theatre Group and the SSCAC's Writer's Group, headed by Langston Hughes and attended by Gwendolyn Brooks. At the official dedication of the Center in 1941, which was attended by First Lady Eleanor Roosevelt, the artists were told not to attend and were only given space to prepare a speech written aloud in their absence. Margaret Burroughs (1987), herself a part of the artist group, called the middle-class *"culture vultures,"* and saw them as hypocrites who used the SSCAC as a social cause they could champion and walk away from, instead of an incubator for true social change (p. 142). The tension between the artists, who saw the Center as a home for their leftist ideas and an official venue for their art, and the middle class, who saw the Center more as an important

charity project for the South Side, became embedded in the fabric of the early years of the Center's existence.

After the shine of the new facility wore off, the Art Center began to struggle. WPA funds were cut due to the advent of World War II, forcing the community to support the Center's numerous programs and teachers. The Center spent several years keeping itself afloat and working out how to pay for the entire facility and staff. Paying teachers and staff became difficult and, although the Center had ample volunteers, there was not enough monetary support to satisfy the South Side population's desire for access to the previously free art classes. More liberal ideas for exhibits were scrapped in favor of more traditional exhibitions of older, established Black artists. The experimentation that began at the Center ceased, as traditional tastes were a better bet to obtain a larger visiting audience. The post-war years brought struggle and led to a more conservative SSCAC moving into the 1950s, hopeful of its position as a cultural beacon of Bronzeville to keep the Center alive—that is, until the intrusion of McCarthyism reached the SSCAC (Hardy, 2015; Mullen, 1999).

McCarthyism and the SSCAC

After World War II, the American public's sentiments toward leftist thinking began to constrict. The pendulum of public opinion, which had reached its peak of leftist radicalism in 1940, swung back towards more conservative tastes. Anti-communist sentiments had begun to build and gained momentum in light of the communist victory in the Chinese Civil War, the increasing threat of Europe's Iron Curtain, and the arrest of Julius and Ethel Rosenberg in 1950 (Schrecker, 2006). Joseph McCarthy, a freshman senator from Wisconsin, fueled the flames of anti-communist rhetoric when he claimed he knew of communist workers within the government (Schrecker, 2006). Quickly, radical leftists, communists, and communist sympathizers became a new public enemy. The explosion of 1930s leftist action that had been fed by Roosevelt's social programs could now be seen as un-American. The Red Scare had begun.

By the 1950s, it became difficult in some locations to be Black and not be labeled a communist. Fueled by McCarthy's actions, anti-communist sentiment ran rampant and those even remotely associated with progressive or leftist groups were ostracized for suspicion of communist actions. The leftism of many African American thinkers and creators during the 1930s made them easy targets to

be labeled as communists, whether or not they actually 'belonged' to the party. Some of the hardest hit fields by the new Red Scare were artists and creatives who had embraced leftist thinking in the 1930s. According to Schrecker (2006), *"because communism had appealed to artists, intellectuals, and other middle-class profession-als, McCarthyism drew its most prominent victims from those fields"* (p. 379). As the post-war pendulum swung back towards a newly conservative America, those who had been involved in the Popular Front movements of the 1930s were targeted.

It should be pointed out here that African American leftists were not simply victims of a wider movement. Rather, the Red Scare systematically targeted African Americans as a way to silence the ever-looming issues surrounding civil rights. The Communist Party had made it part of its mission to aid in desegregation and fight racism during the 1930s and 1940s. Washington (2014) stated, *"We have to understand that the U.S. government, with its Cold War mind-set, was not only in the business of trying to repress the Left; it was also shaping debates over race, integration, and civil rights"* (p. 38). Progress towards racial equality was seen as being too radical for the nation, and attempts were made to squash it by using the Red Scare. Those who spoke out during this period of fear were harassed and blacklisted into submission, effectively removing racial issues from the forefront of social awareness (Washington, 2014). The SSCAC, a cultural center for Chicago's booming Black population and run by outspoken Black leaders, was easily seen as an organization that needed to be silenced, if not removed, in order to continue the racial status quo.

Records indicated that between 1950 and 1953, the SSCAC did not produce any internal documents. Documents end with an article in the *Chicago Defender* in 1949, with the appointing of Margaret Bur-roughs as the new president of the Board. Center records pick up again in March of 1954, where former director David Ross sent out a letter stating that the staff of the SSCAC was *"in the process of getting the program going again"* (Ross, 1954, p. 1). The Center's quietest moments echoed the loudest at the height of the Red Scare. This omission suggests that the Art Center struggled the hardest during the peak of McCarthyism at a time when conservative voices over-rode the words of outspoken individuals from the Center, and those in positions of power worked to eradicate leftist organizations.

Due to the WPA's involvement in its founding, its associations with Black radical organizations, and the artists themselves having

ties to communist groups, the SSCAC was a prime target when the Red Scare began to take hold. In an effort to mitigate prosecution of the Center and face the full closure of its doors, those in charge of the SSCAC decided to cut ties with many artists who had political or social ties to communist parties. This action alienated a great number of the artists and community organizers who helped shape the Center during its initial formation. Many of the original founders of the SSCAC, especially the poorer artists, were associated with the left-leaning or communist groups that had called the Center their home. Those who attended the Negro People's Theatre Group or the SSCAC's Writer's Group meetings were alienated from the organization many of them had helped to establish. By disavowing their connections with many communist organizations that had been their backbone throughout their early years, the SSCAC lost a significant portion of its core founding artist members. This effectively created an Art Center with no artists. Those left in control of the Center were members of the middle class who had championed the Center, but had little experience with running an art organization (Hardy, 2015; Mullen, 1999).

One of the people removed during this communist purging of the SSCAC was Margaret Burroughs, the newly elected president of the SSCAC's Board. It is unknown if Burroughs was forced to step down through organizational pressure or if she relinquished this position willingly. She did retire from her position shortly after being elected. Burroughs had known ties to the Communist Party and was an outspoken leftist activist and a candid speaker against the Black middle class which was now in control of the SSCAC. Her ties to the Communist Party, however, did not falter after she left the Center's Board. She invited known Communist and blacklisted singer Paul Robeson to the Art Center in 1952, securing her ties to other American communists (Mullen, 1999). During this time, the Center rejected Burroughs's membership dues, despite the severe financial strain in which the Center found itself (Mullen, 1999). Burroughs had been the youngest founding member of the Center and an active participant in the organization for over a decade. It was obvious that the Center wanted to sever its ties with Burroughs, despite her passion and commitment to the Center, likely because of her continued affiliation with the Communist Party. By 1953, Burroughs left Chicago altogether, spending time with former SSCAC artist Elizabeth Catlett in Mexico City (Mullen, 1999). Mexico City's strong ties to the Communist Party, including Diego Rivera's artistic influence and harboring Leon Trotsky until his assassination, made

it a safe haven for American communists fleeing the harassment of McCarthyism. Many Black Chicago artists, including Charles White, Hale Woodruff, John Wilson, and Lawrence Jones, studied at the Taller de Gráfica Popular, a printmaking collective located in Mexico City (Mullen, 1999). Mexican influences became apparent in the work of Burroughs, Catlett, and others who spent time as expatriots in Mexico during the 1950s.

Meanwhile, the Center struggled to remain alive. Due to the lack of records or firsthand accounts, a mythology surrounds the SSCAC's hardest moments. Secondhand sources state that Wilhemina Blanks, Fern Gayden, and Grace Thompson Leaming, three middle-class working women from Bronzeville, kept the Center together through the early part of the 1950s (Schlabach, 2013). It is said that these women, so desperate to keep the Center together, gave their own money to pay for water and electricity (Knupfer, 2006). The building, purchased through the tireless dedication of those who believed in its cause in 1940, had to be mortgaged in order to pay the bills (Knupfer, 2006). It is likely that the decision to mortgage the building was an act of desperation, played out to keep the SSCAC solvent. The women opened the SSCAC once a week on the weekends in order to say it was still 'open' and had not shut down, despite not offering classes or displaying art. Blanks, Gayden, and Leaming understood the importance of the Center to the South Side and tried desperately to keep it afloat, even during its most challenging times.

Those in charge of the Center at the beginning of the Red Scare sought to remove the artists they believed would shine a negative light on the Center's happenings. They were afraid that the artists' communist leanings would spell ruin for the facility that was still struggling in its first decade. However, the artists cut from the Center because of their political leanings were the same individuals who kept inspiration and art in the building. When they were removed, the arts went with them. The SSCAC found itself struggling to survive, but unable to accept those who could help it the most, likely because of political outcry. Those of the middle class, many of whom had desperately tried to control the Center during its first few years, found the Center impossible to run without the help and commitment of their communist artists who had been unceremoniously shoved out.

The End of McCarthyism

McCarthy's influence ended in 1954 and the Red Scare subsided substantially. The persecuted artists and writers slowly started to work again, and the hyper-conservativism that typified the first four years of the 1950s had begun to diminish. In 1954, records indicated that the Art Center was *"in the process of getting the program going again"* (Ross, 1954, p. 1). After four years of almost complete silence, the SSCAC began to pick itself back up, invite artists and students back into its doors, and work toward a more financially viable future. Records showed that *"the doors of the Center are now open daily for the first time in many years"* and children's classes started anew (Ross, 1954, p. 1). Margaret Burroughs was invited back into the Center, and the women involved in keeping the Center together during its toughest years worked to pursue fundraising opportunities through other middle-class Black women. An entirely new Board was elected, and by 1957, Board member Helen Eichelberger stated that *"we are quite proud of the progress we have made in our last two years"* (p. 1). Despite the four years of struggle and hardship, the SSCAC had survived and was working tirelessly to be an important artistic gathering space on the South Side.

Conclusion

Margaret Burroughs (1987), reflecting on her experiences at the Center, wrote:

> *A principal excuse given ten years later in the McCarthy period of the 1950s was that the organization had been infiltrated by Communists. But as I remember now, from the very beginning, there were always battle lines drawn between the artists and this bourgeoisie. (p. 174)*

Burroughs believed that internal politics had as much to do with the hiatus as did the external politics of the Red Scare. As no internal sources existed at the height of McCarthyism, it is hard to say whether communist activities or internal politics were to blame for the SSCAC's darkest moments, although a combination of both may well be the answer. As both internal and external politics began to trend conservative, those on the left found themselves on the outs. What is known, however, is that the Center was founded through

the dedication and hard work of leftist and communist artists and writers, creating a cultural beacon during Chicago's Renaissance; in their absence, the Center struggled. The SSCAC has continued to live through feast and famine, and is still operating today, celebrating its 75th anniversary in 2015 as one of the first Black art institutions founded in the United States and the last surviving FAP-funded facility still standing in its original form.

The history of art education is in the beginning stages of writing and interpreting the stories of Black art educators whose voices have been ignored for far too long. These counter-narratives are beginning to weave into the cracks of the master narrative, and break apart what we 'know' about our field in order to complicate and complete our histories. By researching the history of Black art institutions such as the SSCAC, the master narrative within the history of art education can be dismantled, giving way to a wider array of voices. Its legacy creates a counter-narrative that offers space for the histories of Black art educators.

Despite forward strides, there remain few art education historians grappling with the unpleasant histories found in art education. Counter-narratives are emerging from these complicated histories, such as art education during Japanese internment (Wenger, 2012), but many histories remain uninvestigated. The Red Scare is a thorny history that historians still struggle to understand completely. It is a moment in history with more questions than answers, as many artists and educators failed to record what was happening around them. In the case of the SSCAC, the deafening silence from their archives at this time indicates the serious struggle the Center went through. By studying these complicated histories, the field of art education gains a deeper understanding of its history, through both high moments and the inevitable low.

References

Asante, K. M., & Mazama, A. (Eds.). (2004). *Encyclopedia of Black studies*. New York, NY: Sage.

Burroughs, M. T. (1987). Chicago's South Side Community Art Center: A personal recollection. In J. F. White (Ed.), *Art in action: American art centers and the new deal* (pp. 131-144). Metuchen, NJ: The Scarecrow Press.

Communists in the WPA. (1939, April 21). *The Chicago Tribune*. p. 12. Retrieved from http://archives.chicagotribune.com/1939/04/21/page/12/article/communists-in-the-wpa

Eichelberger, H. (1957). *Letter from Helen Eichelberger* (Box 3, Folder 23). South Side Community Art Center Archives, Chicago, IL.

Hardy, D. A. (2015). *And thus we shall survive: The perseverance of the South Side Community Art Center* (Master's thesis). Retrieved from http://hdl.handle.net/2152/31738http://hdl.handle.net/2152/31738

Knupfer, A. M. (2006). *The Chicago black Renaissance and women's activism*. Urbana, IL: University of Illinois Press.

Lawrence, K. (1976). Marx on American slavery [pamphlet]. Chicago, IL: Sojourner Truth Organization.

Mullen, B. V. (1999). *Popular fronts: Chicago and African-American cultural politics, 1935-1946*. Urbana, IL: University of Illinois Press.

Ross, D. (1954). *Form letter from David Ross to potential donors* (Box 3, Folder 2). South Side Community Art Center Archives, Chicago, IL.

Schlabach, E. S. (2013). *Along the streets of Bronzeville: Black Chicago's literary landscape*. Urbana, IL: University of Illinois Press.

Schrecker, E. (2006). McCarthyism and the Red Scare. In J.-C. Agnew & R. Rosenzweig (Eds.), *A companion to post-1945 America* (pp. 371-405). Hoboken, NJ: John Wiley & Sons.

Washington, M. (2014). *The other blacklist: The African American literary and cultural left of the 1950s*. New York, NY: Columbia University Press.

Wenger, G. M. (2012). History matters: Children's art education inside the Japanese American internment camp. *Studies in Art Education, 54*(1), 21-26.

Endnotes

[1]The Red Scare (1950-1954), also known as the Second Red Scare, was driven by anti-Communist sentiment following World War II and increased tension with the Soviet Union. As communism spread throughout Europe, Americans began to panic, believing the Soviet Union was planning to overthrow America's democratic and capitalist institutions.

[2]Through executive order by President Franklin Roosevelt on May 6, 1935, the Works Progress Administration (WPA) became Roosevelt's main government initiative which worked to hire unemployed workers laid off by the Great Depression. Nearly 25% of the working population was unemployed prior to the WPA.

[3]The Federal Art Project was under the banner of the WPA and employed artists as teachers, muralists, sculptors, and poster designers.

Chapter 9

THE MUSEUM OF MODERN ART'S DEPARTMENT OF FILM: HOW EDUCATIONAL FILM PROGRAMS RESPONDED TO SOCIAL AND CULTURAL CHANGES IN THE UNITED STATES

Rebecca Dearlove

The 1960s incorporated progressive ways of thought in the field of art education responding to the visual culture phenomenon. Educators such as June King McFee (1966), Vincent Lanier (1966), and Elliott Eisner (1965) expressed a necessary shift in teaching practices that explored new media including film, television, and advertising, which they believed empowered students to analyze textual and visual communication in art.[1] Interest in this art practice also influenced programming in other educational environments such as museums and libraries. In this paper, I consider visual culture education and its influence in film programming at the Museum of Modern Art's (MoMA) Department of Film (DOF) during the 1960s and early 1970s in accordance to the museum's response to the cultural and societal shifts witnessed in African American communities. The program discussed in this paper, *What's Happening?*, challenged audience members to view films with a critical eye, and to be active participants with the filmmakers who were present at the programs in order to create a discourse about social issues that were unobserved by many major news outlets.[2] The program's mission was to teach audience members how to examine information and media with diverse perspectives and allow a new viewpoint into the communicative structure of the Museum of Modern Art's DOF.

The MoMA's DOF, initially titled the Film Library, was established as a center devoted to collecting and preserving film for serious study.[3] Inducted into the museum in 1935, the library was the first organized film archive in the United States as well as a pioneer of film education, helping to initiate film programs in universities and museums around the country. The DOF strove to promote and expand its educational resources and aided film societies and other museums with topical film packages and literature about film through their unique circulating rental program.[4] Most important to this study, the department also created one of the first dedicated spaces for public programming using film as its focal point. In addition, it established itself as a national cultural force that interacted consistently with its community and programmed film that was appreciated by those interested in learning about all aspects of film and its influential role in society.[5] Haidee Wasson (2005), the DOF's lead researcher, described MoMA's film center as *"a complex and emergent network of ideas, practices, and technologies that coalesced ... around the idea that under carefully designed circumstances films could be studied, discussed, appreciated, and made useful for a range of projects"* (p. 30). Wasson considered that much can be learned from film not simply as an art object but as a piece of visual history. MoMA transformed old films into modern flashpoints of conversation and discussed new ideas about the nature of film's value within the context of what Wasson considered a media-savvy, publicly mandated art museum.[6]

Despite the amount of research covered on the early half of the DOF's history, including Russell Lynes' (1973) *Good Old Modern*, Haidee Wasson's (2005) *Museum Movies: The Museum of Modern Art and the Birth of Art Cinema*, and Robert Sitton's (2014) *Lady in The Dark: Iris Barry and the Art of Film*, little research has been conducted on the changes that occurred in the department during the 1960s and 1970s as well as the department's educational role in providing sources that explored social and cultural conditions in the United States. Changes in the DOF were in part due to drastic shifts in filmmaking as many marginalized groups began producing and distributing their own films. The resurgence of young independent filmmaking came to fruition due to the proliferation of easily accessible and usable film equipment after World War II. Author Elena Rossi-Snook (2005) pointed out an important trend of film production during the post-World War II years, including a *"unique mix of educational films, documentaries, animation, avant-garde films, student projects, and feature films that, today, evidence the*

social evolution of the twentieth century" (p. 2). Easily usable and affordable film equipment enabled aspiring artists to produce, direct, and distribute their own films.[7] These films, often documentaries, centered on politically and socially relevant topics such as race relations and the economic divide in America, the counter revolution and its effect on youth culture, the Vietnam War, and a plethora of other contentious topics that commercial Hollywood film of that time tended to misrepresent or disregard as important areas of contemplation by the American public. In response, the DOF introduced new public programming where independent and underground films were screened regularly as well as programming where young independent filmmakers were invited to screen and discuss their films. After evaluating a number of these programs, it was discovered that many of the films screened were made by African Americans who produced films about their communities, their culture, and their participation in the Civil Rights Movement. By creating a platform for Black artists to gain public exposure, MoMA acted as a moderator between marginalized groups and an audience that was primarily White. Tom Finkelpearl's (2013) chapter "An American Framework" explained that efforts made by civil rights groups in the 1960s, and the democratic institution's social relations were *"mirrors of the socially cooperative art that was simultaneously emerging"* (p. 7). This consideration gives a nod to the programs that were surfacing in libraries, museums, and community centers that enabled audience members to interact with one another by using film as the major vehicle for such communication. Creating a space for community engagement afforded these filmmakers a place to share their cultural narrative from their perspective and, as a result, gain a public voice.

Through the use of archival materials gathered and analyzed from MoMA's research library, I investigated one educational film program called *What's Happening?*, established in 1971 at MoMA's DOF. I explored how the program openly addressed social and cultural conditions for African American communities through the use of educational practices, creating an engaging space for community members. Between the years of 1971 and 1974, 21 films programmed in *What's Happening?* addressed cultural, political, and societal themes within the African American community. After viewing a majority of the films, 15 in total, and contemplating Kyvig and Marty's (2010) analysis in *Nearby History* as well as Williams's (2003) in *The Historian's Toolbox*, I constructed a narrative of the themes found in the films I watched. In their analysis of motion

pictures, Kyvig and Marty concluded that images of the same subject produced by different creators can show very distinct qualities and that *"meaning also depends, in part, on how the image is presented"* (p. 133). I argue that the department during the late 1960s and early 1970s was in its most influential period when tackling large-scale social and cultural issues complicating the daily lives of its audience. I also argue that the DOF played an influential role in addressing the social and cultural conditions of African Americans by presenting an opportunity for Black artists to discuss their cultural narrative, social history, and political and racial obstacles with an audience who was often unfamiliar with this perspective. This topic of film programming provides a lens revealing early alternative educational opportunities found in museums for African Americans similar to concepts explored by progressive educators like June King McFee and Vincent Lanier, and further illuminates the role film has played in the social and cultural experience of America.

Developments in MoMA's Department of Film, 1935-1974

Since 1935, the DOF had become an important resource for film scholars, filmmakers, and the general public interested in the historical influence of film and the trajectory of the film industry. Beyond the practices of collecting film, the central purpose of the DOF was to educate and engage its public about the social and cultural relevance of film. Wasson (2005) described MoMA as one of the leading institutions to forward *"the values of education film viewing, studious attention, face-to-face discussion, and, most important, structured criteria by which films would be engaged"* (p. 186). As Wasson explained, the DOF involved a wider and much more diverse audience than many other departments in the museum because of its exploration of contemporary topics in culture, thus appealing to a younger generation. Being in tune with shifting generational interests afforded the museum with an ability to adapt quickly to changing public needs.

According to researcher Russell Lynes (1973) in *Good Old Modern*, the MoMA was in the midst of a major institutional change during the 1960s, including an exploration of new funding sources and new program structures in all of its departments. In 1965, the museum appointed film director and photographer Willard Van Dyke as the new director of the film department. In a letter written by the president of Knickerbocker Productions, Howard Lesser, to the director of MoMA at the time, René d'Harnancourt, Lesser ex-

pressed his admiration of Van Dyke and explained, *"Of greater import to a museum that is 'modern,' Willard will bring to the tasks that lie ahead a mind that is sympathetically attuned to the ideas and aspirations of the younger generations"* (René d'Harnoncourt Papers, IV.234, MoMA Archives, New York). Van Dyke noted that the film department needed to make changes in its educational mission in order to appeal to a younger generation and to provide opportunities for aspiring filmmakers. Van Dyke and the DOF staff began exploring new areas of film to collect and program, such as experimental and avant-garde film, social documentaries, and independent underground film.[8] Acknowledging that there was a renaissance of young filmmakers in the 1960s and a need for institutions to screen their films, Van Dyke responded by developing new program series, including *What's Happening?*.

African Americans and Independent Filmmaking in the 1960s

Independent films produced in the 1960s and 1970s by African Americans were mainly concerned with the reclamation of the Black narrative in order to escape the countless stereotypes created by the predominately White Hollywood institution. The work of scholars who wrote on the African American influence on film and television, such as John Hess's (1985) *Notes on U.S. Radical Film, 1967-80*, Clyde Taylor's (1985) *Sociology and African-American Studies*, Floyd Coleman's (1990) *Confronting Black Stereotypes Through Visual Artistic Expressions*, Elizabeth Hadley's (1999) *Eyes on the Prize: Reclaiming Black Images, Culture, and History*, Tommy Lee Lott's (1999) *Documenting Social Issues: Black Journal, 1968-1970*, Lars Lierow's (2013) *The Black Man's Vision of the World: Rediscovering Black Arts Filmmaking and the Struggle for a Black Cinematic Aesthetic*, and Jane Rhodes's (2014) *The Electronic Stimulus for a Black Revolution: Black Journal and the 1960s Public Television*, all considered the parallels between Black images in film throughout history and the present work of African American filmmakers attempting to reclaim their narrative. African Americans tried various platforms to tell their story and define their collective and individual cultural identity. According to Rhodes (2014), certain filmmakers utilized mass media as a vehicle to comment on race relations and community issues such as with *Black Journal* (1968), a public affairs television program funded by the Ford Foundation and produced by a number of Black filmmakers who aimed to create an alternative Black cinema in short documentary film (Lott, 1999). Rhodes's

article also described *Black Journal* and other similar programs as an effort to release the *"pressure built up within aggrieved communities that continually erupted into urban uprisings"* (p. 139). Documentary films screened on these television programs told the unique and, until then, obscured stories of African American communities, providing community residents a venue through which to acknowledge, understand, and celebrate one another.

As previously mentioned, the struggle for African Americans to find a cultural voice and reclaim their narrative was in part undertaken through the utilization of filmmaking. Lars Lierow's (2013) *The Black Man's Vision of the World* mentioned that African American filmmakers faced challenges when attempting to represent African American community life accurately. African American filmmakers were inclined *"to pursue film projects in documentary, narrative, or artistic-experimental styles, through independent as well as commercial channels"* (p. 7). Black film produced during this period attempted to shape a new culture for African American identification, and in doing so helped to create a Black consciousness. Lierow's essay reiterated the countless films produced by African Americans that examined their culturally diverse communities. Film was used as a mode of communication that could reach more audiences and affect broader ideologies as well as an effort to help communities learn from each other and reshape their self-identity while spreading messages to the general public that the African American communities were culturally rich and essential to the nation.

MoMA's DOF played a critical role in contributing to the efforts made by African Americans in propagating their multidimensional cultural stories portrayed through film. Its efforts parallel educator Elliot Eisner's belief that teaching through the use of film in a controlled setting can properly teach an audience how to examine information and media from diverse perspectives.[9] If the purpose of education is supposed to identify patterns of behavior as well as to understand eras of history and contemplate complex ideas, then *What's Happening?* was successful at initiating a new form of educational practice outside the classroom and into another less controlled social setting.

Revolution Through *What's Happening?*, 1971-1974

The genesis of *What's Happening?* mirrored the early documentary days of the 1930s, in which filmmakers used the camera to express actual conditions of American life. Witnessing similar trends emerging into practice once again, Willard Van Dyke created a program that best highlighted the type of films that employed techniques from the past and present in order to generate realistic and revealing coverage of major issues in America. The program stimulated a public reaction towards national and international social and political issues. The films selected for *What's Happening?* dealt with issues such as the Vietnam War, student unrest, racism, politics, the sexual revolution, and the women's liberation movement.

This section focuses on a selection of films screened at *What's Happening?* from 1971 to 1974 that dealt primarily with racism in America, daily lives of African Americans in urban and rural communities, the efforts of the Black Panther Groups and the Black Power Movement, and various civil rights developments and obstacles.[10] After analyzing various textual materials found in MoMA's research library, 21 films directly addressing African American life were pulled and analyzed further into several themes such as a focus on individual stories, controversial implications caused by racism, and the fight for equal civil rights.

The Museum of Modern Art and Its Changing Policy

In a letter to Mr. Rick Solomon, Willard Van Dyke discussed the reason for the initiation of new programming in the DOF as a response to the *"accusation that the Museum has not been responsive to current trends. We feel that the film department can respond . . . easily to this accusation . . ."* (Department of Film Exhibition Files, W.1, MoMA Archives, New York). The purpose of *What's Happening?* was to educate the public as well as screen films that generally had not received the theatrical and televised exposure they so deserved. Willard Van Dyke described *What's Happening?* as a program that

> *will not only provide relevant information for the*
> *public that normally would not have access to it,*
> *it will also give a forum to film-makers whose*
> *film are not shown theatrically, films that may be*
> *too editorial for a large television network, but*

which may nonetheless be of interest to audiences that want to keep informed. (Film, W.1, MoMA Archives, New York)

Van Dyke believed that more than ever before, people wanted to know about things that mattered and *"the Museum will attempt to serve the community on this area of film information"* (Film, W.1, MoMA Archives, New York). In the documentary film *Conversations with Willard Van Dyke* (1981), Van Dyke described the need for new programming like *What's Happening?* as a call for film that is relatable to a changing audience as well as for a need for a space responsive to young filmmakers and new film practices. Van Dyke mentioned in Rothschild's (1981) documentary, *"It was important for those people uptown to understand that there were filmmakers, artists, and reporters, and indignant young radicals making films. That was important for them to know and it was just an opportunity that was there."*

According to Van Dyke, the idea of the program was also to stimulate a public reaction through the powerful medium of film. He continued, *"The visual image, being as direct as it is, can only help to illuminate many issues confronting the public. That image is unencumbered and carries its own message; each individual is free to come to his own conclusion"* (Film, W.1, MoMA Archives, New York). This powerful sentiment set the stage for new films of significance and social priority by both new groups of filmmakers and seasoned filmmakers to be programmed to a newly emerging museum audience. By applying creative practices to documentary filmmaking, these new filmmakers prioritized their process by focusing on issues of decided import that directly impacted American people.

Individual Stories About Black Culture

The first film featured in *What's Happening?* on August 20, 1970 was Lionel Rogosin's (1970) *Black Roots*, a creative narrative told through the eyes of the Black community. The film was Rogosin's own personal interpretation of Black culture. The DOF's first programmed film was less politically and militantly conscious, and was instead much more celebratory of Black culture. Represented and considered in the film were many topics, including Black culture in music, art, history, poetry, and humor. The director featured a range of perspectives in his film by interviewing African American urban intellectuals, industrial workers, rural sharecroppers, and

revolutionary members. The film was described as a panorama of American history beginning in 1900 and expanding to the 1960s, told from the perspective of the Black community. A museum memo in the summer of 1970 contained a quote from Rogosin who considered "*black culture a very needed infusion of humanism into our highly industrialized and mechanistic society*" (Film, W.1, Mo-MA Archives, New York). He exposed this reflection in a new form of poetic cinema, juxtaposing dialogue of Black Americans with key elements such as musical interludes of jazz, blues, and other highlights of Black music. According to Rogosin, the point of this stylizing was to emphasize the beauty of Black life in America and to avoid the ugliness and the violence when contemplating political, social, and racial problems. The film was in many ways a psychological study of human nature and the artist's interpretation of the symbolic expression of the sociology of Black culture. Rogosin reflected similar themes in his other documentary, *Woodcutters of the Deep South* (1973). He asked the people of the south, his subjects in the film, to tell and live their own stories while he filmed, which he used as a developing technique when confronting the overarching concern of the film: Whites and Blacks working together to create unity in their shared work environment.

Many of the films in *What's Happening?* explored the personalities of individual African Americans. Besides *Black Roots,* films such as *Al Stacey Hayes* by Joel A. Levitch (1969), *Set-Up* by Nick Doob (1970), *I Am Somebody* by Madeline Anderson (1970), and *Part of the Family* by Paul Ronder (1971), told personal stories of daily life as an African American growing up in rural and urban communities. Not all of these films directly confronted racial concerns; rather, they revealed a wide spectrum of Black American life that clarified the many accounts of Black culture. Rogosin's philosophy behind filmmaking reflected similar attitudes of other directors showcased in *What's Happening?*. Rogosin explained that through dialogue and a focus on an individual's facial expressions, gestures, and words, one "*can capture the essence of personality as opposed to the conventional film which dwells on superficial action and irrelevancies*" (Film, W.1, MoMA Archives, New York).

Part of the Family, produced and directed by Paul Ronder (1971), is perhaps the most profound example of individual Black stories depicted in the *What's Happening?* program. Ronder selected three families from various areas of the country who were unlike one another in race, religion, and economic background. Each of the

families told its story of sorrow and loss, making a statement that no matter how fundamentally diverse people may be in color, culture, or faith, everyone was connected and suffered from loss in comparable ways. The film was Ronder's

> *attempt to remind the American people that the political tragedies they watch on their television sets actually do happen and involve real people just like them. We hear the politicians speak on Vietnam, on the Kent State murders, the Jackson State murders, and we forget that the students who are shot down and the soldiers who die unnecessarily in Vietnam are young people like the boy next door, like our own children, and like ourselves. (Film, W.1, MoMA Archives, New York)*

The director hoped that individual experiences of pain and anger could unite people and lead them to do whatever possible so that meaningless death could be stopped.

Spotlighting Controversial Topics

A December 1970 museum memo that listed and described several films selected in What's Happening? explained that "the established media systematically excludes the information that might allow for clear thinking and effective participation on the part of a great number of people in this country" (Film, W.1, MoMA Archives, New York). Rather than exclude information, the DOF's mission for its position in the film industry was to give people an understanding and perspective of what was happening in the world. MoMA's policy change during this period reflected the goals of many independent production and distribution companies. Many of the films chosen for viewing in the What's Happening? series were obtained through independent companies like Newsreel. Companies such as American Documentary Films, Black Journal, National Education Television, and Pacific St. Film & Editing Co., all with similar values, worked with MoMA so that overlooked or misjudged topics could be discussed from a new perspective.

In Paul Altmeyer's (1972) Busing: Some Voices from the South, the director and a small film crew went to the Deep South to document the progression of busing integration. Altmeyer realized at the time

that southern involvement with shifts in racist attitudes, integration, and desegregation had been largely unreported to the rest of the country. He considered it to be important research that the entire country needed to see as a learning process and as a way to understand further the complexities of changing deep-rooted mentalities directed towards minorities.

MoMA also programmed numerous films about the Black Panther Party and several of the Party's leaders. Generally considered an aggressive and violent group, the Black Panther Party was bestowed an undesirable label by the mass media. Films screened in What's Happening?, such as American Revolution 2, produced by The Film Group, Inc. (1969); Stagolee: Interview with Bobby Seale, directed Francisco Newman (1970); Mayday, made by May First Media, Inc. (1970); and Frame-Up! The Imprisonment of Martin Sostre by the Pacific Street Film Collective (1974), all considered the importance of the Black Panther Group as community leaders. Specifically, they examined members as active individuals fighting for their rights in unconventional ways. Bobby Seal, one of the founders of the Party, was interviewed in prison for the film Stagolee. He had been charged with one crime after another without palpable evidence, had been imprisoned for months, and was facing the gas chamber at the time. In this documentary, Seale was asked to tell his own story. As the film developed, Seale transformed from an impersonal headline story into a relatable human being, who felt the same sorrow and loss that many others also experienced.

A popular screening series during the second season of What's Happening? was the weekly viewing of the trial of Black Panther Group member Lauren R. Watson in Trial—The City and County of Denver vs. Lauren R. Watson by Robert M. Fresco (1970). The first documentary study shown on American television of a courtroom trial, Lauren Watson was tried for resisting arrest as well as interfering with a police officer in the discharge of his duty. This case brought to the surface larger implications dealing with "the system of legal justice as it applies to Blacks and other traditionally under-privileged groups" (Film, W.1 MoMA Archives, New York). MoMA's screening of Trial was a powerful response to what had already been expressed by the defense attorney in Watson's case, who explained that he would not receive a fair trial because he was not being judged by his peers. Having no background or understanding of Watson and his upbringing, the jury's perspective was considered skewed prior to entering the courtroom. By screening Trial in a

major art institution that attracted a majority of White patrons, MoMA attempted to educate its audience by revealing a new evaluation of the trial displayed in a different context.

Civil Unrest and the Fight for African American Rights

The films previously discussed respond on some level to the unmistakable civil unrest that underprivileged groups in America encountered during the 1960s and 1970s, and their efforts to procure their rights despite the surrounding social tension. This overarching theme set the stage for *What's Happening?* as a complete program and highlighted major problems in American society that needed to be addressed in a new context. MoMA's DOF screened films in a secure environment that directly responded to these injustices in an objective way.

Racial integration in the army and in the busing system were addressed in films programmed during *What's Happening?* in 1970 and 1973. Courtesy of *Black Journal,* National Educational Television, MoMA programmed *Black G.I.* in 1970. Produced, directed, and written by Kent Garrett, the film explored racist attitudes Black servicemen faced in the Vietnam War. The documentary portrayed the struggles of Black sailors in confronting racial slurs from Vietnamese soldiers and civilians. The servicemen who were interviewed in the film questioned the mentality of the Asians and how they accepted racial epithets, blaming White American servicemen for vulgar nicknames. The busing system and the progression of integration in the south were also featured in *What's Happening?* in Paul Altmeyer's *Busing: Some Voices from the South,* mentioned previously. The film discussed the difficulty of changing racist behavior that was ingrained in the region's culture. The film argued that much work beyond lawful desegregation still needed to be done in many areas of the country. Despite how progressive some cities were during this time, much of the country still grappled with these major political and social changes in the late 1960s.

Lionel Rogosin's (1973) documentary *Woodcutters of the Deep South,* also discussed previously, detailed poor White and African American woodcutters in Mississippi and Alabama working together to organize a cooperative association against the paper and pulpwood companies where they were employed. Rogosin's film and the workers' organization were in many ways precursors to the efforts made by MoMA and its DOF when developing new, socially engaged programming. Coming together to confront a problem

that affects everyone was the epitome of successful community organization. MoMA handled the criticism of ignoring marginalized groups by creating newly improved programming. It also built an audience who appreciated and relied on these new policy changes within the institution.

What's Happening?: A Space for Discussion and Reflection

MoMA's DOF used programming such as *What's Happening?* as a platform to rectify social injustices by calling people's attention to films that directly commented on major social and political themes.[11] The new film programming at MoMA took risks by screening controversial films in order to appeal to a growing need within its community as well as to examine major cutting-edge and at times explosive issues in the country and around the world. Public discourse and community engagement were the outcomes of offering an audience access to these films. *What's Happening?* not only presented the public with access to films they would not have experienced elsewhere, but it also afforded creative opportunities for artists of all backgrounds to talk about their work with the community, thus creating a participatory environment for the artists, the museum staff, and the audience. Regarding educational practice, the use of newer media has the ability to connect people from around the world.[12] Educators and programmers can be more prolific teachers and relate best to their audience by shaping the form and content of the technology used in classrooms and in public programming.

What's Happening? was designed to offer alternatives to commercial mass media and to educate its audience about the country's diversity. The DOF relied on educational film companies for their distribution of a variety of films, and then used these films as tools to provide its audience with information that reflected the widely differing attitudes and beliefs of diverse communities. The program was able to establish African Americans as *"resistant subjects, rather than objects of scrutiny and scorn"* (Rhodes, 2014, p. 151). Overall, the program helped spawn a generation of independent Black filmmakers who were able to teach unacquainted audiences about racial identity and the need for political and economic freedom.

Although the DOF has not yet been considered for its contributions in the art education field, its intentions were firmly educational. The films screened at *What's Happening?* created a space for Black artists to talk about their work, communities, and culture.

With the help of being associated alongside a prestigious museum, Black artists worked within the system to create nationally recognized heroes through their art, display their propagandistic artwork, glorify historical events and people, and create art that interpreted the mass experience so audiences who were unfamiliar with it could have opportunity to communicate on a new and equitable level. Through its new programming, MoMA played a minor yet important role in building cross-cultural communities and addressing cultural and social conditions for African Americans during the 1960s and 1970s, as well as establishing new forms of education to be passed down to future generations.

References

A film program for adults. (1945, April-May). *Bulletin of the Art Institute of Chicago, 39*(4), 61.

Altmeyer, P. (Director). (1972). *Busing: Some voices from the south* [Television Broadcast]. Philadelphia, PA: CBS News.

Chalmers, G. (2005). Visual culture education in the 1960s. *Art Education, 6*(58), 6-11.

Coleman, F. (1990). Positive negatives and negative positives: Confronting Black stereotypes through visual artistic expressions. In H. B. Shaw (Ed.), *Perspectives of black popular culture* (pp. 85-92). Bowling Green, OH: Bowling Green State University Popular Press.

Department of Film Exhibition Files, W. 1. The Museum of Modern Art Archives, New York.

Eisner, E. W. (1965, October). Curriculum ideas in a time of crisis. *Art Education, 18*(7), 7-12.

Finkelpearl, T. (2013). *What we made.* Durham, NC: Duke University Press.

Fresco, R. (Director). (1970). *Trial: The City and County of Denver vs. Lauren R. Watson* [Motion Picture]. United States: NET Journal & Public Broadcasting Service.

Garett, K. (Director). (1970). *Black G.I.* [Television Broadcast]. New York, NY: Black Journal.

Hadley, E. A. (1999). Eyes on the prize: Reclaiming Black images, culture, and history. In P. R. Klotman & J. K. Cutler (Eds.), *Struggles for representation: African American documentary film and video* (pp. 99-121). Bloomington, IN: Indiana University Press.

Hess, J. (1985). Notes on U.S. radical film, 1967-80. In P. Steven (Ed.), *Jump cut: Hollywood, politics, and counter cinema* (pp. 134-150). New York, NY: Praeger.

Kyvig, D. E., & Marty, M. A. (2010). *Nearby history.* Plymouth, UK: Altamira Press.

Lanier, V. (1966). Newer media and the teaching of art. *Art Education, 19*(4), 5-8.

Lierow, L. (2013). The "black man's vision of the world": Rediscovering black arts filmmaking and the struggle for a black cinematic aesthetic. *Black Camera, 4*(2), 3-21.

Lott, T. L. (1999). Documenting social issues: *Black Journal*, 1968-1970. In P. R. Klotman & J. K. Cutler (Eds.), *Struggles for representation: African American documentary film and video* (pp. 71-98). Bloomington, IN: Indiana University Press.

Lynes, R. (1973). *Good old modern.* New York, NY: Atheneum.

McFee, J. K. (1966). Society, art, and education. In E. Mattil (Ed.), *A seminar in art education for research and curriculum development* (pp. 122-140). University Park, PA: Pennsylvania State University.

Newman, F. (Director). (1970). *Staggerlee: A Conversation with Black Panther Bobby Seale* [Motion Picture]. United States: Library of Congress.

René d'Harnoncourt Papers, IV. 234. The Museum of Modern Art Archives, New York.

Rhodes, J. (2014). The "electronic stimulus for a black revolution": *Black Journal* and the 1960s public television. *Black Renaissance, 2*(14), 136-152.

Rogosin, l. (Director). (1970). *Black Roots* [Motion Picture]. United States: Milestone Film & Video.

Rogosin, L. (Director). (1973). *Woodcutters of the Deep South* [Motion Picture]. United States: Rogosin Films.

Ronder, P. (Director). (1971). *Part of the family* [Motion Picture]. United States: Educational Broadcasting Corporation.

Rossi-Snook, E. (2005). Persistence of vision: Public library 16mm film collections in America. *The Moving Image: The Journal of the Association of Moving Image Archivists, 5*(1), 1-26.

Rothschild, R. A. (Director). (1981). *Conversations with Willard Van Dyke* [Motion Picture]. United States: New Day Films.

Sitton, R. (2014). *Lady in the dark: Iris Barry and the art of film.* New York, NY: Columbia University Press.

Taylor, R. L. (1999). Sociology and African-American studies. *Contemporary Sociology, 5*(28), 517-521.

Wasson, H. (2005). *Museum movies: The Museum of Modern Art and the birth of art cinema.* Berkeley, CA: University of California Press.

Williams, R. C. (2003). *The historian's toolbox: A student guide to the theory and craft of history.* Armonk, NY: M. E. Sharpe.

Work and progress of the film library. (1937, January). *The Bulletin of the Museum of Modern Art, 4*(4), 2-11.

Appendix

List of Films from *What's Happening?* **(1971-1974):**

List of *What's Happening?* screenings at the Museum of Modern Art with African American themes. The films are presented in chronological order from the inauguration of the program in 1970 until 1974, the end of director Willard Van Dyke's career at the MoMA.

August 20, 1970: *Black Roots* (1970). Produced and directed by Lionel Rogosin. (60 mins.)

A portrayal of Black culture emphasizing the beauty of Black life in America. *"An exploration of the personalities of individuals, black Americans of all types"* (W.1 MoMA Archives, New York).

August 27, 1970: *Stagolee: Interview with Bobby Seale* (1970). Produced by KQED and directed by Francisco Newman. (60 mins.)

Documentary interviewing Chairman of the Black Panther Party, Bobby Seale, while in prison. *"The film transforms the screaming headline Bobby Seale into a beautiful human being"* (W.1 MoMA Archives, New York).

October 1, 1970: *Mayday* (1970). Produced and directed by May First Media, Inc. (22 mins.)

Documentary about the imprisonment of members of the Black Panther Party in New Haven, Connecticut, accused of murder.

October 1, 1970: *David Hilliard on "Face The Nation"* (1969). Produced and directed by American Documentary Films. (30 mins.)

Complete version of CBS' *Face the Nation* with David Hilliard, the Black Panther Party Chief of Staff.

November 5, 1970: *Black G.I.* (1970). Produced, directed, and written by Kent Garrett. Courtesy of *Black Journal*, National Educational Television. (54 mins.)

Documentary exploring Black servicemen in Vietnam and their struggles as they confronted racism away from home.

November 5, 1970: *... And We Still Survive* (1969). Produced and directed by Stan Lathan. Courtesy of *Black Journal*, National Educational Television. (13 mins.)

Documentary exploring the struggles of African Americans during the 1960s in America.

December 21 and *Wilmington* (1969). Courtesy of Newsreel Films. (15 mins.)

22, 1970: Film showing the DuPont Corporation's domination of Black and White workers after the assassi-

nation of Martin Luther King, Jr., in which the National Guard was called in to maintain patrols of the Black community for 10 months.

January 4 and 5, 1971: *Trial—The City and County of Denver vs. Lauren R. Watson* (1970). Produced by National Educational Television. Directed by Robert M. Fresco and Denis Sanders. (90 mins.)

The First Day—Selection of the Jury. Documentary study of the trial of Lauren R. Watson, a Black Panther Party member. The charges included resisting a police officer and interfering with a police officer.

January 11 and 12, 1971: *Trial—The City and County of Denver vs. Lauren R. Watson* (1970). Produced by National Educational Television. Directed by Robert M. Fresco and Denis Sanders. (90 mins.)

The Second Day—Officer Cantwell on the Stand. Documentary study of the trial of Lauren R. Watson, a Black Panther Party member. The charges included resisting a police officer and interfering with a police officer.

January 18 and 19, 1971: *Trial—The City and County of Denver vs. Lauren R. Watson* (1970). Produced by National Educational Television. Directed by Robert M. Fresco and Denis Sanders. (90 mins.)

The Third Day—Watson Takes the Stand. Documentary study of the trial of Lauren R. Watson, a Black Panther Party member. The charges included resisting a police officer and interfering with a police officer.

January 25 and 26, 1971: *Trial—The City and County of Denver vs. Lauren r. Watson* (1970). Produced by National Educational Television. Directed by Robert M. Fresco and Denis Sanders. (90 mins.)

The Fourth Day—The Verdict. Documentary study of the trial of Lauren R. Watson, a Black Panther Party member. The charges included resisting a police officer and interfering with a police officer.

February 22 and 23, 1971: *Set-Up* (1970). Produced and directed by Nick Doob and Donald Horner. (60 mins.)

A film about the life story of African American Donald Horner from New Haven, Connecticut,

detailing his views on society, his experience of his time in jail, and his growing relationship with the filmmaker.

March 1 and	*I Am Somebody* (1970). Produced, directed, and edited by Madeline
2, 1971:	Anderson. Courtesy of Contemporary Films/McGraw-Hill. (28 mins.)
	Documentary on the 113-day hospital strike in Charleston, South Carolina. The film explained how Black workers related *"to a union that fuses economic problems and the civil rights struggle into one"* (W.1 MoMA Archives, New York).
March 1 and	*Al Stacey Hayes* (1971). Produced and directed by Joel A. Levitch.
2, 1971:	Courtesy of Jason Films. (25 mins.)
	Film about the Black community in Shelby, Mississippi, a small town in the Delta, and its struggle of fighting for civil rights in Southern rural states.
March 8 and	*Banks and the Poor* (1970). Produced and written by Morton Silverstein.
9, 1971:	Courtesy of National Educational Television. (60 mins.)
	Documentary exploring the bank's attitudes towards the poor in America. The film includes interviews with bank representatives and on-location footage of slums in North Philadelphia, New York City's Bedford-Stuyvesant, and Washington, D.C.
May 17 and	*Part of the Family* (1971). Produced and directed by Paul Ronder.
18, 1971:	Courtesy of NET Division, Educational Broadcasting Corporation, Belafonte Enterprises, Inc. and Summer Morning Films, Inc. (75 mins.)
	Film about three families of different races, different religions, and different economic levels living in different areas of the country. It details each family's struggles with various political tragedies in America.
May 23 and	*American Revolution II* (1969). Produced by the Film Group, Inc.
24, 1972:	including Mike Gray. Courtesy of Vision Quest, Inc. (80 mins.)
	Documentary film about the 1968 Democratic National Convention and its aftermath. It focuses on the creation of the alliance between the Young Patriots Organization and the Chicago Black Panther Party Chapter.

In October 1972, the *What's Happening?* series was taken on by
William Sloan, who was then a librarian with the New York Public
Library, Donnell Library Center. During this period, the *What's
Happening?* programs were screened on succeeding days as
noted, first at the Donnell Library Center and then at the audito-
rium of the MoMA.

October 24 and *Busing: Some Voices from the South* (1972). Di-
rected by Paul Altmeyer.

25, 1972: Produced by and courtesy of Westinghouse
Broadcasting Company.
(52 mins.)

Documentary exploring the issues of integration
of the busing system in the South during the early
1970s.

December 18 and *Ain't Gonna Eat My Mind* (1973). Produced and
directed by Tony Batten.

19, 1973: Courtesy of Carousel Films, N.Y.C. (34 mins.)

Film exploring the gangs in the South Bronx and
how two rival gangs handled the killing of 25-
year-old Cornell Benjamin, known as 'Black
Benjy,' together in a civilized meeting.

March 26 and *Woodcutters of the Deep South* (1973). Produced
and directed by Lionel

27, 1974: Rogosin. Courtesy of Impact Films. (85 mins.)

Film detailing the lives of poor Black and White
working people in Mississippi and Alabama as
they overcame the forces of racism in order to or-
ganize into a cooperative association. *"Rogosin's
film reveals the basic needs and struggles encoun-
tered in the development of all social organization
of this nature"* (W.2 MoMA Archives, New York).

June 11 and *Frame-Up! The Imprisonment of Martin Sostre*
(1974). Produced and

12, 1974: directed by the Pacific Street Film Collective.
Courtesy of Pacific St. Film & Editing Co. (30
mins.)

Documentary about the arrest of Martin Sostre,
owner of the only anti-war Black Liberation
bookstore in Buffalo, NY. The film documents *"a
classic case of American injustice—where the full
power of the state has been brought to bear against
an individual who has chosen to speak out against
the powers at large"* (W.2 MoMA Archives, New
York).

Endnotes

[1]See Graeme Chalmers's (2005) article, "Visual culture education in the 1960s" in *Art Education,* 6(58), 6-11, for more information about the development of visual culture education.

[2]In her 2014 article, "The 'electronic stimulus for a Black revolution': *Black Journal* and the 1960s public television" in *Black Renaissance,* 2(14), 136-152, Jane Rhodes discussed the television news outlets and the misrepresentation of African Americans in the United States.

[3]See the Museum of Modern Art's Department of Film website (www.moma.org/explore/ collection/departments/film) for more information on the department's activities in preservation, collection, and programming throughout history

[4]MoMA's contributions to other museums are detailed in the April-May 1945 article, "A film program for adults," *Bulletin of the Art Institute of Chicago, 39*(4), 61.

[5]The progression of the film department and its interest in social and political influences as seen in film are described in the January 1937 article, "Work and Progress of the Film Library," *The Bulletin of the Museum of Modern Art, 4*(4), 2-11.

[6]More can be read of the MoMA's efforts to collect, preserve, and distribute film in Haidee Wasson's (2005) book, *Museum Movies: The Museum of Modern Art and the Birth of Art Cinema.*

[7]See Elena Rossi-Snook's article "Persistence of Vision: Public Library 16mm Film Collections in America" for a look at changes in film production and film distribution beginning in the 1960s.

[8]Watch *Conversations with Willard Van Dyke* (1981) for an exploration into Van Dyke's career in film and at MoMA, including the development of new programming under his leadership.

[9]See Elliot Eisner's (1965) article "Curriculum Ideas in a Time of Crisis."

[10]See Rhodes for a detailed look at depictions of the Black Panther Group and the Black Power Movement in media, television, and other areas of popular culture during the 1960s and 1970s.

[11]See Wasson's book for an in-depth study of MoMA's cultural and social influence in film programming.

[12]See Vincent Lanier's 1966 article "New Media and the Teaching of Art."

Chapter 10

CONSTRUCTING SOCIAL IMAGINARIES: EXPLORING ANNA CURTIS CHANDLER'S (1890-1969) STORYTELLING PRACTICES AT THE METROPOLITAN MUSEUM OF ART, 1917-1918

Allison M. Clark

Anna Curtis Chandler (1890-1969) is often remembered as one of the preeminent storytellers working in art museum education during the early 20th century, conjuring imaginative tales for audiences of all ages at the Metropolitan Museum of Art (Met) in New York City. During her nearly 18-year career as an educator at the Met, Chandler has been credited with drawing tens of thousands of visitors to the Museum; establishing cooperative partnerships with local public schools; offering teachers resources via lectures and publications; advancing storytelling as a dramatic pedagogy unique to art museums; performing for two nationally broadcast radio programs; and authoring eight widely popular storybooks (Chandler, 1918a, 1920, 1923, 1929a, 1929b, 1937, 1938, 1944; Solli, 2007; Zucker, 1998, 2001).

Yet, how did Chandler become emblematic of exemplary storytelling? Where did her life narrative begin, and what forces propelled her professional storyline forward? In this chapter, I examine how Chandler's personal and professional life developed over three decades, from her early childhood through her inaugural years at the Met. First, I review Chandler's upbringing and formal education in order to postulate how she conceptualized storytelling as a learned skill. Next, I explore Chandler's original occupation at the Museum and her petitions for transfer from the Photography De-

partment to the Education Department, paying particular attention to how she articulated her perceived abilities. I conclude with an analysis of Chandler's activities in the Met's Education Department during the United States' active military involvement in World War I, establishing a biographical portrait that reveals her to be a determined, politically engaged educator whose actions were situated within the nation's contemporaneous Americanization efforts.[1]

From Storytime to Student

Born in 1890 in Brunswick, Maine, Anna Curtis Chandler grew up listening to tales woven by her mother and father before bedtime each night (Chandler, 1920; Wellesley College, 1941). In the epilogue of her second storybook, *More Magic Pictures of the Long Ago* (1920), Chandler described her parents' narratives as *"'made-up' stories in which little people worked and danced and frolicked, and became real companions"* (p. 173). These nightly rituals *"made a deep impression on her,"* presenting new realms of possibility and serving as the impetus for her future career as a storyteller at the Met (Pennell, 1938, n.p.).

Unfortunately, Chandler did not provide further elaboration on her childhood or explicitly offer alternative explanations for why she gravitated toward storytelling as a profession. However, her academic records indicate that her inclination for storytelling aligned with a carefully curated course selection. After graduating with her Bachelor of Arts degree in art, Latin, and English composition from Wellesley College in Wellesley, Massachusetts, in 1909 (see Figure 10.1), Chandler remained at the school for an additional year of graduate study (Wellesley College, 1941). Under the direction of Professor Alice V. V. Brown in the Art Department, Chandler enrolled in art and education classes. Yet, in 1910, Chandler abruptly left Wellesley College without completing her degree and relocated to New York City (Chandler to H. W. Kent, June 23, 1914).[2]

Figure 10.1
**Yearbook photo of Anna Curtis Chandler (far right) at Wellesley College,
ca. 1909**

BUTTERFIELD, JOSEPHINE D.
1205 Norfolk Avenue, Norfolk, Neb.

CECIL, MARTHA B.
1537 Fourth Street, Louisville, Ky.

CHANDLER, ANNA C.
5 Concord Terrace, South Framingham, Mass.

Photo courtesy of Wellesley College Archives.

Chandler's interest in art education persisted, however, and she dedicated her spare time to cultivating her storytelling techniques. Shortly after moving to New York City, she completed a storytelling course taught by Dr. Richard T. Wyche, President of the National League of Story Telling, at the Normal College on Manhattan's Upper East Side.[3] She also enrolled in a "life class" led by Professor Alon Bement at Teachers College, Columbia University (Chandler to H. W. Kent, June 23, 1914). Furthermore, Chandler gained practical performance experience on *"many Sunday afternoons . . . by telling stories at the Hospital for Crippled Children, and the East Side Settlement House"* (Chandler to H. W. Kent, June 23, 1914). By participating in formal education classes as well as actively volunteering at nearby organizations, Chandler demonstrated her belief that storytelling as a profession could be learned—nurtured and perfected in theory and in practice.

Early Years at the Museum

In addition to taking classes upon her relocation to New York City in 1910, Chandler also began working in the Met's Photography Department, which was housed in the Museum's Library. There, she specialized in *"photographs of Painting, Sculpture, Architecture, and Minor Arts"* (Chandler to H. W. Kent, June 23, 1914). In an interview with the *Portland Telegram-Press Herald* in 1938, however, Chandler disclosed that her first position at the Met was far from fulfilling. Tasked with writing labels, handling patron requests, and verifying item descriptions, Chandler rarely interacted with visitors in the way she envisioned she would when she was hired (Pennell, 1938). Consequently, after four years behind a desk in the Met's Library, Chandler sent a letter to the Education Department's overseer, Assistant Secretary Henry Watson Kent, requesting to be considered for an unannounced job opening (Chandler to H. W. Kent, June 23, 1914).

In this two-page handwritten letter inscribed in black ink on stationery from the Museum's Library, Chandler presented herself as a proactive learner and an academically qualified candidate for an educational position. Noting that a current educator, Miss Fenton, was *"leaving,"* Chandler stated, *"I [Chandler] should like to apply for some of the work. . . . I do not know what arrangements have been made for Summer classes, but perhaps there will be a chance for me to take them"* (Chandler to H. W. Kent, June 23, 1914).

One week later, Chandler received unwelcome news. Typed on a single sheet of paper, Kent described the *"little chance of vacancy or an opportunity for you [Chandler] to work along this line"* (Kent to A. C. Chandler, June 30, 1914). Miss Fenton was indeed leaving the Met, but Kent aimed to fill the position with *"one who has had some experience in teaching, and who will be able to take full charge of this branch of the Museum's work"* (Kent to A. C. Chandler, June 30, 1914). If any suitable opportunity arose for Chandler to join the Education Department, however, Kent promised to inform her (Kent to A. C. Chandler, June 30, 1914).

The letter did not deter Chandler in her objective. On July 1, 1914, she penned another handwritten letter to the Assistant Secretary, rebutting his assessment that she lacked teaching experience. According to Chandler, she had a compelling background in instruction:

> *During my graduate year at Wellesley I [Chandler] worked in Art as a major, and Education as a*

minor subject. . . . Part of the work was teaching.
. . . in the Wellesley Hills High School. . . . I think
I spoke, in my other letter, of the experience I
have had here in New York in Story-telling [at the
Hospital for Crippled Children and East Side Set-
tlement House. [at the Hospital for Crippled
Children and East Side Settlement House].
(Chandler to H. W. Kent, July 1, 1914)

It is difficult to gauge if Chandler's note was intentionally impudent or simply explanatory. Either way, no further correspondence between Chandler or Kent is preserved in the Met's Archives for the remainder of 1914. Moreover, communication between the two Museum employees did not resurface until April 1917, roughly two weeks after President Woodrow Wilson declared war on Germany.

It is ambiguous which specific tasks Chandler completed at the Met between 1914 and 1917, but it is apparent that she continued working in the Library and remained interested in transferring to the Education Department. On April 17, 1917, Chandler composed another handwritten letter on Library stationery to Kent, asking to join his staff *"this coming year for at least part time"* (Chandler to H. W. Kent, April 17, 1917). Unlike her initial attempt to move from Library to Education, Chandler plainly stated her professional objectives in this letter: *"besides the Saturday and Sunday story-hours, I should like very much to help with classes"* (Chandler to H. W. Kent, April 17, 1917). Rather than outlining her qualifications, however, Chandler described her involvement with the School Art League in New York City, highlighting her value to another organization in order to suggest that her skills were in demand.[4] Intriguingly, Chandler did not readily offer her services to Kent. Instead, she detailed how she intended to work as a docent for the School Art League *"from one until five, for five days of the week, for nine months of the year, September 15th-June 15th"* (Chandler to H. W. Kent, April 17, 1917). Therefore, any position he provided her at the Museum would have to be restricted to weekday mornings and weekends. In other words, Chandler was truly only applying to be a storyteller during the Saturday and Sunday Story Hours.

Just three days later, Kent informed Chandler of the news she had been waiting almost three years to hear: she would be the Met's newest storyteller. In a typed letter consisting of a single sentence,

Kent reiterated that Chandler would be joining the Museum's Education Department part-time (Kent to A. C. Chandler, April 20, 1917). Not surprisingly, Chandler accepted Kent's offer, officially agreeing to his terms in a handwritten letter dated April 23, 1917 (Chandler to H. W. Kent, April 23, 1917).

One week later, though, Chandler's professional life shifted once again. In a typed one-page letter addressed to Dr. James P. Haney, the School Art League's Chairman of the Board of Managers, Chandler resigned from her prospective position as one of the organization's docents. As Chandler alleged in the letter, the School Art League position was modified from part-time to *"full time, five days a week, for the nine months of the school year"* (Chandler to J. P. Haney, April 30, 1917). Citing her commitment to the Museum's weekend Story Hours and the *"occasional taking of classes or giving stories in the mornings,"* Chandler explained that she could not work for both institutions given the positions' respective time commitments (Chandler to J. P. Haney, April 30, 1917). In short, Chandler opted to pursue a career in the Met's Education Department—even though it was only part-time—rather than teach full-time for the School Art League.

Chandler's Involvement in Storytelling Activities at the Museum

Although the Met's storytelling activities were divided into three distinct programs—Saturday Story Hours for Museum members, Sunday Story Hours for the general public, and weekday Children's Hours for the youngest learners—the two well-attended weekend events were nearly identical to one another in structure.[5]

Organizing the Saturday and Sunday Story Hours

Prior to beginning her presentations, Chandler tried to speak with as many attending visitors as possible. She attempted to gauge which stories they had heard before, which narratives they preferred, and whether or not they were interested in perusing the Met's galleries afterward. Then, she introduced the story, providing listeners with a tantalizing taste of the tale to come. At this time, Chandler welcomed children's comments, encouraging them to share their own thoughts about the story's content. Yet, once she began to tell the story, there were no interruptions (Chandler, 1917). Chandler enlivened the story using dramatic action and often dressed in period clothing. She also adjusted her voice throughout the Story Hour to play multiple roles. According to Chandler in an

interview several years later, the process proved to be a pleasant challenge:

> *As I talked, I took the parts of my various charac-*
> *ters. . . . Sometimes it is a bit difficult to be a*
> *pattern out of a Persian rug, or to step stiff and*
> *angular from the exterior of an Egyptian vase,*
> *but I manage somehow. (Chandler in Willyoung,*
> *1921, p. 4)*

During the Story Hour, Chandler's colleagues—Mrs. Henry L. De Forest, Mrs. Eva Johnston Coe, and Miss Alice H. Nichols—enhanced the narrative by playing contemporary music on the piano and singing period-appropriate songs (Runchey, 1930).

As Chandler explained in the foreword of her fifth storybook, *Story-Lives of Master Artists* (1929b), she based all her stories on Mark Twain's idea that *"it may have happened, it may not have happened, but it could have happened"* (p. xiii). Consequently, facts became mysterious myths that could be bent to Chandler's will, serving her educational aims by constructing enticing narratives capable of capturing listeners' and readers' imaginations, compassions, and, ultimately, consciences.[6]

After she finished telling the story, Chandler further illustrated the narrative by projecting corresponding lantern slides, the majority of which displayed artworks from the Met's permanent collection. While showing the images, Chandler made a point to engage the children, asking them to share their reactions. She then concluded the Story Hour by inviting visitors to explore the galleries and locate the objects she had discussed. On Saturdays, the audience was typically small enough to divide into groups, which could be guided through the Museum by staff members. On Sundays, however, this approach was impractical because of the immense number of visitors the Story Hour had attracted. In these situations, the crowd was merely directed where to go and left to venture into the galleries without guidance (Chandler, 1917).

Even when the Story Hours were at capacity, they did not lack order. Chandler ensured that her program ran smoothly with minimal employee oversight by enlisting the help of volunteer monitors, whom she dubbed her *"feudal order"* (Chandler in Willyoung, 1921, p. 4). Ranging in age from 4 to 16, the boys and girls volunteering for

Chandler were separated into three divisions: pages, who wore blue bands around their arms; squires, who donned purple; and knights, who were awarded gold. The medieval-inspired volunteers oversaw the Story Hours' publicity, organization, and hospitality. Each child also had to pledge allegiance to the Met, vowing *"to learn about the objects of art in the Museum, to see beauty everywhere, to be courteous, honest, punctual and steadfast"* (Chandler in Willyoung, 1921, p. 4). Perhaps the surest demonstration of the feudal order's commitment to the Story Hours was its annual performances (see Figure 10.2), in which the volunteers presented a story to a live audience ("A final children's hour," 1920; "An entertainment by the monitors," 1919).

Figure 10.2
Undated photograph of Chandler's young volunteers performing a story at the Metropolitan Museum of Art

Reproduced in an interview featuring Chandler's storytelling practices by C. Willyoung in *Gas Logic* (1921)

Although the feudal order's contributions may appear marginal, they illustrate how the volunteers viewed the Museum as an extension of themselves. Chandler successfully established the Met as space for creative exploration, and the children were comfortable enough to occupy her stage and present their own interpretation of artworks in the Museum. By equipping her young volunteers with the tools necessary for effective storytelling, Chandler empowered

them to participate in the narrative process, creating a new avenue for imaginative productions and implementing dramatic pedagogy.

Gaining Credibility Through an Imagined Community of Dress and Decorum

When Chandler stepped onto the Met's stage and performed her tales for hundreds of visitors, she captivated audiences both visually and audibly. Yet, her presence transcended mere fascination and allure because she consciously constructed her professional identity in order to maximize her credibility with Museum visitors. She was an expert in her craft or, at least, she succeeded in giving off the impression of expertise to Museum audiences. Either way, her accomplishments were far from accidental, as she deliberately fashioned herself as a respected storyteller, complete with appropriate dress and decorum.

Correspondence between Henry Watson Kent and the Museum's in-house prop maker, Florence W. Ivins, demonstrates Chandler's dedication to appearing artistically authentic. Dated June 25, 1919, a typed letter stamped with Kent's signature thanked Mrs. Ivins for providing a bill of sale for Chandler's new dress, which was to be repeatedly worn for each of her upcoming Story Hours (Kent to F. W. Ivins, June 25, 1919). The bill of sale reveals Ivins' creation of *"one grey satin silk gowne,"* totaling $26.69 (Ivins, 1919, n.p.). Accompanying the bill are three hand-drawn illustrations of the dress (see Figure 10.3), which included two pieces: a *"grey dress of very slimy silk"* and an *"oriental coat of bright linen stamped with flowers or figures"* (Ivins, 1919, n.p.). The items could be worn together or separately, creating a range of looks to complement almost any tale Chandler might perform.

Figure 10.3
Illustrations provided by Florence W. Ivins in her 1919 bill of sale

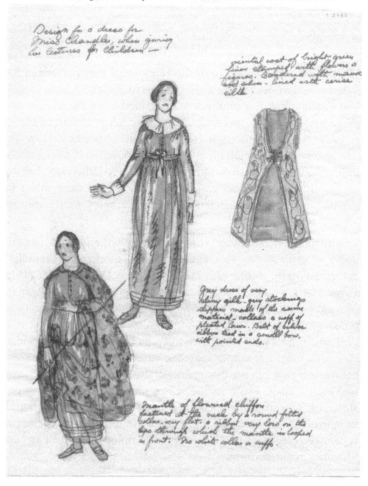

Photo courtesy of the Metropolitan Museum of Art Archives.

Operating on multiple levels, Chandler's costumes signified her participation in "imaginary connections" for the purposes of their "inclusionary and exclusionary functions . . . remind[ing] us [viewers] not to take nationalism for granted but to consider just how fabricated imagined communities have been" (Hoganson, 2007, p. 58). Thus, Chandler theatrically performed difference during her Story Hours in order to demonstrate how disparities are often su-

perficially visual: she remained herself, despite whatever outfit she was wearing. By placing herself in the position of the anthropological 'other,' Chandler urged audience members to view her as someone who was both an outsider and the same as they were. Was she a fellow citizen, or was she someone else, simply because she was wearing clothes associated with a distant locale? Chandler toyed with these questions during her performances, engaging visitors in a form of mental play that encouraged them to work through their personal conceptions of the 'other' and define their own identities.

Chandler used her costumes to illustrate the fluidity of time, place, nationality, and citizenship. While her stories often invoked a distinct sense of 'here' and 'there,' it was in costumes that Chandler collapsed this distance, attempting to bring fantastic, foreign modes of dress and vision into direct contact with Museum visitors. Representing fantasy-fueled historical narratives, Chandler's costumes conflated imagination with reality, pushing viewers into a fictional yet plausible world. Although it is impossible to say with complete certainty that her clothes were historically inaccurate given the tenuous nature of fashion history (Hennessy, 2012), Chandler likely based her performance apparel on source material available in the Museum's artworks and her own inventiveness. Like her stories, they were at once true and untrue. Consequently, Chandler's outfits functioned as invitations for imaginary leaps into the unknown, as well as connotative connections with imagined communities representing differences in time and place (Anderson, 2006).

Chandler's performances relied on more than just her costumes, though. Indeed, she carefully constructed her storytelling persona based on her training from Wellesley College in Wellesley, Massachusetts; the Normal College on Manhattan's Upper East Side; and Teachers College on Manhattan's Upper West Side. She valued clarity and charisma, in addition to a compelling presence that bid listeners to follow her every word and movement. Described as an enchantress in a 1921 interview, Chandler's position as a storyteller is fancifully recounted:

If you have the courage to storm into her strong-hold, it is only a matter of time before you fall victim to her wiles. . . she will tell you the most impossible tales in such a fascinatingly plausible

way that there will be nothing for you to do but believe her. (Willyoung, 1921, p. 3)

Fictive Travel as a Means to (Re)define Citizenship

At the basis of all of Chandler's educational activities is the recurring theme of fictive travel (Stoddard, 1894). With her tall tales of adventures abroad, half-true histories, and fanciful flights to places old and new, near and far, Chandler transported audiences to illusory locales in order to propose alternative ways of understanding the world. This form of fictive travel worked to both reinforce audience members' national identities—which were typically American—and suggest that not all boundaries were clearly defined. What made one person an American and another a foreigner? Why did this differentiation even matter? Given the history of the United States as a nation of immigrants, these enduring questions have challenged generations. However, American national identity became especially critical during the time in which Chandler was writing, as many residents maintained ties to countries in either the Central Powers or the Allied Powers during World War I. Although Chandler never directly answered either of these questions, she guided audiences on paths of personal discovery so they could ponder such queries, implementing fictive travel as her principal instrument of doing so.

Chandler was by no means the only American woman involved in fictive travel. In the late 19th and early 20th centuries, tens of thousands of U.S. women participated in travel clubs, regularly meeting to listen to travelogues, share travel briefings, and imaginatively explore the world without ever leaving the comfort of their neighborhood (see Figure 10.4). By visualizing themselves as tourists trekking across the globe, club members *"challenged the assumption that women's place was in the home,"* gaining entry to sites often restricted to wealthy men and their families (Hoganson, 2007, p. 154).[7] Thus, armchair travel club members were generally working-class women and homemakers, unable to physically travel because of their daily obligations (Hoganson, 2007). Chandler herself was eventually involved in a *"Travel Club"* (Wellesley College, 1941, p. 2). While not exactly a woman lacking economic means or social clout—she was a Wellesley graduate, after all—Chandler's participation in fictive travel clubs enabled her to experience the world through a different lens, viewing faraway locations as a fellow voyeur rather than as a participant.

Figure 10.4
Undated photograph of tourists ascending the Great Pyramid in Egypt

Labeled "Climbing the Great Pyramid, Egypt," from J. L. Stoddard's publication, *A Trip Around the World* (1894).

The United States' fictive travel movement undoubtedly influenced Chandler's teaching strategies, providing inspiration for her performances and offering a basic formula from which she could expand and deviate. Like fictive travel club meetings, Chandler's storytelling performances operated as pseudo-passive listening experiences, with audience members imagining themselves on journeys to distant locales while a lead orator narrated the environment with accompanying images. Yet, fictive travel also offers a glimpse into Chandler's activities that is not clearly captured by the Museum's storytelling programs, contextualizing her efforts within the larger sociopolitical environment of international relations. Through the travel clubs' exploration of the exotic and the extrane-

ous, the unknown gradually became familiar. In other words, the imaginary travel movement propelled *"global consciousness"* (Hoganson, 2007, p. 155). Chandler was able to capitalize upon this phenomenon in her educational endeavors, making the world at large appear—even superficially—more approachable, relatable, and somewhat knowable. Consequently, Chandler situated her American audiences within their local milieu while concurrently catapulting them into the strange surroundings of (a)historical environments, substituting the travel clubs' fascination of the present with her commitment to the past.

More broadly, Chandler's employment of fictive travel in her educational undertakings enabled her to supply audiences with an escape from World War I's harsh realities, providing comfort in imaginative journeys. Such trips reinforced audiences' awareness of their localities, pushing their citizenship statuses and national identities to center stage. By presenting narratives defined by distance, Chandler called attention to individuals' participation in an *"imagined political community"* defined by national boundaries and distinct from other nations (Anderson, 2006, p. 6). If readers of her stories were American citizens, they may have found her tales to be interesting solely because of their sheer otherness—capturing their creativities as well as their consciences. Thus, the United States as a coherent place emerged through its contrast with a culturally distinct Europe. In this way, Chandler contributed to Americanization efforts by bringing a non-American, European 'other' to the forefront of readers' awareness. Readers who were not U.S. citizens, on the other hand, may have viewed her stories as pointed reminders that they were not yet a part of this particular national community, which may have spurred them to actively consider, or even pursue, citizenship further. Either way, Chandler's storytelling activities—both written and acted out—may be classified as an alternative Americanization program, seeking to prepare readers and listeners for their roles as democratic citizens in the United States both throughout and after the disorder created by World War I had subsided.

Conclusion

In any given day, we hear and read a countless number of stories. This was also true for Chandler's many audience members and storybook readers, whom she led on imaginative journeys throughout the Metropolitan Museum of Art and, ultimately, throughout time and place. Yet, stories are—and have always been—capable of

achieving more than simply connecting listeners and readers with particular objects, eras, and spaces. As one storytelling handbook from 1923 indicated, storytelling supported Americanization programs designed to integrate immigrants into the United States' social sphere by reassuring them that America was not so different from their homelands, introducing them to knowledge that American-born citizens already possessed, and inspiring them to improve their own communities (Forbes, 1923). As this chapter suggests, Chandler was invested in the Americanization movement, situating Story Hours as a public venue for democratization. For art educators today, this picture of Chandler represents a re-imagining of the historical roots of storytelling practices in museums, revealing their political nature and ability to enroll visitors in value formation, as well as their strength as pedagogical tools in teaching history.

References

A final children's hour. (1920, June). *The Metropolitan Museum of Art Bulletin, 15*(6), 142.

Anderson, B. R. (2006). *Imagined communities: Reflections on the origin and spread of nationalism* (2nd ed.). London, UK: Verso.

An entertainment by the monitors. (1919, July). *The Metropolitan Museum of Art Bulletin, 14*(7), 163-165.

Chandler, A. C. (1914, June 23). [Letter to Henry W. Kent]. The Metropolitan Museum of Art Archives, The Metropolitan Museum of Art, New York, NY. 2015, August 17.

Chandler, A. C. (1914, July 1). [Letter to Henry W. Kent]. The Metropolitan Museum of Art Archives, The Metropolitan Museum of Art, New York, NY. 2015, August 17.

Chandler, A. C. (1917). Museum story hours. *The Storytellers' Magazine, 5*(9), 381-384.

Chandler, A. C. (1917, April 17). [Letter to Henry W. Kent]. The Metropolitan Museum of Art Archives, The Metropolitan Museum of Art, New York, NY. 2015, August 17.

Chandler, A. C. (1917, April 23). [Letter to Henry W. Kent]. The Metropolitan Museum of Art Archives, The Metropolitan Museum of Art, New York, NY. 2015, August 17.

Chandler, A. C. (1917, April 30). [Letter to James P. Haney]. The Metropolitan Museum of Art Archives, The Metropolitan Museum of Art, New York, NY. 2015, August 17.

Chandler, A. C. (1918a). *Magic pictures of the long ago: Stories of the people of many lands.* New York, NY: Henry Holt and Company.

Chandler, A. C. (1918b). *Story Hours report, 1918.* The Metropolitan Museum of Art Archives, The Metropolitan Museum of Art, New York, NY. 2015, August 17.

Chandler, A. C. (1920). *More magic pictures of the long ago: Stories of the people of many lands.* New York, NY: Henry Holt and Company.

Chandler, A. C. (1923). *Pan the Piper and other marvelous tales.* New York, NY: Harper & Brothers.

Chandler, A. C. (1929a). *A voyage to Treasure Island.* New York, NY: Harper & Brothers.

Chandler, A. C. (1929b). *Story-lives of master artists.* New York, NY: Frederick A. Stokes Company.

Chandler, A. C. (1937). *Treasure trails in art.* Boston, MA: Hale, Cushman & Flint.

Chandler, A. C. (1938). *Famous mothers and their children.* New York, NY: Frederick A. Stokes Company.

Chandler, A. C. (1944). *Dragons on guard: An imaginative interpretation of Old China in stories of art and history.* New York, NY: J. B. Lippincott Company.

Clark, A. M. (2016, May). *Constructing citizenship by telling tales: Anna Curtis Chandler's storytelling practices during the United States' involvement in World War I (1917-1918)* (Unpublished Master's thesis). The University of Texas at Austin.

Forbes, M. P. (1923). *Good citizenship through story-telling: A textbook for readers, social workers, and home-makers.* New York, NY: The Macmillan Company.

Hennessy, K. (Ed.). (2012). *Fashion: The definitive history of costume and style.* New York, NY: Dorling Kindersley.

History. (2016). Department of Anthropology, Hunter College. Retrieved from http://www.hunter.cuny.edu/anthropology/about/history

Hoganson, K. L. (2007). *Consumer's imperium: The global production of American domesticity, 1865-1920.* Chapel Hill, NC: The University of North Carolina Press.

Ivins, F. W. (1919). *Bill of sale.* The Metropolitan Museum of Art Archives, The Metropolitan Museum of Art, New York, NY. 2015, August 17.

Kent, H. W. (1914, June 30). [Letter to Anna C. Chandler]. The Metropolitan Museum of Art Archives, The Metropolitan Museum of Art, New York, NY. 2015, August 17.

Kent, H. W. (1917, April 20). [Letter to Anna C. Chandler]. The Metropolitan Museum of Art Archives, The Metropolitan Museum of Art, New York, NY. 2015, August 17.

Kent, H. W. (1919, June 25). [Letter to Florence W. Ivins]. The Metropolitan Museum of Art Archives, The Metropolitan Museum of Art, New York, NY. 2015, August 17.

Pennell, P. (1938). Energetic daughter of Maine is author of children's books. *Portland Telegram-Press Herald.*

Runchey, G. (1930). Art appreciation for children: The work of Anna Curtis Chandler in the Metropolitan Museum of Art, New York. *School Arts Magazine, 29*(5), 316-320, ix.

Solli, K. E. (2007, August). *"Story hour enchantress": Anna Curtis Chandler and a transformative era in museum education at the Metropolitan Museum of Art, 1917-1934* (Unpublished Master's thesis). The University of Texas at Austin.

Stoddard, J. L. (1894). *A trip around the world with John L. Stoddard: A collection of photo-engravings of famous scenes, cities and paintings of Europe, Asia, Africa, Australia, North and South America.* Chicago, IL: The Werner Company.

The School Art League. (n.d.). Retrieved from http://schoolartleague.org/

Wellesley College. (1941). *Wellesley College Alumnae Association 1942 biographical record.* (1941, October 1). Wellesley College Archives. Wellesley, MA. 2015, July 13.

Willyoung, C. (1921, November). When the paintings come to life in the museum. *Gas Logic, 30*(5), 3-4, 13.

Zucker, B. F. (1998). Competition for audience: Museum storytellers and "the movies" (1910-1920). *Animation Journal, 7*(1), 35-51.

Zucker, B. F. (2001). Anna Curtis Chandler: Art educator nonpareil at the Metropolitan Museum of Art. In K. G. Congdon, D. Blandy, & P. E. Bolin (Eds.), *Histories of community-based art education* (pp. 8-18). Reston, VA: National Art Education Association.

Endnotes

[1]For more information on methods of gathering information regarding Chandler's life through archival research, see Clark (2016).

[2]Intriguingly, no record indicating the reason behind Chandler's abrupt departure from graduate school has yet been uncovered.

[3]In 1914, the Normal College was renamed Hunter College of the City of New York in honor of Thomas Hunter, the College's founding President ("History," 2016).

[4]The School Art League established its headquarters on 215 West 57th Street in New York City in 1892 ("The School Art League," n.d.).

[5]The Children's Hours took place twice during the week: on Wednesdays for the general public and on Thursdays for Museum members (Chandler, 1918b).

[6]For more information on Chandler's writing and selection process, see Clark (2016).

[7]Participants in travel clubs were largely female, although men occasionally participated, most often as invited speakers (Hoganson, 2007).

Chapter 11

THE HIGHWAYMEN'S STORY: LANDSCAPE PAINTING IN THE SHADOW OF JIM CROW

Kristin G. Congdon

In 2006, 26 African American landscape painters (25 men and one woman) were inducted into the Florida Artist Hall of Fame. What is surprising about this honor is that these artists, mostly centered in Fort Pierce, Florida, became artists in the late 1950s to the early 1970s, in the Jim Crow South[1] when there were no visible Black role models, no galleries that would show their work, and few opportunities to do much more than work in the citrus groves or farm fields (Anderson, 2000).

Inspired by A. E. 'Bean' Backus, a successful White artist who defied racial conventions, and Zanobia Jefferson, a Black science and art teacher, these 26 young people learned to paint. They mimicked Backus, taught each other, and experimented with varying techniques on their own. Recognizing that White people did not identify Blacks as artists, they painted quickly and produced tens of thousands of paintings, selling them inexpensively in White communities. Rediscovered in the 1990s, many of the artists now take time to produce excellent work and some of their paintings currently sell in galleries and at art festivals for high prices. Because they originally took to the roadways to sell their work, in the 1990s they were named 'The Highwaymen.'[2]

In 2011, I was invited to be the lead scholar for a Highwaymen Heritage Trail[3] in the Fort Pierce area. Funded in part by the Florida Humanities Council and opening on February 20, 2016, it included kiosks, artworks, a website, and a designated trail. In order to give their work context, I wrote about the artists, their family members, and relevant educational spaces, as well as the topics of race, agriculture, the Highwaymen name, and the artists' legacy.[4] I discov-

ered that these artists offer lessons in both how to look at art and how to think about art education.

In this chapter, I briefly tell the story of the Highwaymen and how they were educated as painters in the Jim Crow South; view their work in a historical context and from the perspective of an African American aesthetic; and present how their artistic actions can be understood within the context of the Civil Rights Movement.

The Highwaymen and Their Art Education[5]

Scholars, collectors, and curators agree that two individuals started the Highwaymen painting movement: Alfred Hair (1941-1970) and Harold Newton (1934-1994) (see Figure 11.1).[6]

Figure 11.1
Landscape by Alfred Hair

Courtesy of C.J. Williams Collection.

Alfred Hair was a charismatic high school student when his Lincoln Park Academy art teacher, Zanobia Jefferson (1926-2016), noticed he had talent. Jefferson was raised in Chicago and studied at the Art Institute of Chicago and Fisk University with Aaron Douglas (1899-1979).[7] Because Fisk did not offer a major in art, Jefferson focused her studies on science education but took studio art courses as electives. In the 1950s, she and her husband, also an educator, moved to Fort Pierce to teach. They secured positions at Lincoln Park Academy, a segregated school with dedicated teachers and a strong community reputation. Although Jefferson was pri-

marily a science teacher, she believed art was important and started teaching art classes. In order to encourage Hair's budding talent, she enlisted the help of 'Bean' Backus, a successful White landscape painter she knew who had a studio just over the railroad tracks from what was then called 'colored town' (Monroe, 2001).

Backus's parents, who both came from theatrical families in the North, embraced people of all races and classes. 'Bean' followed suit. He loved jazz, rum, and good conversation—especially about art. Backus was a high school dropout (due to the Depression from 1929 to the late 1930s) who, in his teens, was able to scrape together enough money to study art for two summers at Parsons School of Art in New York City. Upon Jefferson's request, Alfred Hair was welcomed into his studio as a student in the late 1950s. Alfred paid his small tuition by making frames and cleaning the studio. Soon, Alfred's friends began coming to the studio to watch Backus paint. While Alfred was the only painter who had received formal lessons, several young men credited Backus with their start as artists (Firestone & Firestone, 2001; Petterson, 2003) (see Figure 11.2).

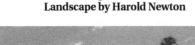

Figure 11.2
Landscape by Harold Newton

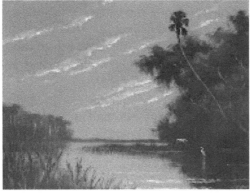

Courtesy of C.J. Williams Collection

Harold Newton was born in Gifford, Florida (not far from Fort Pierce), and raised in Tifton, Georgia. Unlike Alfred Hair, he did not graduate from high school; he had to drop out at the age of 16 to help support his family after his father died. Harold enjoyed drawing, and in his youth, he painted religious scenes on black velvet,

which he occasionally sold to local people, mostly poor like him. Harold soon moved back to Gifford where he could find farm work easily. He heard about Backus and sought him out for help with his painting. Backus welcomed Harold, encouraged him to paint on Upson board (an inexpensive building material) instead of velvet, and suggested he paint landscapes instead of religious scenes. Like Alfred, Harold began by watching Backus paint. He memorized the composition, brushstrokes, and the way the White artist used a palette knife, and then went home and painted a scene as close to Backus's painting as he could muster. He then returned to Backus with his newly finished painting for a critique (Beatty, 2005; Monroe, 2007).

Newton was more interested in making a quality painting than was Hair, whose primary focus was directed toward making money. Consequently, Hair's paintings were created fast and furious, often in the company of other painters who worked with him, while Newton set up his Upson board in solitary fashion. For practical reasons, almost all the early Highwaymen paintings were created outside, where they had space. But they were not painting the landscape around them (that would come later); instead, they were painting Backus's compositions, paintings he constructed from specific landscapes he knew and studied. Would-be painters came to watch Hair and Newton paint as they had done with Backus. It was mostly a 'watch and learn' method of instruction. Moreover, just as Newton and Hair had done, many of those who watched went home to practice.

According to historian Gary Mormino (2005), Florida's great export in the mid-20th century was optimism. Everyone, Black and White, wanted a piece of the American Dream. The youth who became the Highwaymen lived in a segregated community, like all Black neighborhoods in the South. People took care of each other. Some residents owned small businesses. Small gardens were everywhere, and hunting and fishing were everyday occurrences. Although times were tough, a living could be eked out if one was willing to work hard since the environment offered opportunities. Backus, who lived close by with an open studio door, was part of the Black community's resources.

For the 25 young male artists and Mary Ann Carroll, who was raising seven children alone, painting was a way of moving up and out—up the economic ladder and out of poverty and a life relegated to migrant work. They painted quickly, often making 8, 10, or 12

paintings a day. At one point, Alfred's wife, Dorothea, and her younger brother, Carnell Smith, painted the backgrounds in a factory-like manner, working several boards at a time with similar scenes and colors. Alfred would then paint the foregrounds. Other neighborhood youth made frames out of crown molding and the oil paintings were loaded into the trunk of a car (within time, Cadillacs and other high-end automobiles) and sold, still wet, to White patrons. One of the salesmen, Al Black, learned to paint by touching up the wet canvases that were damaged on the highway.

Because the early Highwaymen were not painting their experience in the landscape as much as they were painting the spaces of the White artist who created the compositions, they were metaphorically moving into the landscapes that Backus frequented, as well as into Backus's role as an artist. Some of the landscapes were places where Blacks were not welcomed. For all these young artists, painting was not primarily about their experience in a specific landscape; it was about the monetary freedom painting could bring, as well as the freedom of mobility that came with selling their work. By the mid-1960s, sales were good, money was flowing, and Highwaymen paintings were ubiquitous in White-owned hotels, businesses, and homes up and down the east coast of Florida (see Figure 11.3).

Figure 11.3
Landscape by Livingston Roberts

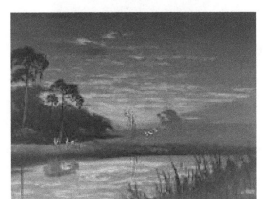

Courtesy of C. J. Williams Collection.

Everything changed on August 9, 1970. Alfred Hair was having a beer with friends at Eddie's Place, a local juke joint. Julius Funderburk, a ranch hand who had recently been released from prison,

shot and killed Hair over an argument about a girlfriend. Alfred was 29. The community fell into deep mourning. Many artists stopped painting and began working other jobs. Livingston Roberts, Hair's best friend who was with him that night, left town to deal with his grief. Two painters, Robert Lewis and Willie Reagan, became art teachers. Only James Gibson never stopped painting full-time (see Figure 11.4).

Figure 11.4
James Gibson painting

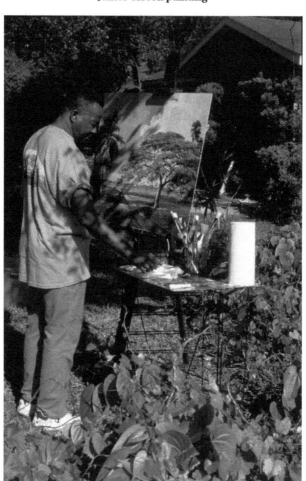

Photo by Bud Lee.

In the 1990s, a White collector named Jim Fitch set a goal of establishing the existence of a Florida painting tradition. He continually came across landscape paintings in flea markets and at garage sales. Researching the artists (who were scattered and elusive), he eventually named the group 'The Highwaymen' because they sold their paintings by traveling the roadways. Publicity followed and prices soared. The painters once more began painting landscapes, this time paying careful attention to their craft and becoming more inventive with composition and experimentation.

The African American Aesthetic and the Civil Rights Movement

While these artworks can be viewed simply as scenes of a vanishing Florida, the more deeply understood way to approach the work is to recognize the overall context in which they were created, an approach long proposed by many art educators (e.g., Chalmers, 1981; Congdon, 1985; McFee, 1966). Additionally, James Banks (2008) asked that educational practices work to eliminate the pain and discrimination that so many people have suffered. Viewed from these perspectives, the racial context in which the Highwaymen paintings were made is important to address. According to Ta-Nehisi Coates (2015), *"race is the child of racism, not the father. And the processes of naming 'the people' has never been a matter of genealogy and physiognomy so much as it is one of hierarchy"* (p. 7). The Highwaymen painted in a hierarchical context, one that designated certain roles (e.g., the artist) to Whites only, as well as the ability to move freely in geographical spaces. Jim Crow laws[8] relegated Blacks to the most undesirable parts of the landscape, making them largely invisible to Whites (Connolly, 2014).

However, African Americans did not live and work in designated 'colored spaces' simply as victims. George Lipsitz (2011) referred to what happened in these boundaried spaces as *"Black spatial imaginary."* This approach taught Blacks *"that every problem had a solution, that the terms and tools of oppression can be turned into instruments of emancipation, [and] that strong people don't need strong leaders"* (p. 256). Furthermore, Black spatial imaginary is a philosophy *"that sees art as a vital part of the life of a community, that finds value in devalued spaces, and that offers alternatives to possessive individualism and competitive citizenship"* (p. 19).

These young painters embraced each other as they passed on knowledge and assisted others in finding a place in their enterprise. If someone was too inexperienced to paint, he or she could make

frames, prepare Upson board, or paint skies. If one salesperson went to Miami, another might head to Orlando so as not to compete for the same customers. Lipsitz (2011) called what the Highwaymen did as *"not so much 'community-based art making' as 'art-based community making'"* (p. 138), and reminded us that, *"in the Afro-diasporic tradition, what matters is not so much the path you take, but rather the path you make"* (p. 218) (see Figure 11.5).

Figure 11.5
James Gibson selling his landscape paintings

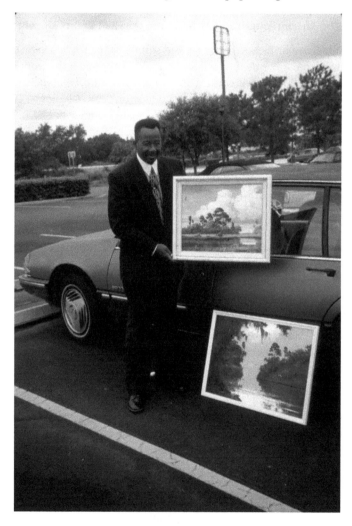

Photo by Kristin G. Congdon

By painting and selling landscapes, these artists established themselves as more equal to their White counterparts than Jim Crow allowed them to be. They moved into off-limit territories, acting much like the character in John tales, a legendary figure that was part of their cultural roots. John is a trickster slave who continually outwits the White plantation owner by being cunning and inventive, demonstrating superiority by his keen wit (Fordham, 2006).[9] In their roles as artists/salespeople, the Highwaymen took certain spaces as their own—their place as artists, the land they painted, and the world they moved in to sell their works. Once a sale was finalized, the evidence of their actions remained in the White person's hotel, business, or home—places they were told they could not inhabit. Smart and subversive, they outwitted the system.

'But are these good paintings?' one might ask. Lipsitz (2011) turned the tables on western ways of viewing art and provided us with an African American perspective that comes from listening to gospel, which is not only about good singing. Instead, it is a recognition of how much effort a singer of lesser skill puts into making a song communicate. The aesthetic, then, has to do with more than just having a good voice.

Louis Armstrong, who often played with less-skilled musicians and grew up in a sanctified church, understood this way of listening and valuing a performance. For him, passion and conviction were most important. Additionally, in these Black performative contexts, everyone is someone; everyone who plays jazz gets his or her chance to shine. Additionally, one can learn to hear or see these characteristics, and how an audience listens, sees, and responds can be as important as the way the music is played or the paintings are rendered. Alfred Hair, Harold Newton, and other artists embraced anyone in the community who wanted to learn to paint. Paintings may or may not exhibit great skill (it could vary), but the way one sees and values them also has to do with how hard and under what conditions an artist works to convey a message. Making judgments is not just about artists and their work, but also about an audience's willingness to learn and see. Because the story of the Highwaymen is part of the paintings, it is important to teach others to see not just a painting in a frame, but also the Highwaymen's efforts to paint their way out of segregation, poverty, and creative restrictions.

The story of the Highwaymen is not only a story (a history) about race, resilience, and civil rights; it is also a story about families,

friendships, faith in God, a cooperative community art education, and raw determination. It is a story of poverty and riches beyond dreams, painting, jazz, and the changing landscape. It is also about work, drugs, prison, oppression, boundaries, breaking boundaries, and the violence and beauty of a struggle. The Highwaymen have numerous stories. They are men and women who loved, lost, and triumphed. They are con artists, salesmen and women, re-purposers, and keenly educated movers and shakers. When I see a Highwaymen painting, I see friendships, educators, students, and a community that has lived, died, and is being reborn. While others marched during the Civil Rights Movement, sat at Woolworth counters, and demanded their rights to expand their freedom of access, the Highwaymen did so as well. Only they moved under the radar, bearing gifts like delicious tricksters in a John tale. As Theaster Gates (2015), another artist/hustler, acknowledged, the African American's rich culture can lift the burdens of slavery, Jim Crow, and racism.

A History of Art Education Through the Highwaymen

So how does the Highwaymen's story affect the history of art education? As Coates (2015) wrote, "To be educated in my Baltimore mostly meant always packing an extra number 2 pencil and working quietly. Educated children walked in single file on the right side of the hallway, raised their hands to use the lavatory, and carried the lavatory pass when in route" (p. 25). Coates did not do well in public schools; he even dropped out of Howard University where he felt more at home. He wondered, "Why, precisely, was I sitting in this classroom?" (p. 28). "The classroom was a jail of other people's interests" whereas, for him, the library was not (p. 48). Most of the Highwaymen's art education, like Coates's education, did not come from the classroom. Instead, it mostly came from their library—the community spaces they inhabited and the political circumstances in which they lived. The Highwaymen were not the only African American artists who used their communities like a library. There were also Purvis Young, Noah Purifoy, Thornton Dial, Lonnie Holley, Gregory Warmack (aka Mr. Imagination), the Gee's Bend quilters, Charlie Lucas, and so many others.

This story is part of African American history that, as Coates (2015) said, "was made forged in the shadow of the murdered, the raped, the disembodied" (p. 120). Yet, in the midst of the Highwaymen's violent history, these young artists understood the ways in

which the Black community worked and used it to their advantage, sharing knowledge and lifting each other up as they made their individual and collective ways into an unwelcoming world.

There is another side to this story. When White patrons purchased their paintings in the early years for $25 to $35, they did so with the understanding that they were buying into a new world vision, one that included an understanding of youthful Black talent. They connected that talent to a landscape they saw turning to concrete. In essence, the Highwaymen's patrons were also moving into a changing world as they hung their middle-class dreams of owning an oil painting on their walls. In this way, the Highwaymen's story is closely aligned with the fluid and open-ended approach of relational aesthetics (Bourriaud, 2002), but still deeply rooted in the Black spatial imaginary. The challenge for art educators is to tell this story grounded in its educational approach, its aesthetic understandings, and its goal of emancipation so that we can all learn in varying ways and see art from diverse perspectives.[10] Art is best understood within the context of its time and place. It is from this rich place of understanding where the artists and their specific and collective stories can enhance artworks (Congdon, Blandy, & Bolin, 2001). The Highwaymen landscapes are not just paintings of Florida's unspoiled territory before it became mind-numbing urban sprawl. These are paintings that broke boundaries.

References

Anderson, M. L. (2000). Self-taught art and the conscience of museums. In P. Arnett & W. Arnett (Eds.), *Souls grown deep: African American vernacular art of the South* (Vol. 1) (pp. 526-527). Atlanta, GA: Tinwood Books.

Banks, J. A. (2008). *An introduction to multicultural education.* Boston, MA: Pearson.

Beatty, B. (2005). *Florida's Highwaymen: Legendary landscapes.* Orlando, FL: Historical Society of Central Florida.

Bourriaud, N. (2002). *Relational aesthetics.* Dijon, France: Les Presse du Reel.

Chalmers, F. G. (1981). Art education as ethnology. *Studies in Art Education, 22*(3), 6-14.

Coates, T. (2015). *Between the world and me.* New York, NY: Spiegel & Grau.

Congdon, K. G. (1985). A folk group focus for art education. *Art Education, 37*(1), 13-16.

Congdon, K. G., Blandy, D., & Bolin, P. E. (Eds.). (2001). *Histories of community-based art education.* Reston, VA: National Art Education Association.

Connolly, N. D. B. (2014). *A world more concrete: Real estate and the remaking of Jim Crow in South Florida.* Chicago, IL: University of Chicago Press.

Enns, C. M. (2009). *The journey of the Highwaymen.* New York, NY: Abrams.

Firestone, S., & Firestone, G. (2001). *Southern skies, gentle breezes: The artistry of A. E. Backus.* Coral Gables, FL: Dorset Hollow Press.

Fordham, D. L. (2006). John tales. In A. Prahlad (Ed.), *The Greenwood encyclopedia of African American folklore* (pp. 709-710). Westport, CT: Greenwood.

Gates, T. (2015). How to revive a neighborhood: With imagination, beauty, and art. *Ted Talk.* Retrieved from https://www.ted.com/talks/theaster_gates_how_to_revive_a_ neighborhood_with_imagination_beauty_and_art/ transcript?language=en

Lipsitz, G. (2011). *How racism takes place.* Philadelphia, PA: Temple University Press.

McFee, J. K. (1966). Society, art and education. In E. L. Mattill (Ed.), *A seminar for research in art education.* University Park, PA: Pennsylvania State University.

Monroe, G. (2001). *The Highwaymen: Florida's African-American landscape painters.* Gainesville, FL: University of Florida Press.

Monroe, G. (2007). *Harold Newton: The original Highwayman.* Gainesville, FL: University of Florida Press.

Mormino, G. R. (2005). *Land of sunshine, state of dreams: A social history of modern Florida.* Gainesville, FL: University of Florida Press.

Petterson, O. D. (2003). *A. E. Backus.* Orlando, FL: Fidelity Press.

Endnotes

[1]The Jim Crow South or the Jim Crow era was a time when laws were made and enforced to keep Blacks and Whites apart. They began after the Reconstruction period and were enforced until 1965.

[2]Jim Fitch, a White collector, named the group in the mid-1990s. The name is problematic for this reason as well as the fact that it implies criminality. Additionally, Mary Ann Carroll, the only woman formally recognized in the group, objected to the sexist nature of the word. However, the name stuck and most of the painters are either resigned to the fact that it reflects their identity or feel as if the Highwaymen are now so well known that the initial criminal aspect of the word has been tempered, if not eliminated.

[3]The website for the Highwaymen Heritage Trail can be found at http://thehighwaymentrail.com/heritagetrail/

[4]Eight of the artists are deceased. The Highwaymen who were alive at the time were interviewed, along with some family members. Friends and family members of the deceased artists were also interviewed. Numerous books and articles were read for information. Resources for the Trail can be found at this link: http://thehighwaymentrail.com/bibliography/

[5]Unless otherwise noted, the story of the Highwaymen and their education comes from interviews I did with the artists, their families, collectors, scholars, and community members from 2011 to 2015.

[6]For example, see books by Monroe (2001, 2007) and Enns (2009). In 2006, the Museum of Art in Fort Lauderdale had an exhibition honoring the two founders of the movement. The exhibition was titled *Highwaymen Newton and Hair: The American Dream in the Sunshine State.*

[7]Aaron Douglas, a painter and illustrator, was a major figure in the Harlem Renaissance. His style paid homage to African Art; his inspiration came from biblical history and social issues.

[8]Jim Crow times were approximately 1877 to 1965.

[9]Zora Neale Hurston, who spent her last 10 years in Fort Pierce, among others, collected John Tales. "Old John" was also known as "High John the Conqueror" in some parts of the South.

[10]Near the end of his book, Coates wrote to his son: *"We are captured, broth-er, surrounded by the majoritarian bandits of America. And this has happened here, in our only home, and the terrible truth is that we can-not will ourselves to an escape on our own"* (p. 146). He went on to say that knowing this fact is the hope for the future. He also told his son that he cannot live his life as if the Dreamers will understand. But those of us who hear him can at least try.

Epilogue

This volume has assembled 11 papers presented at the conference *Brushes with History: Imagination and Innovation in Art Education History*, held at Teachers College, Columbia University, in November 2015. As months of conference planning and the meeting itself unfolded, we as organizers were struck by the resonant theme of 'historical disclosure' that emerged in a significant number of the more than 50 papers presented at this professional gathering. This disclosure of the past was revealed through many told-for-the-first-time accounts brought to light by the conference presenters, and also in newly developed narratives and critiques regarding the accomplishments of familiar individuals in art education. The lives of these people and their past actions were presented, discussed, and in some cases debated, and we believe the field of art education has been made richer by the contemplative dialogue that permeated the conference. Whether these historical narratives were about overlooked individuals or institutions from the past, or involved new interpretations of familiar people and incidents from times before our own, we believe that history within art education is re-energized and revitalized through the narratives included in this volume. We trust you feel this way as well.

Yet, this publication is only a beginning. The investigation of art education history is still in its academic infancy. Much work is needed; many more historical stories are yet to be discovered and told, debated and challenged. It is primarily through such historically based research and critical conversation that much needed maturation occurs within the field of art education. The territory of early art education is fertile ground for probing historical investigation and reflection. The pursuit of meaningful understanding about the past in art education involves searching the terrain with deep questioning and keen eyes to explore its hidden crevices. The task is not easy, but the rewards for doing so are motivationally energizing to the researcher and critically beneficial for the field. Thus, the reciprocity that occurs between an investigator of history and their surrounding professional field should be acknowledged and cultivated for everyone's well-being. A thorough and conscientious examination of a full range of individuals, events, institutions, and circumstances in art education lays a vital foundational cornerstone that will support the future growth and development of the field.

This enterprise calls on art educators to acknowledge the usefulness of interpretive outcomes that are drawn through historical research.

The body of work produced for this conference and ultimately for this book offers a robust contribution to advance historical dialogue in art education. Previously, the work of Bolin, Blandy, and Congdon (2000), and Congdon, Blandy, and Bolin (2001) has looked at art educators from the past whose lives and accomplishments have often been overlooked. *Revitalizing History* follows the approach of these two earlier volumes, offering a voice for art educators who have been hidden from historical conversation. There are instances when the accomplishments of women in art education—both in the past and present—have been documented and championed (e.g., Congdon & Zimmerman, 1993; Grauer, Irwin, & Zimmerman, 2003; Sacca & Zimmerman, 1998; Stankiewicz & Zimmerman, 1985; Zimmerman & Stankiewicz, 1982), yet beyond these publications, little focused emphasis has been placed on the achievements of women within the history of art education.

As well, research on the struggles and triumphs of African American art educators in the United States has been nearly non-existent—until this volume. This longtime exclusion of the many rich and valuable accounts centered on African Americans within our field is both regrettable and troubling, and must be addressed and altered. Not doing so only perpetuates the situation in art education that was captured so vividly in the poignant statement made by art educator Edward Mattil (1997), when speaking at the 1995 history of art education symposium held at the Pennsylvania State University: *"To allow extraordinary teachers and programs to go undocumented and unstudied is a tragic waste"* (p. 505). This volume, and other similar historical works that we hope will follow, will bring to the fore interpretive accounts of art educators who are presently unrecognized and excluded from discussions in the field of art education.

The time to recognize and honor the lives and accomplishments of African American and women art educators—and all ignored art educators—is long overdue, and it is time to acknowledge and celebrate the efforts of these individuals and their communities. This volume is a step forward in this recognition and celebration, and it calls for further investigation into a wide range of art educators who still remain overlooked and excluded from historically based conversations. We hope that these writings motivate new opportunities to recognize the efforts and achievements of long invisible and

unheard art educators, and catalyzes the exploration and documentation of their lives, their work, and their impact on art education and the world.

T. S. Eliot's words from his 1942 poem *Little Gidding* underscore for us a way to reflect on our purpose. When applied to historical research and writing, the following lines pose a contemplative challenge for future historians of art education to remain active in the work they do:

What we call the beginning is often the end

And to make an end is to make a beginning.

The end is where we start from

Every phrase and every sentence is an end and a beginning. (p. 15)

Historical engagement involves taking up the task of investigation into the past, not as an end but as a continuous interpretive beginning, in an effort to recognize the achievements of voices that have been overlooked, omitted, excluded, and silenced. The vitality of our field demands ongoing historical engagement. As this volume concludes, may the information and ideas presented herein be viewed not as an end but as a beginning. It is our hope the chapters included here will kindle within researchers and writers of history a desire to search out and provide historical disclosure and voice for the many yet untold stories currently hidden within the recesses of our unexplored past.

Paul E. Bolin and Ami Kantawala, Editors

References

Bolin, P. E., Blandy, D., & Congdon, K. G. (Eds.). (2000). *Remembering others: Making invisible histories of art education visible*. Reston, VA: National Art Education Association.

Congdon, K. G., Blandy, D., & Bolin, P. E. (Eds.). (2001). *Histories of community-based art education*. Reston, VA: National Art Education Association.

Congdon, K. G., & Zimmerman, E. (Eds.). (1993). *Women art educators III*. Bloomington, IN: Mary J. Rouse Memorial Foundation at Indiana University and the NAEA Women's Caucus.

Eliot, T. S. (1942). *Little Gidding*. London, UK: Faber and Faber.

Grauer, K., Irwin, R., & Zimmerman, E. (Eds.). (2003). *Women art educators V: Conversations across time: Remembering, revisioning, reconsidering*. Kingston, Canada: Canadian Society for Education Through Art/Reston, VA: National Art Education Association.

Mattil, E. (1997). Opening remarks. In A. A. Anderson & P. E. Bolin (Eds.), *History of art education: Proceedings from the Third Penn State International Symposium* (pp. 505-508). University Park, PA: The Pennsylvania State University.

Sacca, E. J., & Zimmerman, E. (Eds.). (1998). *Women art educators IV: Herstories, ourstories, future stories*. Boucherville, Quebec: Canadian Society for Education Through Art.

Stankiewicz, M. A., & Zimmerman, E. (Eds.). (1985). *Women art educators II*. Bloomington, IN: Indiana University Press.

Zimmerman, E., & Stankiewicz, M. A. (Eds.). (1982). *Women art educators*. Bloomington, IN: Indiana University Press.